The Digital Photography Book

The step-by-step secrets for how to
make your photos look like the pros'! Book

Scott Kelby

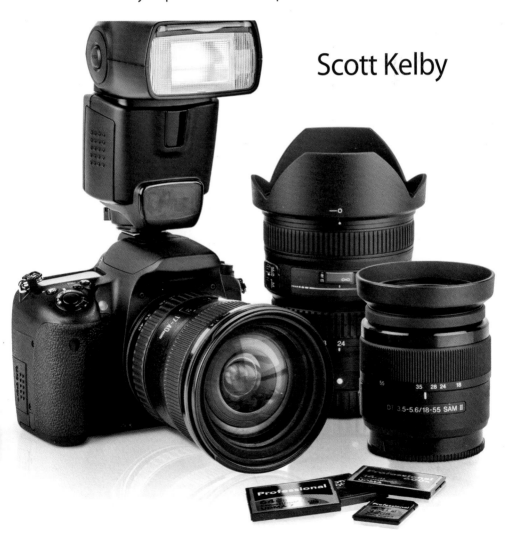

The Digital Photography Book, part 2

The Digital Photography Book, part 2 Team

CREATIVE DIRECTOR
Felix Nelson

ART DIRECTOR
Jessica Maldonado

TECHNICAL EDITORS
Kim Doty
Cindy Snyder

EDITORIAL CONSULTANTS
David Hobby
David Ziser
Steve Dantzig

PRODUCTION MANAGER
Dave Damstra

PHOTOGRAPHY
Scott Kelby

STUDIO AND
PRODUCTION SHOTS
Brad Moore

PUBLISHED BY

Peachpit Press

©2014 Scott Kelby

Composed in Myriad Pro (Adobe Systems Incorporated) and LCD (Esselte) by Kelby Media Group Inc.

Trademarks
All terms mentioned in this book that are known to be trademarks or service marks have been appropriately capitalized. Peachpit Press cannot attest to the accuracy of this information. Use of a term in the book should not be regarded as affecting the validity of any trademark or service mark.

Photoshop, Elements, and Lightroom are registered trademarks of Adobe Systems, Inc.
Nikon is a registered trademark of Nikon Corporation.
Canon is a registered trademark of Canon Inc.
Sony is a registered trademark of Sony Corporation.

Warning and Disclaimer
This book is designed to provide information about digital photography. Every effort has been made to make this book as complete and as accurate as possible, but no warranty of fitness is implied.

The information is provided on an as-is basis. The author and Peachpit Press shall have neither the liability nor responsibility to any person or entity with respect to any loss or damages arising from the information contained in this book or from the use of the discs or programs that may accompany it.

ISBN 13: 978-0-321-94854-0

ISBN 10: 0-321-94854-8

15 14 13 12 11 10 9 8 7 6 5 4 3 2

Printed and bound in the United States of America

www.peachpit.com
www.kelbytraining.com

*This book is dedicated to the memory of
Lakeland High School Band Director William C. Miller.
His job was to teach us music, but the things he taught us
about life changed us, challenged us, and improved us
in ways he could never imagine. I feel very
fortunate to have been one of his students.*

Acknowledgments

Although only one name appears on the spine of this book, it takes a team of dedicated and talented people to pull a project like this together. I'm not only delighted to be working with them, but I also get the honor and privilege of thanking them here.

To my amazing wife Kalebra: I don't know how you do it, but each year you somehow get more beautiful, more compassionate, more generous, more fun, and you get me to fall even more madly in love with you than the year before (and so far, you've done this 24 years in a row)! They don't make words to express how I feel about you, and how thankful and blessed I am to have you as my wife, but since all I have here are words—thank you for making me the luckiest man in the world.

To my wonderful, crazy, fun-filled, son Jordan: When I wrote the first version of this book, I wrote that you were the coolest little boy any dad could ever ask for. Now that you're 16 years old, and you're 6'1" and 220 lbs. of muscle (my brother calls you "The Wall"), you're not a little boy by any means, but you definitely still are the coolest! Although I know you don't read these acknowledgments, it means so much to me that I can write it, just to tell you how proud I am of you, how thrilled I am to be your dad, and what a great big brother you've become to your little sister. Your mom and I were truly blessed the day you were born.

To my beautiful daughter Kira: You are a little clone of your mom, and that's the best compliment I could ever give you. You have your mom's sweet nature, her beautiful smile, and like her, you always have a song in your heart. You're already starting to realize that your mom is someone incredibly special, and take it from Dad, you're in for a really fun, exciting, hug-filled, and adventure-filled life. I'm so proud to be your dad.

To my big brother Jeff: A lot of younger brothers look up to their older brother because, well…they're older. But I look up to you because you've been much more than a brother to me. It's like you've been my "other dad" in the way you always looked out for me, gave me wise and thoughtful council, and always put me first—just like Dad put us first. Your boundless generosity, kindness, positive attitude, and humility have been an inspiration to me my entire life, and I'm just so honored to be your brother and lifelong friend.

To my friend and fellow photographer Brad Moore: My personal thanks for shooting most of the product shots for this book and for working as first assistant on many of the shots I took throughout it. You're absolutely invaluable and an awful lot of fun.

To my in-house team at Kelby Media Group: You make coming into work an awful lot of fun for me, and each time I walk in the door, I can feel that infectious buzz of creativity you put out that makes me enjoy what we do so much. I'm still amazed to this day at how we all come together to hit our often impossible deadlines, and as always, you do it with class, poise, and a can-do attitude that is truly inspiring. You guys rock!

To my Editor Kim Doty: It broke Kim's heart that she wasn't able to work on the original, first edition of this book, but she had a pretty good excuse with that whole "I'm having a baby" thing. Kim, it's wonderful to have you back for this second edition (though, **Cindy Snyder** did a really great job pinch-hitting for you while you were out), and to have both you and Cindy working with me on this edition is really a treat.

To Jessica Maldonado (a.k.a. Photoshop Girl): I can't thank you enough for all your hard work on the cover, and on the look of this and all my books. I love the way you design, and all the clever little things you add to everything you do. You're incredibly talented, a joy to work with, and I feel very, very fortunate to have you on my team.

To my friend and Creative Director Felix Nelson: You're the glue that keeps this whole thing together, and not only could I not do this without you—I wouldn't want to. Keep doin' that Felix thing you do!

To my best buddy Dave Moser: Besides being the driving force behind all our books, I just want you to know how touched and honored I was that you chose me to be the Best Man at your wedding. It meant more than you know.

To my dear friend and business partner Jean A. Kendra: Thanks for putting up with me all these years, and for your support for all my crazy ideas. It really means a lot.

To my Executive Assistant Susan Hageanon: Thanks so much for managing my schedule, so I can find the time to write these books, and also for keeping a lot of plates in the air while I'm doing it. I know I don't make it easy, but you sure do! Thanks so much!

To Ted Waitt, my awesome Editor at Peachpit Press: There's nothing like having a serious photographer as your editor, and while you're a kick-butt editor, you're an even better friend.

To my publisher Nancy Aldrich-Ruenzel, marketing mavericks Scott Cowlin and Sara Jane Todd (SJ), and the incredibly dedicated team at Peachpit Press: It's a real honor to get to work with people who really just want to make great books.

To David Ziser, David Hobby, and Steve Dantzig who acted as tech editors on the original edition of this book, in three very important chapters: the wedding photography chapter, the off-camera flash chapter, and the studio chapter, respectively. I asked for your help because I knew you were the best, and the book is far better because of your input, suggestions, and ideas. I am so very grateful to you all.

To all the talented and gifted photographers who've taught me so much over the years: Moose Peterson, Joe McNally, Bill Fortney, George Lepp, Anne Cahill, Vincent Versace, David Ziser, Jim DiVitale, Cliff Mautner, Dave Black, Helene Glassman, and Monte Zucker.

To my mentors John Graden, Jack Lee, Dave Gales, Judy Farmer, and Douglas Poole: Your wisdom and whip-cracking have helped me immeasurably throughout my life, and I will always be in your debt, and grateful for your friendship and guidance.

Most importantly, I want to thank God, and His Son Jesus Christ, for leading me to the woman of my dreams, for blessing us with such amazing children, for allowing me to make a living doing something I truly love, for always being there when I need Him, for blessing me with a wonderful, fulfilling, and happy life, and such a warm, loving family to share it with.

Other Books by Scott Kelby

*Professional Portrait Retouching Techniques for Photographers
Using Photoshop*

The Digital Photography Book, parts 1, 2, 3 & 4

*Light It, Shoot It, Retouch It: Learn Step by Step How to Go from
Empty Studio to Finished Image*

The Adobe Photoshop Book for Digital Photographers

The Photoshop Elements Book for Digital Photographers

The Adobe Photoshop Lightroom Book for Digital Photographers

The iPhone Book

It's a Jesus Thing: The Book for Wanna Be-lievers

*Photo Recipes Live: Behind the Scenes: Your Guide to Today's
Most Popular Lighting Techniques,* parts 1 & 2

About the Author

Scott is Editor, Publisher, and co-founder of *Photoshop User* magazine, is Publisher of *Light It!* and *Lightroom* digital magazines, and is co-host of the weekly webcasts *The Grid* (a photography talk show) and *Photoshop User TV*.

He is President of the National Association of Photoshop Professionals (NAPP), the trade association for Adobe® Photoshop® users, and he's President of the software training, education, and publishing firm Kelby Media Group.

Scott is a photographer, designer, and an award-winning author of more than 50 books, including *The Digital Photography Book*, parts 1, 2, 3, & 4, *The Adobe Photoshop Book for Digital Photographers*, *Professional Portrait Retouching Techniques for Photographers Using Photoshop*, *The Adobe Photoshop Lightroom Book for Digital Photographers*, *Light It, Shoot It, Retouch It: Learn Step by Step How to Go from Empty Studio to Finished Image*, and *The iPhone Book*. His book, *The Digital Photography Book*, part 1, is now the top-selling book on digital photography ever.

For the past three years, Scott has been honored with the distinction of being the world's #1 best-selling author of books on photography. His books have been translated into dozens of different languages, including Chinese, Russian, Spanish, Korean, Polish, Taiwanese, French, German, Italian, Japanese, Dutch, Swedish, Turkish, and Portuguese, among others.

Scott is Training Director for the Adobe Photoshop Seminar Tour, and Conference Technical Chair for the Photoshop World Conference & Expo. He's featured in a series of online courses (from KelbyTraining.com), and has been training photographers and Adobe Photoshop users since 1993. He is also the founder of Scott Kelby's Annual Worldwide Photowalk, the largest global social event for photographers, which brings tens of thousands of photographers together on one day each year to shoot in over a thousand cities worldwide.

For more information on Scott, visit him at:

His daily blog: **http://scottkelby.com**
Twitter: **@scottkelby**
Facebook: **www.facebook.com/skelby**
Google+: **Scottgplus.com**

Chapter One 1

Using Flash Like a Pro

If You Hate the Way Photos Look with Flash,
You're Not Alone

Chapter Five 135

Shooting Weddings Like a Pro
How to Get Professional Results from Your Next Shoot

Chapter Six 157

Shooting Travel Like a Pro
How to Bring Back Photos That Really Make Them Wish They Were There

Chapter Seven 173

Shooting Macro Like a Pro
How to Take Really Captivating Close-Up Photos

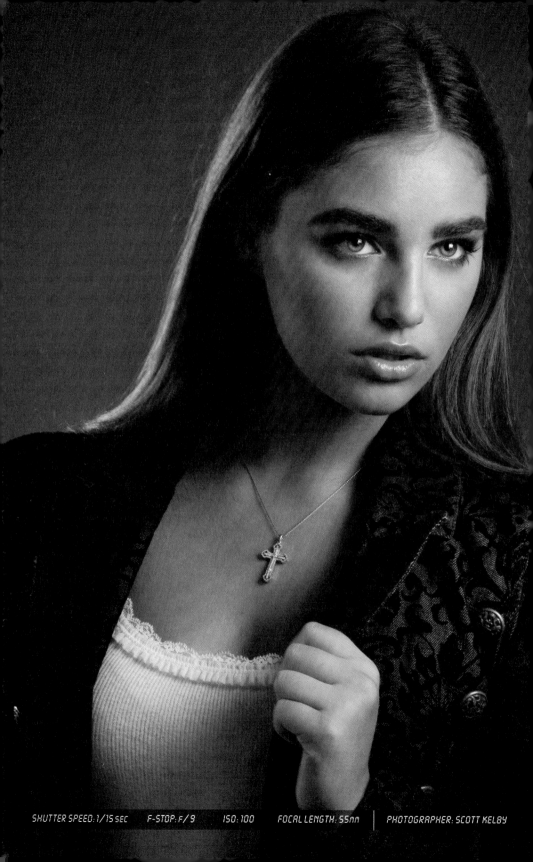

Chapter One
Using Flash
Like a Pro
If You Hate the Way Photos Look with Flash, You're Not Alone

If you've taken a photo with your camera's pop-up flash, you're probably wondering how camera manufacturers list pop-up flash as a feature and keep a straight face. It's probably because the term "pop-up flash" is actually a marketing phrase dreamed up by a high-powered PR agency, because its original, more descriptive, and more accurate name is actually "the ugly-maker." You'd usually have to go to the Driver's License Bureau to experience this quality of photographic light, but luckily for us, it's just one simple push of a button, and—BAM—harsh, unflattering, annoying, blinding light fires right into your subject's face. Seriously, does it get any better than that? Actually, it does. You just have to get your flash off your camera. Now, the first time you actually use pop-up flash and you see the quality of light it creates (and by "quality" I mean "a total lack thereof"), you'll be tempted to do just that—rip that tiny little flash right off the top of your camera (I'm not the only one who did that, right?). I have to figure that camera manufacturers include a pop-up flash on most camera models to do one thing and one thing only: spur sales of dedicated off-camera flash units (which are actually fantastic). Because as soon as you see the results from your pop-up flash, you think, "There has just got to be something better than this!" or maybe "I must be doing something wrong," or "My camera must be broken," or "This camera must have been stolen from the Driver's License Bureau." Anyway, this chapter is for people who figured there must be something better, and if someone would just show them how to use it, they could love flash again (not pop-up flash, mind you, but off-camera flash, which is a gas, gas, gas!).

10 Things You'll Wish You Had Known...

Okay, there aren't really 10, there are just eight, but "Eight Things" sounded kinda lame.

(1) **First, go right now to http://kelbytraining.com/books/digphotogv2** and watch the short video I made to explain these points in more detail. It's short, it's quick, and it will help you read this book in half the time (that "half the time" thing is marketing hype, but you'll get a lot out of the video, so head over there first. I'll make it worth your while).

(2) **Here's how this book works:** Basically, it's you and me together at a shoot, and I'm giving you the same tips, the same advice, and sharing the same techniques I've learned over the years from some of the top working pros. When I'm with a friend, I skip all the technical stuff, so for example, if you turned to me and said, "Hey Scott, I want the light to look really soft and flattering. How far back should I put this softbox?" I wouldn't give you a lecture about lighting ratios or flash modifiers. In real life, I'd just turn to you and say, "Move it in as close as you can to your subject without it actually showing up in the shot. The closer you get, the softer and more wrapping the light gets." I'd tell you short and right to the point. Like that. So that's what I do.

(3) **Sometimes you have to buy stuff.** This is not a book to sell you stuff, but before you move forward, understand that to get pro results, sometimes you have to use some accessories that the pros use. I don't get a kickback or promo fee from any companies whose products I recommend. I'm just giving you the exact same advice I'd give a friend.

...Before Reading This Book!

(4) We don't all have budgets like the pros, so wherever possible I break my suggestions down into three categories:

If you see this symbol, it means this is gear for people on a tight budget.

If you see this symbol, it means photography is your passion, and you're willing to spend a bit more to have some pretty nice gear.

If you see this symbol, it means this gear is for people who don't really have a budget, like doctors, lawyers, venture capitalists, pro ball players, U.S. senators, etc.

To make this stuff easier to find, I've put up a webpage with links to all this gear, and you can find it at **http://kelbytraining.com/books/vol2gear**.

(5) If you're shooting with an Olympus or a Sigma digital camera, don't let it throw you that a Nikon, Canon, or Sony camera is pictured. Since most people are shooting with a Nikon, Canon, or Sony, I usually show one of them, but don't sweat it if you're not—most of the techniques in this book apply to any digital SLR camera, and many of the point-and-shoot digital cameras, as well.

Here Are Those Last Three Things

(6) The intro page at the beginning of each chapter is designed to give you a quick mental break, and honestly, they have little to do with the chapter. In fact, they have little to do with anything, but writing these off-the-wall chapter intros is kind of a tradition of mine (I do this in all my books), but if you're one of those really "serious" types, you can skip them because they'll just get on your nerves.

(7) This is part 2 of *The Digital Photography Book* and it picks up where the last book left off (so it's not an update of that book, it's new stuff that people who bought the first book asked me to write about next). If you didn't buy part 1, now would be a really good time to do that (just think of it as a "prequel." Hey, it worked for George Lucas).

(8) Keep this in mind: This is a "show me how to do it" book. I'm telling you these tips just like I'd tell a shooting buddy, and that means, oftentimes, it's just which button to push, which setting to change, where to put the light, and not a whole lot of reasons why. I figure that once you start getting amazing results from your camera, you'll go out and buy one of those "tell me all about it" digital camera or lighting books. Okay, it's almost time to get to work. I do truly hope this book ignites your passion for photography by helping you get the kind of results you always hoped you'd get from your digital photography. Now pack up your gear, it's time to head out for our first shoot.

Pop-Up Flash: Use It as a Weapon

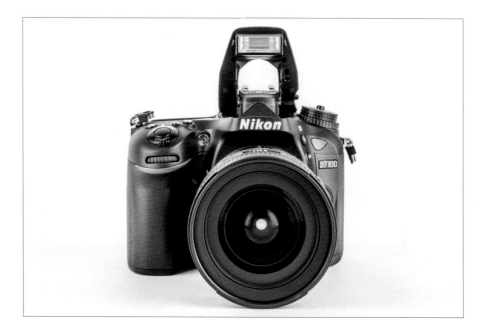

The pop-up flash built into your digital camera is designed to do one thing: give you the flattest, harshest, most unflattering light modern-day man has ever created. If you have a grudge against someone, shoot them with your camera's pop-up flash and it will even the score. Here are just some of the reasons why you want to avoid using that flash at all costs: (1) The face of the pop-up flash itself (where the light comes out) is very, very tiny and the smaller the light source, the harsher the light it produces. (2) Since the flash is positioned right above your camera's lens, you get the same quality of light and angle that a coal miner gets from the light mounted on the front of his helmet. (3) Using a pop-up flash is almost a 100% guarantee that your subject will have red eye, because the flash is mounted so close to, and directly above, the lens. (4) Because the flash hits your subject straight on, right square in the face, your subject tends to look very flat and lack dimension all around. (5) You have little control over the light, where it goes, or how it lands. It's like a lighting grenade. These are the reasons why so many people are so disappointed with how their shots look using their camera's flash, and it's exactly why using your pop-up flash should be absolutely, positively a last resort and only done in the most desperate of situations (okay, actually it can do a somewhat decent job if you're shooting outdoors, your subject has the sun behind them, and you need a little bit of light so they're not just a silhouette. Then, maybe, but other than that…). So, what should you use instead? That's on the next page.

The Advantages of a Dedicated Flash

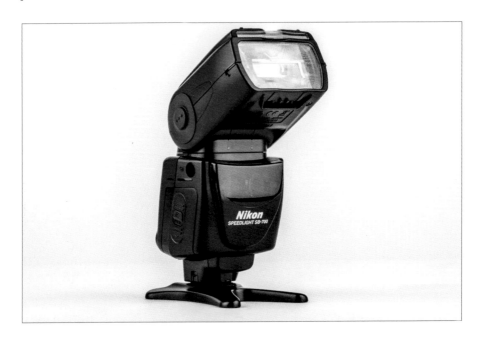

If you want to get pro-quality results from using flash, you're going to need to get a dedicated flash unit (like the one shown above or the ones listed below). What makes these dedicated flashes so great is:

(a) You can aim the flash in different directions (a pop-up flash just blasts straight ahead);

(b) You can angle the flash upward (this is huge—you'll see why later in this chapter);

(c) You can take this flash off your camera to create directional light;

(d) Even when mounted on your camera, because it's higher, you'll get less red eye;

(e) You get control, a more powerful flash, and most importantly, a better quality of light.

Best of all—today's dedicated flashes do almost all the work for you. Here are some I like:

Scott's Gear Finder

Yongnuo YN-560 II Flash (around $62)

Nikon SB-700 Flash (around $327) or Canon 320EX (around $209)

Nikon SB-910 (around $547) or Canon 600EX-RT (around $499)

If You Don't Already Own a Dedicated Flash

Nikon and Canon both make really great, pro-quality dedicated flashes (we call them "hot shoe flashes" because they're designed to sit in the hot shoe flash mount on top of DSLR cameras). But, if you're just getting into this and you're not sure you want to plunk down a few hundred bucks for a Nikon or Canon entry-level flash, you might want to consider a Yongnuo YN-560 II flash for around $62. These inexpensive flashes look and feel pretty much like a Canon 600EX-RT flash, for about $437 less (in fact, if I handed you one and you didn't look closely, you'd just assume it was the Canon 600EX-RT flash). They actually work well and do a pretty darn good job (after all, any flash unit just creates a "bright flash of white light." It's really what you do with that bright flash of light— how you aim it, how you soften the light from the flash, and so on—that determines how your light will actually look on your subject). By buying a Yongnuo for just $62, you're fully in the flash game without risking a big chunk of change right up front, and if you eventually fall in love with hot shoe flash, then you can go buy a fancy Nikon or Canon flash.

The Pro Look: Get It Off-Camera & Soften It

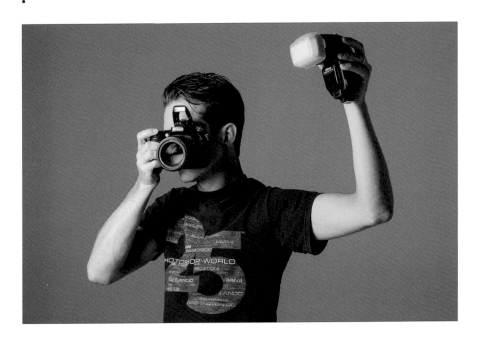

There are really just four things you need to do to get professional-looking images using a dedicated flash, and the two that are the most essential are: (1) you've got to get that flash off the top of your camera, so you can place it where it's much more flattering for your subjects (which you'll learn next, and there are a number of ways to do just that), and (2) you've got to find a way to soften and diffuse the light from the flash to make it beautiful. Otherwise, these flashes create really bright, really harsh, really unflattering light (and there are a number of ways to do that, as well, and we'll cover those in a bit). So, just so you know going in, these are the two hurdles we're going to focus on, because they pretty much are the key to great-looking flash images. So, if you keep that in mind (and don't overthink everything), the whole hot shoe flash thing becomes pretty easy and fun. Remember: Our goal is to get it off the top of the camera, and then make it soft and beautiful. That's what the rest of this chapter is about.

Get Your Flash Off Your Camera, Method #1

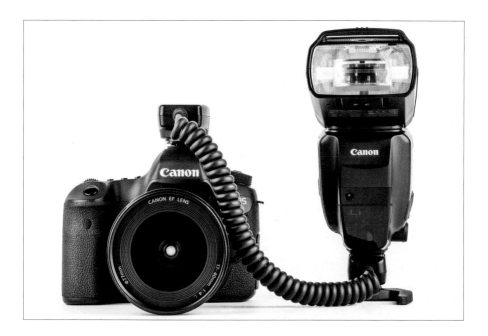

As I just mentioned, one of the best things you can do to get better results from your dedicated flash is to literally get it off the camera. That way, you can create directional light—light that comes from the side of your subject or above (or both)—rather than the flat, straight-on light you get when your flash is mounted on your camera. Directional light is much more flattering, more professional looking, and it adds dimension and depth to your photos. There are three ways to get your flash off your camera, and we'll cover the first one here, which is to use a flash sync cord. One end plugs into the flash; the other end connects to the sync terminal on your camera or slides into its hot shoe flash mount. Easy enough. Prices vary for the cord. It's not pretty. It's not elegant (and you'll probably trip over it at some point, if it's a long one), but it beats the heck out of having the flash on top of your camera. Although you're about to learn the two other ways to get your flash off-camera, it doesn't matter which method you choose, because getting that dedicated flash unit off-camera is one of the big steps to getting pro-quality results, and is all that's standing between you and more professional-looking directional light.

Using Pop-Up Flash Wirelessly (#2)

If your DSLR camera has a built-in pop-up flash, you can configure that pop-up flash so it doesn't light your subject, but instead sends out a dim, mini pre-flash that fires your big dedicated flash wirelessly (and you don't have to worry about your flash sync cord breaking or getting lost. In fact, you don't have to worry about dealing with cables at all). However, for this to work, the dedicated flash has to be able to "see" the mini pre-flash from your pop-up flash (that's why this type of wireless flash triggering is called "line of sight"—if the dedicated flash can't see the light from the pop-up flash, it won't fire). This won't ever be a problem until the one time where you really, really need it to fire, which is why there is a second way to fire your flash wirelessly (on the next page).

Using a Wireless Triggering System (#3)

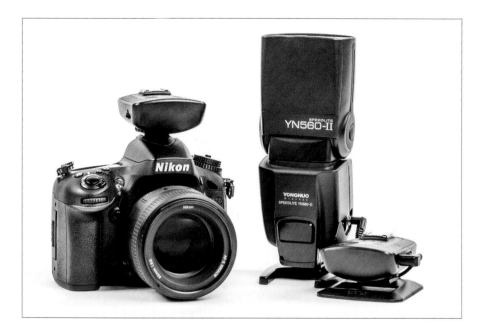

You can consistently fire your wireless flash using a wireless triggering system (these work the best and, of course, they're the most expensive). There are two parts to this: (1) a wireless flash transmitter (which sits in your camera's hot shoe flash socket on top of your camera) and (2) a wireless receiver that attaches to a small socket on your dedicated flash itself with a very small utility cable (only a few inches long). This used to be a very expensive proposition, but today you can buy a decent set (both a transmitter and a receiver) for around $60. That's a steal. Just a few years ago, it was more like $400. What's great about these is they're *not* line of sight. These are real radio transmitters, so you can put them wherever you need them, even a few hundred feet away, and they'll still fire every time. The downside: you change the power of the flash by walking over to the flash and turning the power up/down (although there are some transmitters that will let you change power from the transceiver itself).

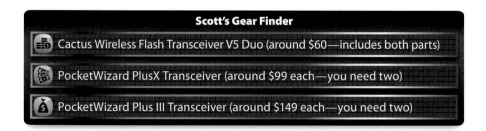

Scott's Gear Finder

Cactus Wireless Flash Transceiver V5 Duo (around $60—includes both parts)

PocketWizard PlusX Transceiver (around $99 each—you need two)

PocketWizard Plus III Transceiver (around $149 each—you need two)

Going Wireless (Nikon), Part I

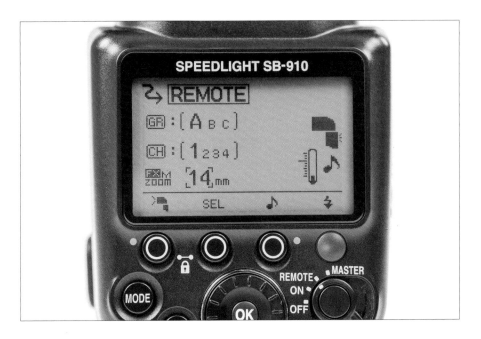

If your Nikon camera has a built-in pop-up flash, you can make a Nikon SB-700, SB-900, or SB-910 flash go wireless in two easy steps: (1) On the back of your Nikon flash unit, just turn the ON/OFF switch to Remote and your flash is now wireless. (See? At least step one is really easy.) The second step is on the next page (because it kinda needs its own page).

Note: If you have a higher-end Nikon pro camera, they don't come with a built-in pop-up flash, so you have to buy something to trigger your other flash. So, what will work? Well, you could buy another Nikon flash, which you can use to trigger your first Nikon flash (as if it was a pop-up flash), or you can buy a Nikon SU-800 Wireless Speedlight Commander Unit for around $250, which despite its fancy name is still line of sight [sigh]. They both work, but they're both kinda expensive (well, in comparison to a pop-up flash anyway, which is free as long as your camera has one).

GOING WIRELESS WITH AN OLDER NIKON SB-600 OR SB-800 FLASH

Press-and-hold the Zoom and – (minus sign) buttons until the Custom Settings menu appears. You should see the word "OFF" and a squiggly line with an arrow beneath it. Press the Mode button to turn the wireless function On, then press the ON/OFF button, and your flash is now wireless.

Going Wireless (Nikon), Part II

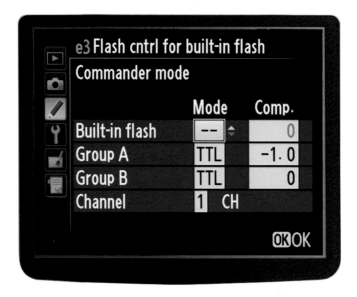

Okay, here's what we need to set up on the camera itself:

(1) First, pop up your camera's built-in pop-up flash (it actually triggers the wireless flash, so if you don't have your built-in flash popped up, it won't work) by pressing the little flash symbol button near the flash.

(2) Now, you need to switch your camera's pop-up flash into Commander mode, so instead of firing its flash, it only sends a small light pulse to your wireless off-camera flash unit to trigger it. To do this, press the Menu button on the back of your camera, go to the Custom Settings menu, and choose Bracketing/Flash. When the Bracketing/Flash menu appears, choose Built-in Flash, then choose Commander Mode. Highlight the Built-in Flash field, and use the dial on the back of your camera to toggle the setting until it reads just "--" (as shown above), which means the pop-up flash is off (except for that little light pulse, of course).

(3) Now when you fire your shutter, as long as your flash unit's sensor can see the little light pulse (it's that small red circle on the side), it will fire when you press the shutter button. You control the brightness of your wireless flash from this same menu—just scroll down to Group A and over to the last field on the right. To lower the brightness (power output), use a negative number (like –1.0, as shown above, for one stop less power) or a positive number to make the flash brighter. I've put together a short video clip just to show how to set this all up at **http://kelbytraining.com/books/digphotogv2**.

Going Wireless (Canon), Part I

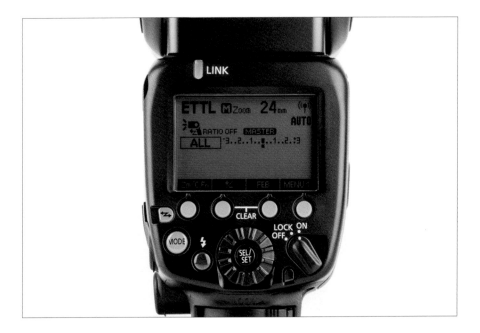

With Canon flashes, to go wireless you'll need either of the following:

(1) A Canon Speedlite Transmitter ST-E2 (around $220 at B&H Photo) or ST-E3-RT for radio transmission (around $287), which sit right on your camera's hot shoe, and not only trigger the wireless flash, but let you control its brightness (power output), which is a key part of this process.

(2) You can use another Canon Speedlite flash (like a second 600EX-RT, which does line of sight or radio transmission) as your transmitter. This second flash sits on the hot shoe on top of your camera, doing basically the same job that the Speedlite Transmitter does, which is to send a tiny light pulse or radio signal from your camera to the wireless flash unit to tell it when to flash, and it lets you control the brightness of the wireless flash, as well.

Either way, the process is pretty similar: If you're using the transmitter, it's already set up as your wireless controller, and it has no flash of its own to turn off, so just put it into your camera's hot shoe and it's ready to go—you can jump over to the next page and pick up there. If you're using a Canon 600EX-RT, press the wireless button on the back of the flash until you see the radio transmission icon or optical transmission icon and Master. Now go to Part 2 on the next page. (*Note:* If you're using an older flash, like the 580EX II Speedlite, put it in your camera's hot shoe, then hold the Zoom button on the back of the flash until the display starts flashing. Then turn the Select dial until the screen reads Master and press the center Select button.)

Going Wireless (Canon), Part II

Now that you have a master flash mounted on your camera's hot shoe, you have to set up the other flash (the one you want to be wireless). (1) If you're using a Canon 600EX-RT, press the wireless button on the back of the flash until you see the radio transmission icon or optical transmission icon and Slave. (*Note:* If you're using an older Canon flash, like the 580EX II Speedlite, hold the Zoom button on the back of the flash until the display starts flashing. Then turn the Select dial until the screen reads Slave and press the center Select button.) Now, to recap: The flash unit on top of your camera is set to be the master unit (the controller), and the other flash is set to be the wireless unit (the slave). (2) Turn off the flash on the master unit so it just emits a pulse of light or radio signal, which triggers the wireless flash (you don't actually want it to light your subject). To do this, press function button 4 on the back of the flash to display Menu 2. Then press function button 1 until you see the Master Flash Firing OFF icon. I've put together a video to show you exactly how this all is done, and you can watch it at **http://kelbytraining.com/books/ digphotogv2**.

IF YOUR WIRELESS FLASH DOESN'T FIRE

If your wireless flash isn't firing, make sure your master unit and slave unit are both on the same channel (or wireless radio ID). If not, press function button 4 to display Menu 3, then press function button 1 to set the channel or function button 2 to set the radio ID, and turn the Select dial.

"Drag the Shutter" to See More Background

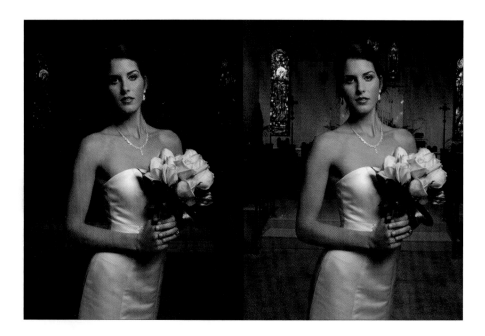

Like I mentioned, there are four big things the pros do to get beautiful quality light (and professional-looking images) from their dedicated flash units. One, you've already learned, is getting the flash off the camera so you can create directional light. The second is to set up your flash so it blends in with the available light already in the room, so the background behind your subjects looks natural. Without using this technique, you'll get what everybody else gets—the background behind your subjects turns black, they look harsh, and the shot will look pretty awful, which is why most people hate flash shots. The technique is called "dragging the shutter," and what you're doing is slowing down your camera's shutter speed so it allows in the existing light, then your flash fires to light your subject. Although this sounds complicated, it's incredibly simple. First, set your camera to shoot in program mode. Then, aim at your subject and hold the shutter button down halfway, so your camera takes a meter reading of the scene. Look in your viewfinder and see the f-stop and shutter speed your camera chose to properly expose your subject, and remember those two numbers. Now, switch to manual mode and dial in those same two numbers. If the camera showed a shutter speed of $^1/_{60}$ of a second, to drag the shutter you'd need to use a slower shutter speed, right? So try lowering the shutter speed to $^1/_{15}$ of a second and take the shot. Don't worry—your subject won't be blurry, because when the flash fires it will freeze your subject. You'll be amazed at what just lowering the shutter speed like this will do to the quality of your flash photos.

How to Soften the Light from Your Flash

Okay, so you've used all the tricks we've covered so far, and your flash photos are already looking better—but there's still a problem. The light is still harsh because the flash itself is very small, and the smaller the light source, the harsher the light. So, to get softer, more flattering light, you need to make your light source larger, right? Right! There are a number of different tricks for doing this, and each pro does it differently, but I will tell you this— they all do it. They all use tricks to soften and diffuse the light from their flash (it's the third thing [and second most essential one] to do to get professional-looking light from your dedicated flash). Probably the quickest and easiest way to soften the light from your flash is to snap a diffusion dome cap over the end of your flash (like the one shown above), which softens and diffuses your light. Considering how small and light it is, it does a pretty decent job. Once this cap is on, you aim your flash head upward at a 45° angle and it takes care of the rest. If you're a Nikon user and buy a Nikon SB-910 flash, it comes with the dif- fusion dome you see above right in the box (if you've lost your SW-13H dome, you can buy a replacement from B&H Photo). If you have a Canon flash, you can buy a diffusion dome separately, and the one I recommend is the Sto-Fen Omni-Bounce, which does a great job and is a favorite with pro wedding and event photographers (it sells for around $10 at B&H Photo). One thing to note: Adding this diffusion dome works great indoors, but outdoors where there's really nothing much for the light to bounce off of, it doesn't do much at all. Hey, I thought you should know.

Make It Softer Light by Bouncing It

Another popular way to soften the quality of your light is to bounce your light off a ceiling. This does three wonderful things: (1) When your small, direct flash of light hits the large ceiling, it spreads out big time, so the quality of the light that falls back onto your subject is much wider and much softer. It immediately takes the harshness out of your flash, and gives you better quality light. (2) Because the light is now coming from above, it's no longer that one-dimensional, straight-on flash—now it's directional flash, which creates nice shadows and lots of dimension for your subject's face, and as a bonus (3) it keeps you from having harsh shadows on the wall behind your subject. Because the light is coming from above (down from the ceiling), the shadows appear on the floor behind your subject, not on the wall behind them. Plus, because the light is softer, the shadows are softer, too. So, if this bouncing off the ceiling technique is so great, why don't we use it all the time? Well, there are a number of reasons: (1) There's not always a ceiling you can bounce off. Sometimes you're outdoors, or (2) the ceiling is too high to bounce off of (like in a church). If the ceiling is much higher than about 10 feet, the bounce trick really doesn't work because the light has too far to travel up and back, and your subject doesn't get properly lit. Of course there's also (3) the fact that light picks up the color of what it hits, so if the ceiling is yellowish, your light becomes yellowish, and your subject will now appear (come on, say it with me) yellowish! However, if it's an 8' or 9' white ceiling, you're set.

Putting That Nice Twinkle of Light in the Eyes

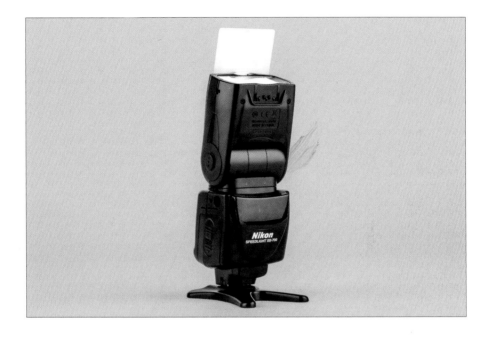

If you're using bounce flash and you want to add a little bit of life and sparkle into your subject's eyes, then simply pull out and raise the little white bounce card that's tucked into your flash head (well, at least it is if you're using a Nikon or Canon flash), as shown above. When you put that little white bounce card up, it redirects just enough of that light heading toward the ceiling back onto your subject to add a nice little catch light in their eyes, and the bonus is this also often removes some of the shadows that appear under their eyes. The key to making this work is that your flash head is aiming up at a 45° angle and the card is fully extended.

WHAT TO DO IF YOU DON'T HAVE A BOUNCE CARD OR YOURS BREAKS

If your bounce card is broken, or if your flash doesn't have a bounce card (hey, it's possible), then try this: use your hand. That's right—shoot with your camera in one hand, and then put your other hand up at the same position and angle a bounce card would be. It will send some of that light forward (like a bounce card), and because light picks up the color of whatever it reflects off of, your light will be nice and warm (thanks to your skin tone).

Softbox-Quality Softening from Your Flash

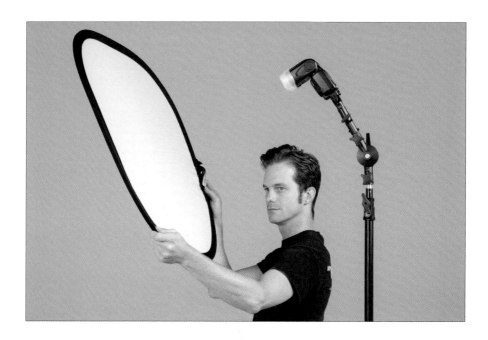

If you want to take this whole softening thing to the next level (quality-wise), you could buy a small softbox that mounts over your flash, but the problem is they're small, so the light doesn't spread and soften all that much. So, one really easy way to spread and soften your light is to shoot your flash directly through a large diffusion panel. These panels are made of white translucent stretched fabric (usually round or square with rounded corners like the one you see above), and they spread and diffuse the light from your flash. Since they're just fabric, they're super-lightweight—they're designed to collapse down into a very small, flat size, so they're easy to take with you (they come with a small, flat carrying pouch)—and best of all, they're a bargain! You can get a Westcott 30" 5-in-1 Reflector (the same one I use), which includes a 30" diffuser, for around $30 (plus, now you have a great reflector, as well. Actually, you'll have four reflectors—more on them later). To use this diffuser, have an assistant (or a friend, spouse, etc.) hold the panel about 1 foot or more in front of your flash. That way, when the tiny light from the flash hits the panel, it causes the light to spread out dramatically, which gives you much softer, smoother, more flattering light. If you don't have an assistant or a friend nearby, you can clamp your diffuser on a second light stand using a Manfrotto 275 Mini Clip Clamp for around $14.50. If you want to invest in a pro-quality diffusion panel, check out Lastolite's 30" TriGrip Diffuser, One Stop (with a built-in handle) for around $70.

Tip for Shooting Through a Diffuser

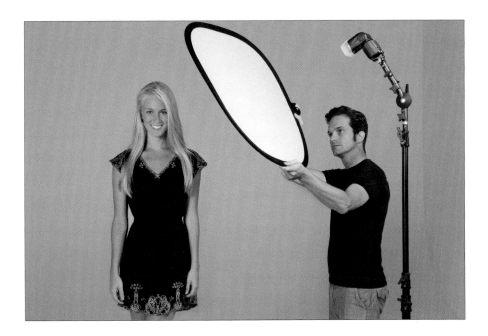

If you're shooting your flash through a diffuser (like the Westcott diffuser I just mentioned), here's a tip: position the diffuser as close to your subject as possible without it actually being seen in the photo. This gives you the best quality wraparound light that is the softest and most flattering (think "closer is better"). Then position your flash so it's aimed at your subject, but still firing through the diffuser (set it at least 1 foot back from the diffuser, or even farther if you'd like softer, smoother light, but just know that the farther away you move the flash, the lower the power the light will become, so if you move it far away, you'll have to increase the power of the flash).

WHERE TO LEARN MORE ABOUT OFF-CAMERA FLASH

If this chapter ignites your passion for off-camera flash, and you want to take things to the next level, you'll definitely want to check out Strobist, which is the #1 site on the web for flash enthusiasts (both amateurs and pros). It's run by David Hobby, a tremendous photographer and teacher who has built an entire worldwide community of flash users, and there's really nothing like it anywhere on the web. Highly recommended (you'll find it at www.strobist.blogspot.com).

Why You Might Want a Stand for Your Flash

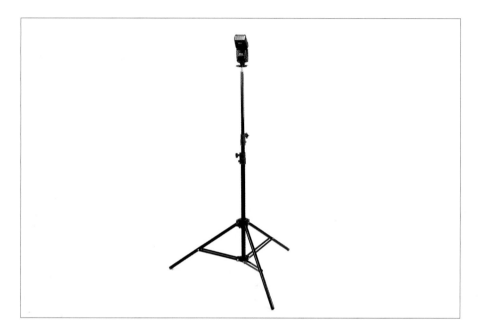

Most of us don't have the luxury of having an assistant to hold and position our wireless flash for us, so we either wind up holding the flash in our left hand (so our right hand is still free to press the shutter button), or we put our flash on a lightweight light stand and position it where we'd like it. You can buy a standard light stand, like the 8' Impact Air-Cushioned Light Stand, for around $33. You'll also need a flash shoe mount (less than $25 from B&H Photo), which lets you mount your flash on a light stand like the Impact. This mount has a little plastic hot shoe on it, and your flash slides right into that hot shoe to hold your flash securely on top of the light stand. That flash shoe mount is surely the inexpensive route, but the downside is they don't all allow you to angle your flash head downward—only upward, and that's why the Justin Clamp, while more expensive, is really the way to go (see the next page for more on this). So, once you've got your flash on this light stand, where do you put it? There's no single right answer, but I'll give you a good starting point—put it to the left, and in front, of your camera, up about a foot or so higher than your subject. That way, if you have your flash mounted on a Justin Clamp, you can aim the flash head back down at your subject, so the light is more like studio light (or window light) and helps to create that all-important directional light.

Mounting Flashes Anywhere

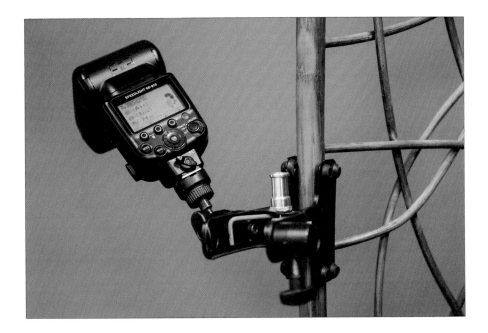

If you're going to wind up attaching your flash to something other than a light stand (heck, this works great even if you're using a light stand), I recommend picking up a Manfrotto 175F Justin Spring Clamp with Flash Shoe (better known as simply a "Justin Clamp"). This is just the handiest little gizmo and you'll love it for two reasons: (1) Your flash slides into a little plastic hot shoe on the top of the clamp, and that clamp is connected to a miniature ballhead that lets you easily and instantly position your flash in any direction or at any angle. So, instead of moving the light stand every time you want to change the angle of the flash, you just move that little ballhead. (2) It has a large clamp on one end, so if setting up a light stand isn't practical (or isn't allowed), you can clamp it onto just about anything, from a railing, to a tree branch, to a ceiling tile. These sell for around $61 (at B&H Photo, anyway), and it's one of those accessories that once you use it, you'll never go anywhere without it.

Rear Sync Rocks (& Why You Should Use It)

There's a setting on your camera that will help you get better-quality photos using flash. In fact, your flash shots will get so much better that you'll wonder why this feature isn't turned on by default (but it's not—you'll have to go and turn it on yourself). It's called Rear Sync, and what it basically does is changes when the flash actually fires. Usually, your flash fires the moment you press the shutter button, right? So it does freeze any action in the scene, but it also generally makes everything solid black behind your subject (like you see in most snapshots). Changing to Rear Sync makes the flash fire at the end of the exposure (rather than the beginning), which lets the camera expose for the natural background light in the room first, and then at the very last second, it fires the flash to freeze your subject. Now your background isn't black—instead, it has color, depth, and detail (as seen above right), and this gives you a much more professional look all the way around. In the example above, the shot on the left is using the normal default flash setting (notice how dark the background is, and how washed out the flash makes him look). For the shot on the right, I only changed one single thing—I switched the flash to Rear Sync. Give it a try and you'll see what I mean (just remember to keep the camera still when shooting in Rear Sync mode, because the shutter stays open longer—enough to expose for the background. This can create some cool effects if your subject is moving while your shutter is open, or it can create some irritating effects if they're moving and you don't want them to).

The Fourth Secret to Pro Flash Results

The fourth of the four pro flash tricks is one you can use to make your flash look like natural light. In fact, this trick works so well that if you do it right, most folks won't be able to tell that you used a flash at all—you'll just have glorious-looking, soft, natural light whenever and wherever you want it. Your goal is to create light from your flash that matches, and blends in with, the current lighting in the scene (the ambient light) and doesn't overpower it. Here's the trick: don't change your f-stop or shutter speed—instead, just lower the power output of the flash until it matches the available light. To do that, first get the flash off the camera for directional light, and diffuse the light, then take a test shot. Chances are your flash will overpower the existing light. Now, go to your flash unit itself, lower the flash output power by one stop, and take another test shot. Look at the LCD panel on the back of your camera, and see if the light from your flash still looks obvious—like light from a flash. If it does, lower the power of your flash another ½ stop and shoot another test shot. Keep doing this (lowering the power and shooting a test shot) until you're getting just enough flash to light your subject, and nothing more. That way, it looks real, directional, and natural, instead of looking like flash (like the shot above, lit with one flash). It might take you five or six test shots to dial in the right amount of power, but that's the beauty of digital cameras: it doesn't cost anything to do test shots—as many as you need—until you strike that perfect balance between ambient (existing) light and the light from your flash.

Using Gels (& Why You Need Them)

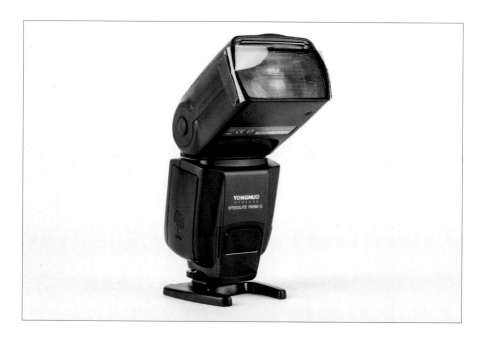

The light from your flash is always the same color—white. It's nice, bright, white light, which is great in most circumstances, but what if you're doing a portrait of someone in an office, or you're shooting in a locker room, or in a meeting room? Well, that's a problem, because the color of the light from your flash won't match the color of the lighting in the room, which is exactly why some flashes (like the Nikon SB-910) actually come with pre-cut gels that slide right onto the flash to let you change the color of your flash's light, so it matches the rest of the lighting in the room. (*Note:* If you have an older Canon flash or your flash doesn't come with gels, you can buy a large sheet of Rosco CTO gel for around $6.50 from B&H Photo. You'll have to cut it down in size so it fits over your flash head, but at least you'll have a huge supply of them, whereas Nikon only gives you one. Or, check out Rosco's Strobist 55-Piece Filter Kit, which comes with 55 pre-cut gels, for around $18.50.) Amateurs don't worry about this because they're going to just overpower the light in the room, right? But since you now know the pro tricks of how to balance the light from your flash with the ambient light already existing in the room, you'll need to do this next step, but believe me, for the 20 seconds it takes to slide that gel into place, it's worth it. You'd use a yellow gel for balancing your flash color with incandescent light (the standard light found in homes), and a green gel for balancing the light if you're shooting under fluorescent lights, like the ones found in most office interiors (Rosco makes those, too). Just pop that tiny gel inside your diffusion dome, or tape it to your flash with some gaffer's tape, and you're ready to go!

Using Gels to Get That *SI* Look

There's a very cool trick you can do using just a yellow gel that I learned from *Sports Illustrated* photographer Dave Black when he and I were teaching a class out in San Francisco. When you try it, you'll see it has that *SI* look you see in a lot of outdoor sports portraits. It actually requires you to do two things: (1) First, you set the white balance on your camera to Tungsten (it's one of your camera's built-in white balance presets, and it makes your whole photo look very blue—well, at least it does if you're shooting outdoors), then (2) pop a yellow gel onto your flash (see the tip on the previous page to find out if you already have them or where to get them). That's it. Now, you want to shoot this near dusk, so the background sky is dark and moody. The Tungsten white balance setting makes the sky look moody and blue, but the yellow light (from the gel on your flash) hits your subject with a warm light. It's a very clever combo that is easy to achieve, and lots of pros are using this style today because, well…it's really cool (no pun intended, but I wish it had been).

If You Have to Use Pop-Up Flash, Do This

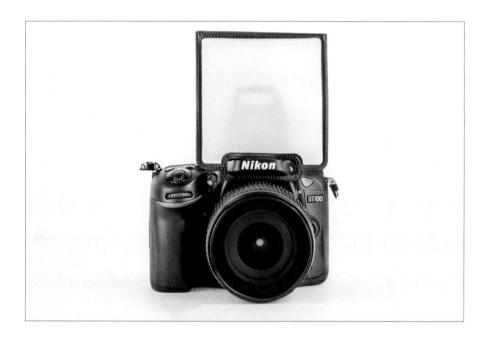

If you can't get around it, and you are in a situation where you must use your camera's pop-up flash, then at least do these two things: (1) set your flash to Rear Sync first, so you'll pick up some of the ambient light in the room (we covered this back on page 24), and (2) do something—anything—to soften the harshness of the flash, and that can be as simple as shooting your pop-up flash through a white table napkin or cutting a rectangle-shaped diffuser out of the side of a plastic jug of milk and shooting through that. If you know in advance that you might have to shoot with your pop-up flash, then check out LumiQuest's Soft Screen (shown above), which is designed to fit over your pop-up flash to spread and diffuse the light. Luckily, it's very inexpensive (around $12), and well…if you have to use pop-up flash, this will at least make it bearable.

TWO TIPS FOR GETTING BETTER RESULTS FROM YOUR POP-UP FLASH

Another thing that will help you get better-looking images from your pop-up flash is to reduce the flash's brightness (lower its power) or lower your flash exposure (using flash exposure compensation). Most DSLRs have a setting where you can lower the brightness of the flash, and that helps to not blow out your subject with harsh white light. You might also try taping a small warming gel (like a ¼-cut CTO gel from B&H Photo) over your flash and leaving it there all the time. This gives the cold flash a much warmer, more pleasing look. Thanks to flash guru David Hobby for sharing these tips.

Using a Second Flash

If you want to add a second wireless flash (maybe you want to use it as a hair light, or to light the background, or…whatever), it's easy. When your first flash fires, it automatically triggers the second flash so they both fire at exactly the same time. Let's say you want to add a flash to light your subject's hair. First, position the flash behind your subject, but off to the right (if you're holding your other flash in your left hand while you're shooting or have it positioned to the left), as shown here. This is a perfect time to use one of those Justin Clamps I mentioned earlier, so you can clamp your second wireless flash to anything nearby, or you can position your second flash on a light stand—just make sure you don't see the stand, or the flash unit itself, when you look through your camera's viewfinder. Set your second flash to wireless mode (look back on page 12 for Nikon flashes or page 14 for Canon flashes). Best of all, you can control the brightness of this second flash wirelessly from on your camera (see the next page[s] to find out how).

Controlling a Second Flash (Nikon)

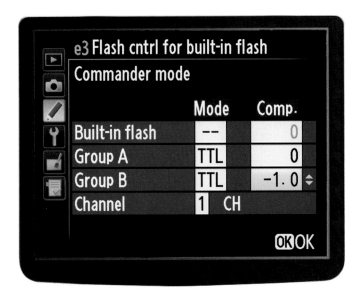

You will want to be able to control the brightness of each flash individually, so that way if the second flash is too bright, you can lower it without affecting the first flash or you can turn it off altogether. However, you want to be able to do all this right from your camera itself—without running around behind your subject, or running from flash unit to flash unit. On a higher-end Nikon camera, here's how it's done: On the back of the flash, set this second flash to Group B. That's all you do on the flash itself. Now, you control the brightness of each flash by pressing the Menu button on the back of your camera, going to the Custom Settings menu, and choosing Bracketing/Flash. When the Bracketing/Flash menu appears, choose Built-in Flash, then scroll down and choose Commander Mode. Your first flash (the one you hold in your left hand, or near you on a light stand) is in Group A. You set your second flash to Group B, so the brightness control for your second flash is found in the Comp field to the far right of Group B. Scroll over to that field, and to lower the brightness by one stop, dial in –1.0 (as shown above). Now shoot a test shot, and if that second flash appears too bright, try lowering it to –1.3 and shoot another test shot, etc., until it looks right. To turn if off altogether, toggle over to the Mode field, and change the setting until it reads "--" which turns off your second flash. To control the brightness of your main off-camera flash, it's controlled the same way, but in Group A. Just remember, for all of this to work, you have to have your pop-up flash up, because it triggers the flash (or you can use an SU-800 transmitter if your camera doesn't have pop-up flash).

Controlling a Second Flash (Canon)

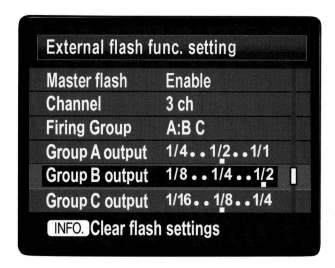

To add a second Canon Speedlite flash (one you'll use for a hair light or to light the background), press the Wireless button on the back of the flash until you see the radio transmission icon or optical transmission icon and Slave. Now your first wireless flash and this second flash will fire simultaneously, which is good, but you want to be able to control the brightness of each flash individually, right from your camera (so you're not running back behind your subject just to lower the brightness of the second flash. After all, what's the good of wireless if you have to keep running over to the flash every time you need to make a small change, eh?). To do that, you'll want to assign this second flash to a separate control group (Group B). To assign the second flash to Group B, while Menu 1 is showing, press function button 3 on the back of your Speedlite, and then select Group B. Now you can put this flash into place (behind the subject), and do a test shot. Both flashes should fire, but if the second flash (the one behind your subject) is too bright, then press the Menu button on the back of your camera, go to Shooting Menu 1, choose Flash Control, then choose External Flash Function Setting. Under Flash Mode, choose Manual Flash, then scroll down to Group B Output and set the ratio to 1/2 (one stop less bright), then do a test shot. If the second flash still looks too bright (when you look at the shot in your LCD monitor), then lower the brightness to 1/4 or 1/8 and shoot another test shot, and keep this up until the second flash looks balanced. If you want to control the brightness of the first flash, make sure it's on Group A, and it's controlled the same way.

How Far Back Can You Stand Using Flash?

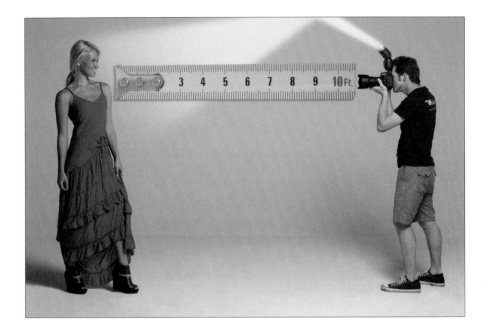

So, how far back can you stand from your subjects and still get pro-quality results from your flash? Well, if you're using a flash with a diffusion dome, or you're bouncing your flash, or you're using some type of diffuser to soften the light (and you should be), as a general rule, you really don't want to stand farther than about 10 feet back from your subjects. Unfortunately, any farther than that and your dedicated flash won't have enough power to get the right amount of light all the way over to your subjects to light them properly.

How to Stand Back Even Farther

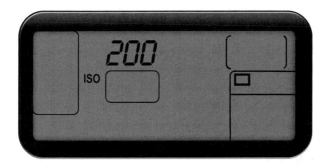

If you absolutely need to stand back more than 10 feet from your subject, then you can use this trick to extend the power and range of your flash: just raise your camera's ISO setting (making the camera more sensitive to light). So, if you're shooting at 100 ISO (it's always our goal to shoot at the lowest possible ISO—more on this later), then if you increase your ISO to 200, you effectively double the power (and range) of your flash. So, if you need to be 20 feet back, try increasing your camera's ISO to 200 or 400, and that should do the trick. Okay, well, there is one more thing you can try: if you don't want to raise your ISO and you have to be back farther than 10 feet from your subject, then you'll need to (gasp!) remove the diffuser cap from your flash, so your light has more power and reach (personally, I'd raise the ISO, but hey—that's just me).

HOW TO GET MORE POWER FROM YOUR FLASH AT LONG DISTANCES

If you find yourself having to shoot pretty far back (maybe you do a lot of large group shots), you might want to buy another diffusion dome cap and cut out a little section of the top so some of that light reaches a bit farther.

Controlling Your Light to Add Drama

If you want to add some serious drama and interest to your flash images, one of the quickest ways to get there is to limit the amount and shape of the light that hits your subject. By lighting only part of your subject, it puts part of your subject into the shadows, and although this is a fairly common technique using full-blown studio lighting, ExpoImaging has come up with their own inexpensive, lightweight light modifiers for hot shoe flashes like the Nikon SB-910 and Canon 600EX-RT. They're called Rogue FlashBenders and they've got a 10" positionable reflector you can shape into a snoot (as seen above) that acts like a funnel for light—concentrating it in just one area. It fits right over your flash head and is secured with a little ring of velcro. The snoot sells for around $40 at B&H Photo.

Shooting Sunset Portraits with Flash

First, turn off your flash, then switch your camera to shutter priority mode (S), and dial in ¹/₁₂₅ of a second (a good, safe sync speed for our flash). Now, aim up at the sky (but not directly at the sun itself), and press-and-hold your shutter button halfway down, so your camera takes a meter reading of the sky. While that button is still held down, look in your viewfinder to see the f-stop your camera chose, and remember that number (in the example above, it read f/5.6, so remember that f-stop). Now, switch your camera to manual mode, dial in ¹/₁₂₅ of a second for your shutter speed, and dial in that f-stop your camera chose in shutter priority mode (which, in this case, was f/5.6). Next, position your subject so the sun is behind them. Your job is to turn your subject into a silhouette against the sky. Luckily this is pretty easy—just raise the f-stop by a stop or two (our f-stop was f/5.6, so we'll raise it to f/8) and take a test shot. If your subject isn't a silhouette yet, raise it another stop to f/11, and take another test shot. Usually that'll do it, but you might have to go as high as f/16 (or any one of those fractional f-stops in-between, like f/13). When you choose a darker f-stop, the sky will get much darker and richer, which is great. Once your subject is a silhouette against a beautiful, dark, rich-colored sky, turn your flash on (switch your flash to Manual mode and choose a low power setting, like ¹/₄ power), and take a test shot. If the flash is too bright, try lowering the power to ¹/₈ power, then take another test shot. If the flash isn't bright enough, raise the power to ½. Don't change the camera settings—they're set just right—instead lower (or raise, as the case may be) the power (brightness) of your flash to get a realistic mix between the sky and your subject. That's the recipe for portraits at sunset.

Chapter Two
Building a Studio from Scratch
It's Much Easier and Less Expensive Than You'd Think

It used to be that only full-time working professionals could afford to put together a studio, but these days the prices of studio gear have come down so much, and the equipment is so much easier to use, that anyone (well, anyone with a platinum American Express card) can now build a studio of their own. Of course, I'm joking, you don't have to have a platinum card (a gold card will do just fine). Actually, the main reason why building a studio from scratch is within most folks' reach today is that you can do so much with just one light. In fact, nearly this entire chapter is to show you how to get professional results using just one light. Now, in the studio we don't always refer to lights as simply "lights," because then people would know what they do (we call them "strobes," because it sounds much cooler). Studio photography is intentionally shrouded in mystery to make the process appear more complicated than it really is. In fact, there is a special committee, The Council for Creation of Complex-Sounding Studio Gear Names (the CCCSSGN, for short), whose charter is to create confusing insider lingo to throw beginners off track. For example, when we talk about the color of light, we don't use the term "indoor lighting." Nope, people would realize what that is, because they've been indoors before. Instead, we assign a color temperature measured in Kelvin, so to throw beginners off, we might say to one another, "It looks like that strobe is throwing 5500 Kelvin." And the other person might say, "It looks a bit warmer to me. More like 5900," then the other person might say, "Ya know, you might be right—it is more like 5900 Kelvin." It's amazing that either of these people ever get a date. Anyway, this chapter is designed to cut through the Kelvin and show you the light.

Studio Backgrounds

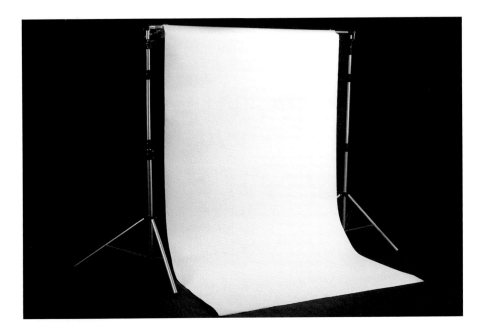

One of the least expensive, and most popular, studio backgrounds is seamless paper. This paper comes in long rolls, and the two most popular widths are just over 4 feet wide (53") and nearly 9 feet wide (107"). The nice things about seamless paper are: (1) It's cheap. A 53-inch-wide white roll that's 12 yards long goes for around $25 (at B&H Photo), and if you want the 9-foot-wide roll, it's only around $40. (2) It's seamless. There's no visible seam where the paper folds as it reaches the floor (or a tabletop), so the background looks continuous. (3) The stands to support seamless paper backgrounds are pretty cheap, too. For example, the Savage Economy Background Stand Support System, which supports both the 53" and 107" rolls, only costs around $75. That ain't bad. And, (4) this paper comes in a wide variety of colors, from solid white to solid black, to blue, green, and everything in between (hey, that rhymes). If you're building your first studio, this is a great way to start, because you can get your background and the supports to hold it up for around $100.

SO WHICH SHOULD I GET, THE 53" OR THE 107" SEAMLESS?

If you're planning on shooting products on a table, or strictly just head-and-shoulder shots of people, you can get away with the 53" width. If you need to see more of your subjects, go with the 107".

Using Studio Flash (Called Strobes)

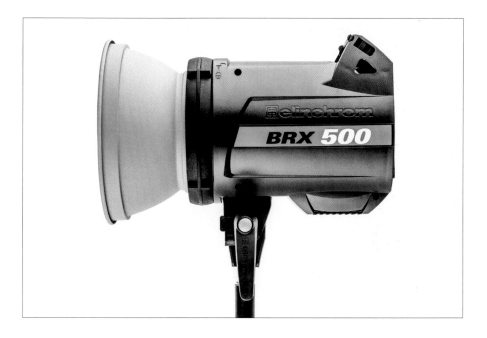

A lot of people are intimidated by studio lighting, thinking it's complicated or too techni-cal for them, but in reality, most studio lights are just bigger versions of the hot shoe flash you're already used to using off-camera (in fact, they are flashes, but in the industry they're usually called "studio strobes" or just "strobes"). The main differences between hot shoe flashes (like a Nikon Speedlight or a Canon Speedlite) and studio strobes are: (1) studio strobes usually plug into the wall rather than running on batteries; (2) studio strobes are much more powerful (they put out a lot more light) than the hot shoe flashes; (3) they have a modeling light (more on this on page 43); (4) they're designed to have lighting accessories, like softboxes, attached right to the front of them; and, (5) since they're designed to be mounted on top of a light stand, they have a light stand mount right on the bottom of the strobe itself (to mount a hot shoe flash on a light stand, you usually will need some sort of separate adapter or swivel head).

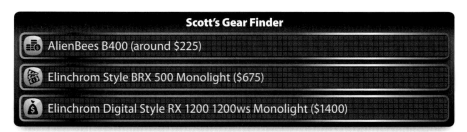

Scott's Gear Finder

AlienBees B400 (around $225)

Elinchrom Style BRX 500 Monolight ($675)

Elinchrom Digital Style RX 1200 1200ws Monolight ($1400)

Softening Harsh Studio Strobes

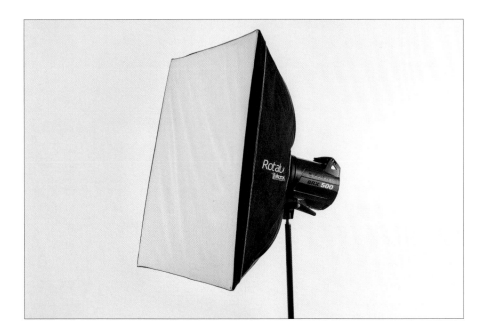

So, if the light from your regular off-camera flash is harsh, imagine how harsh the light will be from a brighter, more powerful flash (your studio strobe). Right, it's harsh city. To diffuse that light and make it softer, you have to make the light that comes from your strobe larger, because the rule is: the larger the light source, the softer the light. So, we have to put something big between our studio strobe and our subject to spread and soften that light, and for that I recommend a softbox. They're aptly named because they soften the light from your strobe big time, and they are very popular with professional studio photographers (in fact, it's the softening device of choice for most top pros). They fit right over your studio strobe (they have a hole in one end) and your flash fires through the white diffusion material at the large end of the softbox. This spreads the light, so when it hits your subject, it's a bigger source of light, and that means it's a much more flattering, softer light. But this softer light isn't just for lighting people—even if your subject is a product, you still want nice, soft shadows throughout your image, and a softbox is your key to getting just that.

Why I Prefer Softboxes to Umbrellas

Besides softboxes, another way to spread and soften your light is to use a lighting umbrella. Surprisingly, you don't generally put the umbrella between your strobe and the subject (although you could). Instead, you turn the strobe so it's aiming 180° away from your subject—in the opposite direction. Then you put the umbrella in front of the flash (strobe) itself, so that your strobe fires into the underside of the umbrella. When the light hits the umbrella, it spreads out and travels back in the opposite direction, back toward your subject. Because the light spreads out when it hits that umbrella, the light from your strobe is much softer. So, why don't I like, or recommend, using an umbrella? It's because with a softbox your light is pretty much contained within a box—it doesn't spill out, so your light is more directional. You aim it in a direction and it pretty much goes right there. But with an umbrella, you have less control over what happens once the light leaves your umbrella. I think of it more like a lighting grenade—you throw it in the general direction of what you're trying to light, and it'll probably light it. So, while an umbrella does take the harsh light from your strobe and create soft, pretty light from it, it kind of goes everywhere. Whereas, a softbox is more contained, more directional, and you can add other accessories to narrow the throw of your softbox light even more.

What a Speed Ring Does (& Why You Need It)

So, you need: (1) a strobe, (2) a light stand to hold it up, (3) a softbox to spread and soften the light, and (4) you're also gonna need a speed ring. A speed ring is generally made of a light metal, and has four holes on the edge where you insert the ends of the four thin metal poles on each corner of your softbox. Once you insert those poles into the speed ring, it gives your softbox its form (it creates the shape of a box), and then you attach this whole rig (the speed ring with your softbox attached) to your strobe. I use an Elinchrom Rotalux softbox, which has an Elinchrom speed ring built right in, with an Elinchrom BRX 500. However, most softboxes don't come with a speed ring built in, so if you have to order one, make sure you order one designed to fit your brand of strobe. By the way, most speed rings are rotating (meaning you can rotate the softbox from tall to wide while it's mounted on the strobe), and if that's important to you (and I would think it would be), then make sure the one you have or order does rotate.

Using a Modeling Light

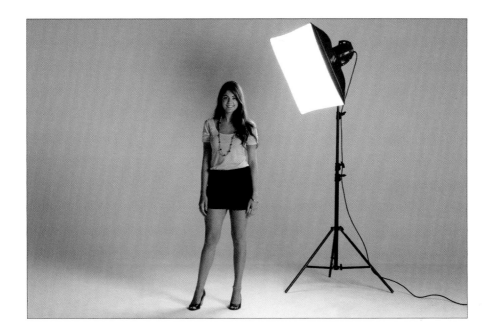

Usually, when you're shooting in a studio environment, the only lights you want to light your subject are the studio strobes themselves. Otherwise, the other lights in the room can affect your exposure, so studios are generally pretty dark once the shooting starts. This creates a problem, because the autofocus on the camera needs some light to lock its focus onto. That's one reason why studio strobes usually come with a built-in modeling light, which is a fairly dim, continuous light that stays on between flashes to let your camera's autofocus do its thing. Another advantage of using a modeling light is that it gives you an idea where your shadows are going to fall on your subject (it's not exact, but it does give you an idea). I leave the modeling light on all the time during a shoot, but you'll find an on/off switch on the back of your strobe unit itself (or on a separate power pack or battery pack, if you're using one).

When you're talking about studio strobes, there are basically two kinds: (1) A monolight, which is what we've been talking about here in the book, is a self-contained unit (with the power pack, flash bulb, and power controls all in one) that plugs directly into a standard wall outlet, and (2) a flash head, which is just the flash itself, and all controls are in a separate power pack or battery pack, which you plug the flash head into.

Firing Your Studio Strobe

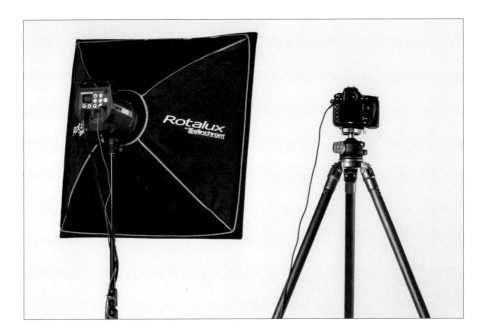

To get your strobe to fire when you press your camera's shutter button, you'll need to connect your strobe to your camera (either wirelessly or using a sync cord). If you go with a sync cord (it's way cheaper, around $10 for a 15' sync cord at B&H Photo), it's pretty straightforward: one end plugs into your camera's sync terminal, and the other end plugs into your strobe. That's it. Now when you press your shutter button, your studio strobe fires. That being said, I can't really recommend using a sync cord because, at some point, you or your subject will trip over it. Guaranteed. Somebody's going to trip over it and, at the very least, pull your whole lighting rig over (you'll know exactly when this happens because of the sound of shattering glass), or they'll pull over your camera rig (listen for the sound of lenses shattering), or both. At that moment, however much you saved by using a cheap sync cord will pale in comparison to the repair bill and/or attorney's fees (if your subject trips and falls) you'll be faced with next. So, I highly recommend using wireless to fire your strobes (it's easier than you'd think).

Firing Your Studio Strobe Wirelessly

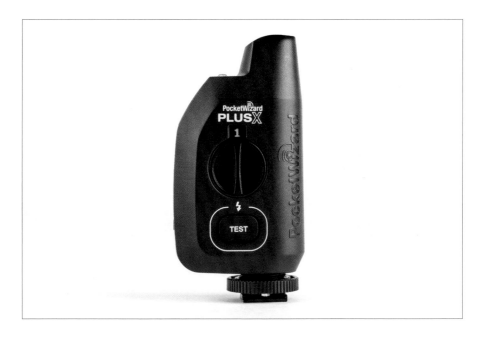

Besides avoiding the potential for broken glass (well, broken everything actually), there's another thing using a wireless flash setup gives you—freedom. You're no longer tied (well, actually tethered) to your strobe. You're free to move around the studio, completely untethered, unencumbered, unfettered (insert your own "un" word here), without being on a leash (so to speak). Here's how it works: to start, you need two of these wireless devices—one sits on the top of your camera (in your camera's hot shoe) and transmits the wireless signal to the other wireless unit, which plugs into the sync input on your strobe. What I love about them is you just plug them in, turn them on, and they do their thing. There's no real configuring or messing around for this simple setup. Now when you press your shutter button, it instantly fires your strobe, even if it's across the room (even way across the room). The most popular wireless units are from a company called PocketWizard, and their new PocketWizard PlusX is a small, thin, lightweight model of simplicity that is incredibly reliable and very well made. They go for around $100 each (and you need two of them, so $200 for the set. They also make more expensive units with more features and stuff, but at this point, you don't need 'em). If you want a cheaper alternative, go with the Cactus Flash Transceiver V5 Duo. They're a bargain at around $60 for a set of two (so, $30 each), and they actually work really well. Perhaps they're not quite as rock-solid as the PocketWizard, and they may not have the 300+ foot range of a PocketWizard, but they're pretty darn reliable and about $140 cheaper.

Using Continuous Light Instead

A fast-growing alternative to studio strobes is continuous lights, and with these lights there is no "flash of light"—instead, the lights just stay on continuously. This makes studio lighting incredibly easy, because what you see is what you get. I use these continuous lights in my studio (I have three of them) and I took them on the road with my Adobe Photoshop Lightroom Live Tour, where they nearly created a sensation, because no matter what I tell you about them here in this book, it doesn't have the impact of seeing them used live. People just go nuts over them. The ones I use are Westcott Spiderlite TD6s (as shown above), which use daylight-balanced fluorescent light (since they're fluorescent, they produce hardly any heat—they stay nice and cool the entire time you're shooting with them, and your subjects stay cool, too). These lights are naturally softer than the studio strobes, but of course I still use them with a softbox attached, and the nice thing is the speed ring is built right into the light itself, so you don't have to buy a speed ring. Best of all—they're fairly inexpensive, and you can buy a kit, which includes a light stand, the Spiderlite TD6 fixture, a tilter bracket, and a 24x32" softbox, for around $830 at B&H Photo. Hard to beat. So, what's the downside with these lights? There's one: since there's no flash to freeze things, things need to be fairly still, because the fluorescent lights aren't as bright as the light from a strobe. So as long as your subjects don't move a whole bunch (for example, I wouldn't buy these for shooting toddlers or puppies), they're awesome.

Choosing the Size for Your Softbox

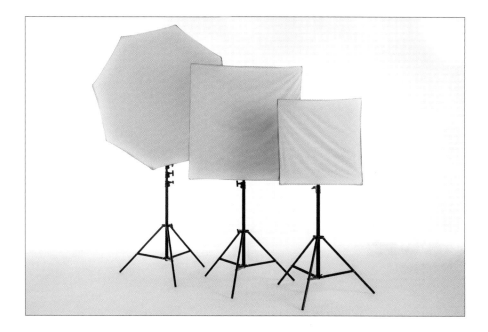

When you're trying to decide which size to choose for your softbox, there are a couple of considerations: the first being, what are you planning to shoot, and the second being, how soft do you want your light? We'll tackle the "What are you planning to shoot?" question first. If you're shooting product shots on a table, you can get away with a smaller softbox, like one that's 2x3', yet it would still be big enough to also work for head-and-shoulders portraits. If you're going to be shooting people, and doing more than just head-and-shoulder-type stuff, then you'll need to go with a larger softbox. I mentioned before that the larger the light source, the softer the light, so if you buy a very large softbox (like one that's 3x4'), you're going to get very soft light, and you're going to be able to light a larger area. I use three sizes in my studio: a 27x27", a 39x39" for people shots, and a 53" Elinchrom Midi-Octa (it's an octagonal-shaped softbox) when I want really, really, wonderfully soft wraparound light.

Scott's Gear Finder

Photoflex 2x3' (24x32") Litedome Softbox (around $113)

Chimera Pro II 3x4' Softbox (around $196)

Elinchrom 53" Midi-Octa Light Bank (around $315)

How a Light Meter Makes Your Studio Life Easier

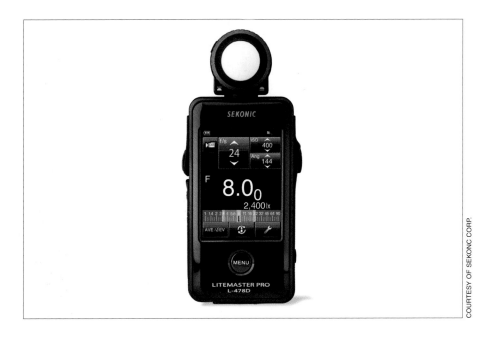

COURTESY OF SEKONIC CORP.

Once you've got your lighting all set up, how will you know what f-stop to set your camera at to get a proper exposure? Of course, once you've had years of experience you can get pretty close, or you can go the trial and error route. But, what if there were a device that would actually tell you to "set your f-stop at this number," and then all you had to do was dial in that f-stop on your camera and your exposure would be right on the money? Well, that's what a light meter does. In fact, that's all a light meter does. You fire your strobe, the meter measures the light from the strobe, and it shows you on its screen what f-stop to use for a perfect exposure. Sounds like cheating, right? It kinda is.

Scott's Gear Finder

Gossen Digiflash Light Meter 2 (around $200)

Sekonic Litemaster Pro L-478D Light Meter (around $390)

Gossen DIGISKY Light Meter (around $470)

How to Use a Light Meter

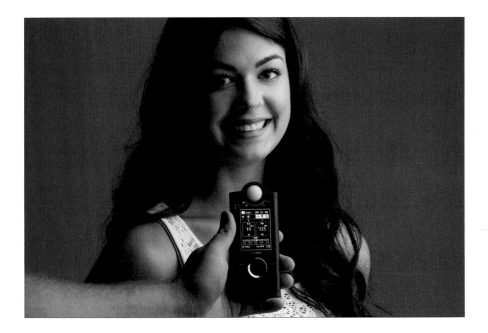

Before you get started, there are three simple things you'll need to do before you measure the light from your flash: (1) Enter the ISO that your camera is set to into your light meter (so, if you're shooting at 100 ISO, you enter 100 ISO). (2) Enter the shutter speed you're going to be using (in a studio, I generally use $1/125$ of a second—a good, safe shutter speed for working with studio flash. So, go ahead and enter $1/125$ of a second). And, (3) make sure the round white plastic dome on the meter is extended (turn the wheel so it extends out). That's it—you're ready to put it to use. Most people aim the light meter at the light itself, but today's meters are actually designed so they work with that white plastic dome aiming back directly at your camera's lens. If you're metering a person for a portrait, position the meter directly under their chin, with the dome aiming back directly at the camera. Now, push the measurement button on the meter, and then fire the flash (if you're firing your flashes wirelessly, make sure you get a light meter that has a wireless trigger built right in, so when you push the measurement button, it fires the flash for you. Otherwise, you'll have to have your subject hold the meter under their chin and push the measurement button, so you can walk back to your camera to take a test shot which fires the flash). When the flash fires, it instantly tells you the exact f-stop you need to dial in on your camera for a perfect exposure. Go over to your camera, make sure you're in manual mode, set your f-stop to what it said (make sure your shutter speed is still set at $1/125$ of a second) and you've got it—perfect exposure. As long as you don't move the light or change the power of the flash, you can continue to use those settings. If anything does change, just take a new meter reading the same way and dial in your f-stop just like before.

How Many Lights Should You Use?

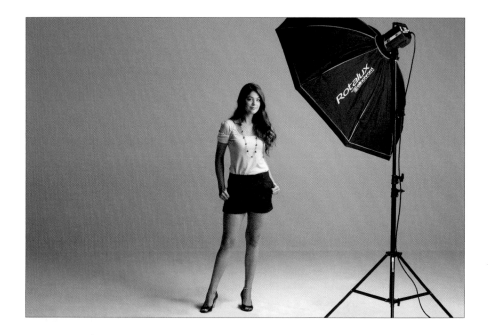

One. I am not kidding. The secret to lighting success is to keep it simple, and if you stick with just one light at this stage, your chances for success go up by about 1000%. Here's why: (1) You won't get into trouble with just one light. You'll set it up, you'll position it, you'll take a shot, it'll look great, and you'll be happy (think: less is more). In fact, it'll probably look so good that you'll want to add more lights. But, as soon as you start setting up more lights, the problems begin because, while one light is simple, two lights takes the complexity of getting overall good light up a big notch. Three lights is a total circus (at least until you really know what you're doing). So, do yourself a favor and get really good at just one light. (2) One light costs about half of what two lights cost, it takes about half the time to set up, and it weighs half as much. (3) With one light, you'll probably sidestep one of the biggest mistakes people new to studio lighting always tend to make, and that is to "overlight" everything. They use too many lights and make everything too bright. (4) You'll have a chance to really understand light because the whole process will be really simple. You'll get really, really good at using one light. You'll become a master of one light, and then you'll know exactly when you need to use a second light, and precisely why. This "stick with just one light" is some of the best advice in this chapter (heck, in this whole book), and if you do stick with it, it won't be long before you'll become known for your lighting. I know that sounds like a dream at this point, and it will stay a dream if you rush out and buy a three-light kit. Go with one.

The Least Expensive Extra Light

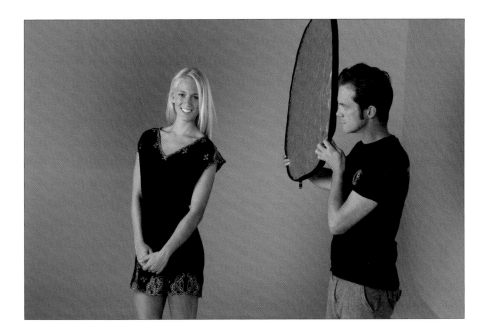

So, what do you do if you set up your one light and your subject's eyes look too dark, or if one side of their face is too dark, but I just told you not to use more than one light? Still don't buy that other light (not yet anyway). Instead, buy a reflector. They're cheap (about $30 for the Westcott reflector I use) and it's like having a second light but without the cost, complexity, size, weight, or electrical requirements. Here's how they work: When light hits a reflector, it bounces off it the way a billiard ball bounces off the rail cushion in a game of pool—it hits the reflector and changes direction. Your job is to direct that bounced light back toward your subject (well, back toward the part that needs more light). So, the idea is this: if one side of your subject's face is really dark, position the reflector so the light from your strobe hits it, and then bounces back onto that side of their face. Is it really that simple? Yup. You control how bright this bounced light is in two ways: (1) just like a real light, the closer the reflector is to your subject, the brighter it will be (so if it's too bright, move it farther away), and (2) the color you use affects how much light it bounces back— silver reflectors reflect a lot of light; white reflectors reflect much less (you can buy reflectors with white on one side, and silver on the other). So, if you just need a little light to fill in those shadows, use the white side. If you need a lot of light, use silver. Also, there are probably just two places you're really going to wind up placing this reflector in a studio: (1) right beside your subject, on the opposite side of the light to bounce light back toward the shadowy side of your subject, or (2) directly in front of your subject for headshots, to bounce light back into their eyes, usually around chest or waist level.

Adding a Hair Light

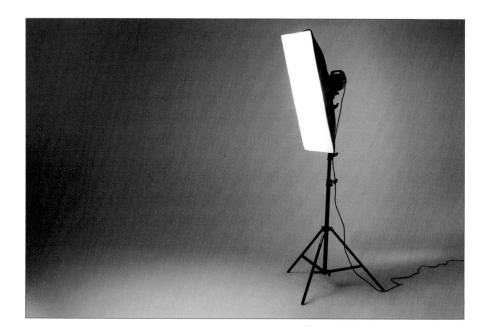

If you're thinking of adding a second light to your studio, it should probably be a hair light. A hair light is just another strobe, but it's generally aimed directly at your subject's hair (did I even have to say that?), which helps to separate your subject from the background and give your portraits a more professional look all around. For lighting hair these days, we generally use a tall, thin rectangular softbox called a strip bank, which helps keep the light more directional (and lights just the hair and/or shoulders, instead of spilling over everywhere). The strip bank size I use is 12x36". Also, I usually set the power on my strobe for the hair light so it's around one stop brighter than my front light, so the light from my front light doesn't overpower it.

Scott's Gear Finder

Westcott Strip Softbox 12x36" ($150)

Chimera 9x36" Super Pro Plus Strip ($183)

Westcott Strip Softbox 12x50" ($248)

Where to Position Your Hair Light

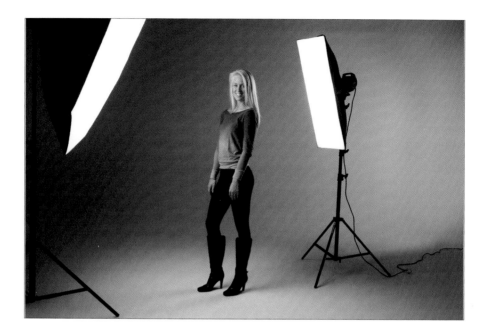

We used to position hair lights on a boom stand directly above our subjects, but honestly, that's kind of an outdated "old school" approach to hair lighting. Today, it's much more popular to use a strip bank behind and to the side of your subject instead. Generally, you position it on the opposite side of your front light (catty-corner to it), behind your subject, aiming back at their hair. As far as height goes, position it so about the top half of the soft-box is above their head and then you angle it down slightly toward your subject. As far as how close/far to place this hair light from your subject, that's easy: if you want the light to be harder, move it farther away (6 to 8 feet); if you want it softer, get it as close as you can to your subject (without it being visible in the shot. I didn't really have to say that last part, did I?). One more advantage of not going "old school" with the boom stand right overhead: you don't need a boom stand. You can do this strip bank hair light using just a regular ol' light stand. Another victory for simplicity!

Testing Your Hair Light's Position

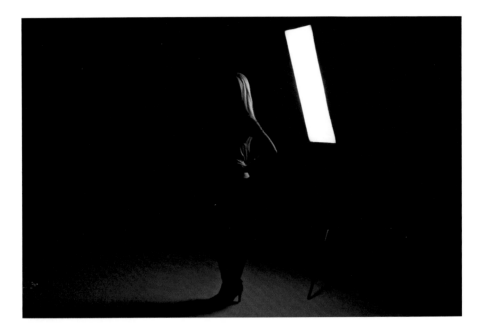

A trick for checking the position of your hair light, to make sure none of the light from it is spilling onto your subject's face, is to turn off your main strobe (your front light), so nothing but the hair light is turned on. Your subject should be in complete silhouette, with no light on their nose, cheeks, or face whatsoever. If you see any light now, you'll need to reposition your hair light (maybe move it back a little bit, or to the side), until you only see light on their head and shoulders—none on the face. By the way, this "turn off the front light" trick isn't just for hair lights—it's for any time you're using more than one light. By doing a test shot with just one light on at a time, you'll see exactly what each one is doing. If you turn them all on from the beginning, the lighting won't look good, but you won't have any idea why. So, always start with just one light (I always do any back lights first), and then add another light, one at a time. If something doesn't look right when you add another light, turn the other lights off, adjust the one that didn't look right, then turn them on again, one at a time.

Keeping Your Hair Light from Spilling

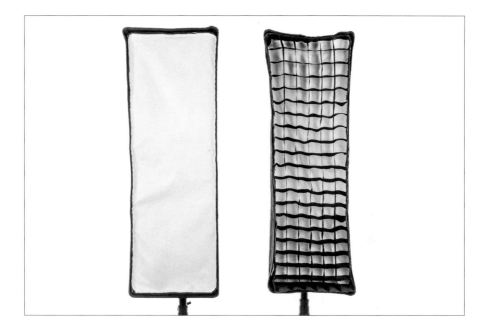

Probably the most popular accessory for hair lights is an egg crate grid. This is a fabric grid that Velcros (or slips, depending on the brand) over the front of your strip bank. It narrowly focuses the light from your hair light so it doesn't spill out the sides, and it really does a wonderful job of focusing your light just where you want it. They come in different sizes, and there's one to match the exact size and shape of your strip light. These used to be insanely expensive (literally, often more than the cost of the softbox itself, like the price was controlled by some sort of egg crate cartel), but a number of new sources now have them at really affordable prices (for example, instead of being $190 for a grid for 12x36" strip banks, you can get one from Denny Manufacturing [www.dennymfg.com] for around $40. Whew! That's better). Once you use one, you'll always use one, because for hair lights they're absolutely ideal.

Which Mode Should You Shoot In?

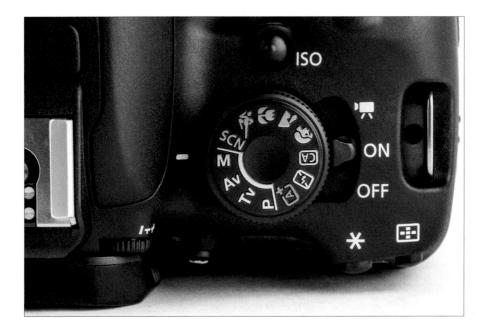

When it comes to shooting with studio strobes or flashes, this is the one time I would absolutely recommend that you shoot in manual mode. The reason is you need to set both the f-stop and shutter speed independently, and manual mode easily lets you do just that. Start by setting your shutter speed at 1/125 of a second (a good, safe speed that will sync your camera with your flash unit, no sweat). This shutter speed, in a studio, is a "set it and forget it" setting. Now all you have to worry about is setting your f-stop. So, set your shutter speed to 1/125 of a second, your f-stop to f/11 (great for studio portraits because everything will be in focus), and then take a shot and see how it looks on your camera's LCD monitor. If it's too dark/too bright, don't change the settings. Instead, just raise/lower your flash power until the lighting looks right to you. Of course, you could just use a light meter to tell you exactly which f-stop to use for the power setting you currently have on your flash (if you'd rather not mess with changing the power of your flash).

A "SHOW ME HOW TO DO IT" BOOK

This is a "show me how to do it" book. I'm telling you these tips just like I'd tell a shooting buddy, and that means, oftentimes, it's just which button to push, which setting to change, where to put the light, and not a whole lot of reasons why. I figure that once you start getting amazing results from your camera, you'll go out and buy one of those "tell me all about it" digital camera or lighting books.

Where to Position Your Main Light

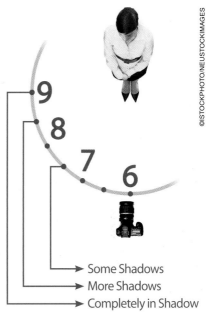

©ISTOCKPHOTO/NEUSTOCKIMAGES

Some Shadows
More Shadows
Completely in Shadow

There is no absolute "right" place to position your lights, so it really comes down to your personal preference about how you want the shadows to look on your subject. Shadows are what create depth and dimension on a person's face (and having soft shadows on your subject's face is usually very flattering), so I usually position my main light so it's at a 45° angle to the subject. So, for example, if your subject was standing at the center of a clock face, and the camera is straight in front of them at 6:00, then you'd place the light at around 7:30. This creates some nice soft shadows on the side of their face that's farthest away from the light (the side opposite the light). If you want more shadows on that side of their face, you'd move the light to around 8:00. Want more shadows? Move it to 8:30. Want that whole side of their face totally in shadow (often seen in dramatic portraits of men)? Put the light right beside them at 9:00. Okay, what if you actually want less shadows on that opposite side of their face—maybe just a hint of shadows? Then, move the light closer to the camera position—to around 7:00. If you move the light right in front of the subject, their whole face will be lit evenly with no shadows on the opposite side of their face. This is "flat lighting" and it usually looks okay on someone with really good skin. Okay, so which one of these positions is the "right" position? The one you choose—it's totally up to your personal preference (my preference has me positioning my light at between 7:30 and 8:00 most of the time).

How High to Position Your Main Light

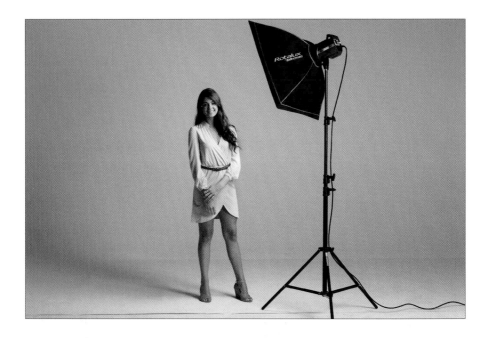

If you were doing a shoot using natural light from the sun, where does the light come from? It comes from above us, right? When it's straight above us, it's really harsh midday sun, but later in the day, the sun is lower in the sky and it becomes softer and more flattering as it now comes down on us at an angle. We want to do the same thing with our studio lights—we want to mimic that soft, late afternoon position. That's why we position our light up high above our subject, and aiming down at them at an angle, so it creates a more flattering look to our light. So, in short, we place it above them, angled down at them. If they're standing, the center of the light is usually up a couple of feet higher than their eye level. If they're sitting, it's also usually a couple of feet up higher than their eye level. Easy enough.

SOMETIMES YOU HAVE TO BUY GEAR

Just so you know, I don't get a kickback, bonus, or promotional fee from any of the companies whose products I recommend. I'm just giving you the same advice I'd give a friend if we were out shooting (which is the theme behind this entire book). This is not a book to sell you stuff, but before you move forward, understand that to get pro results, sometimes you have to use (and that means buy) some of what the pros use.

How Close to Position Your Light

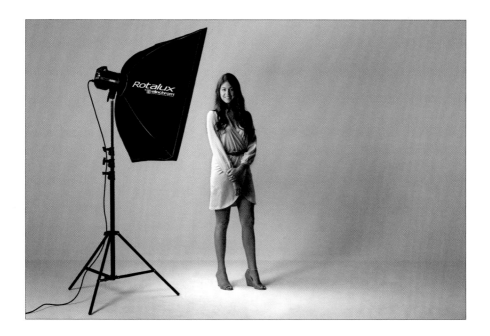

Once you know this rule, you'll know exactly how close (or far away) to position the light. The rule is actually very simple: the closer the light is to your subject, the softer the light is. That's it. Now that you know that rule, how far the light is positioned away from your subject is actually based on (wait for it…wait for it…) your subject. For example, if you're shooting a mother and daughter portrait, and you want the light to be really soft and beautiful, you'll position the light as close to them as possible (without actually seeing the softbox in the shot). If you're shooting a boxer, and you want the light on him to be hard and edgy, move the light back maybe 8 or 10 feet, and the shadows become much harder and edgier. The farther the light is away from him, the harder it will be. So, really, how close (or far) you position the light from your subject is based on how soft or hard you want the light to be. By the way, there's nothing to say you couldn't have soft, beautiful light on a boxer—it's actually a good look (I've done it myself). But, in the end, this is a call you make based on your subject and how soft or hard you want the light to be. Soft = close. Hard = far away. One thing to remember: when you move the light close to your subject, it gets brighter, so you might have to turn the power down. By the same token, if you move the light away from your subject for a harder look, the light gets darker (I know, duh!), so you'll have to turn the power of your flash up to compensate.

Using a Fan for Windblown Effects

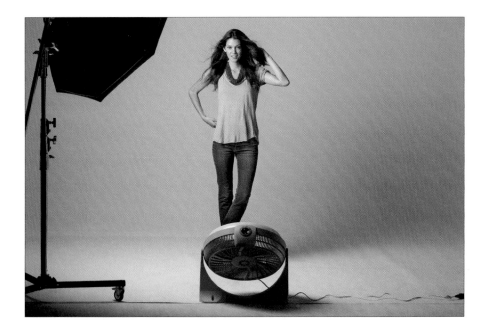

If you're shooting portraits of women, this is going to sound silly at first, but you want to buy a fan. Not just a fan, a powerful, hurricane-force commercial fan that would put most of your lighting equipment in jeopardy if you were to ever turn it on to its highest possible setting (which I believe, on most fans, is marked "Category Five"). Anyway, a fan with a nice kick to it (like the Lasko 3520 20" Cyclone Pivoting Floor Fan, for around $35) creates a windblown hair effect that can add energy and excitement to your portraits (besides making the subject's hair look full and glamorous). The fan should be positioned on the ground, aiming upward at your subject, and once the fan is in place and turned on, there's not much else to do but shoot. If you really want to "blow people away," take a look at Buffalo Tools' 42" Industrial Fan (it sells for $366), which was designed for use in factories and sports arenas, and features high-performance, belt-driven motion with a two-speed capacitor and a thermal cut-off (whatever that means). In short, it's guaranteed to relocate anything in your studio that's not bolted to the foundation.

> ### WANT TO IMPRESS THE FOLKS AT VOGUE? BUY THIS FAN!
>
> If you get a huge, paying, fashion cover shot gig and you want to really impress your new clients, buy the only fan I've found that is made for shooting fashion—the Bowens Jet Stream 350 Wind Machine. With its 2500-rpm blast and a wireless remote, it'll be knocking your clients off their feet (and it should—it sells for around $1,300). B&H Photo has 'em in stock. What the heck—buy two!

Want Softer, More Even Light? Feather It!

If you're already using a large softbox (one that's around 36x48" or larger), and you want softer, more even light than it delivers, then you can use a technique called feathering, which puts your subject in the softest and most even light your softbox can deliver. Feathering just means that you turn the light away from your subject, so they are now lit by just the edges of the light. They won't be getting the full intensity of the light when you feather it, so you might have to adjust your exposure so it's not too dark (use a lower number f-stop on your lens—like f/4 or f/3.5, etc.—or better yet, use your light meter and it will tell you exactly which settings to use when feathering your light). This light out at the edges of your softbox is very even, very soft, and very flattering (since the light in the center of the softbox is usually brighter and less even), so when you really need that super-soft, even light—now you know where to get it. This technique looks great on portraits of young children, a mother/daughter shot, or when you want a very soft, glamorous look to your lighting.

What That Extra Panel in Your Softbox Does

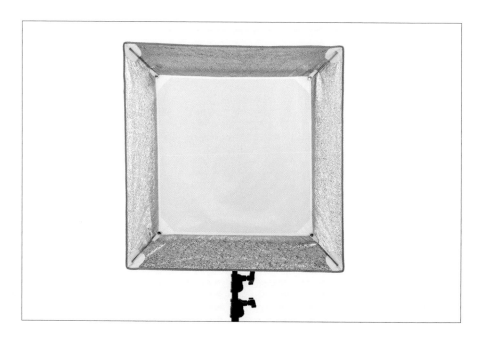

When you buy your first softbox, it may come with a second, smaller diffusion panel, which you place inside the softbox (and then you place the larger outer diffusion panel on the inside edge of the softbox, to cover the front). That internal diffusion panel really serves one purpose: to try to even out the light, so you don't get a hot spot in the center of your light where the flash bulb is. This internal panel does make the light a tiny bit softer, but that's not its main job—it's to hide that hot spot. Of course, by adding this internal panel, your light has to pass through that diffusion material first, so you lose a little bit of light in the process. As a general rule, if I'm using continuous light (like the Westcott Spiderlites), I always take this extra internal diffusion panel out. That's because those daylight fluorescent bulbs are already soft (by their very nature), and the panel doesn't really soften them significantly, it just eats up light, so I especially want them out when using continuous lights, because I need all the brightness I can get. Otherwise, if I'm using strobes, I leave them in place.

Using a Pop-Up Collapsible Background

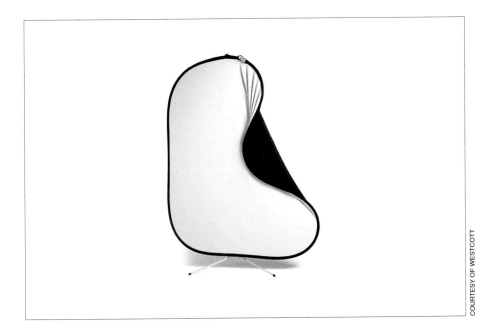

COURTESY OF WESTCOTT

Another quick and flexible studio background is a pop-up collapsible background that instantly folds up into a small, flat circle, but expands to be a full studio background in a matter of seconds. The one I use is a 6x7' Westcott Masterpiece 2-in-1 Collapsible Illuminator Background with white on one side and black on the other. It sells for around $220, and I also recommend buying the Illuminator stand to hold it up, which is another $90, but unless you can stand there and hold it up (or have somebody else hold it up), it's worth its weight in gold. So, with this background, anytime you want to shoot, you just open the round plastic case it comes in, pull it out, and it pops up, ready to go. You put it on the Illuminator background stand, and you're ready to go. Another advantage of this particular background (over the seamless paper route) is that it's very portable, lightweight, and you can set it up in literally seconds—by yourself. The only downside is it doesn't go all the way to the floor seamlessly, so it's fine for 3/4-body shots, but not full-body shots. One more thing: although I use the black/white version, these collapsible backgrounds come in all sorts of patterns, looks, sizes, and colors.

Keep Light from Hitting the Background

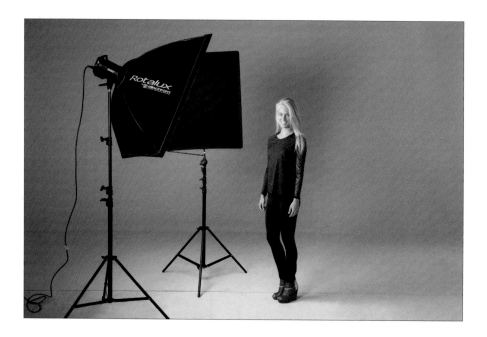

If you want to create a portrait with dramatic lighting, the key is to control where the light goes, so only a small portion of it actually hits your subject (and little or none winds up lighting the background). The problem is that even with a softbox (which is fairly directional compared to an umbrella), the light aiming back at your subject can spread too much, so we use black "flags" to block the light from hitting our background (or anything else we don't want it to hit). These flags are really just tall, or wide, black rectangular reflectors that absorb and block light, so you put one between your strobe (softbox) and the background, and voilá—it stops the light from spilling (as shown above). So, if you have more than one, you can really keep your light pretty much directed just where you want it by putting these black flags up to block any extra light. I use two Mathews 24x36" black flags (around $42 each). If you're not ready to plunk down that kind of change, you could always get two large black pieces of poster board or foam core, and that will do the trick.

Three Backgrounds for the Price of One

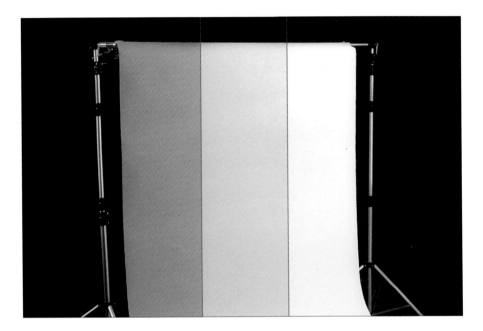

One of the advantages of shooting on a white background is that you can get three different looks from it, depending on how you light it. For example, if you put two bright strobes (or continuous lights, for that matter) aiming at the background behind your subject (or product), the background will look bright white. If you dim those lights, or remove one, then the background looks like a light gray. If you leave the background lights off altogether, your white background will now look medium gray. So, with white you get three separate looks: bright white, light gray, and medium gray—all based on whether, and how, you light the background.

Using Off-Camera Flash to Light Backgrounds

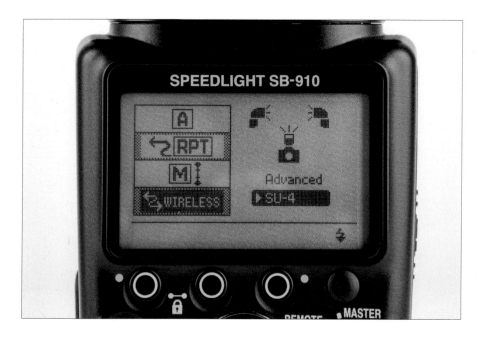

If you want to add a light to your background (aiming back at your seamless paper), but you don't want to go through the extra expense of adding a second studio strobe, if you have a standard off-camera flash (like a Nikon SB-910 or a Canon 600EX-RT), you're in luck. You can set either of these off-camera flashes to become wireless slave flashes, meaning that when your studio strobe fires to light your subject, it automatically triggers your off-camera flash to light your background. You only have to do two things to make this happen: (1) Put your flash on a light stand. (*Note:* If you have a Nikon SB-910 flash, it actually comes with wonderful little flash stand that lets you set your flash on the floor. Then you aim the head back up at your background, and this will work in a pinch.) So, the first thing (once again) is to put your flash on a light stand, and position it directly behind your subject so your subject's body hides the flash from view. Then, (2) set your off-camera flash to Slave, so it fires when it senses the light from your studio strobe. For example, on a Nikon SB-910, turn the ON/OFF switch to Remote, press the Menu button, scroll down to Wireless, and then choose SU-4 (as shown above). Press the OK button, then press the Menu button, and you're ready to go.

The Advantage of Shooting Tethered

You know that tiny LCD screen on the back of your camera? Yeah, that one. That little screen is what we use to make critical decisions about our photography (like "is this photo really tack sharp" or "are my subject's eyes both open"), but that screen (usually either 2½" or 3" in size) is actually smaller than the screen on our cell phones. I know—crazy, right? No wonder we misjudge sharpness and quality so often—that screen is absolutely tiny. That's why, if I'm shooting in a studio, I shoot tethered directly into my computer, so that way I see each image really large (at least at 8x10" size on my laptop, or larger on my desktop monitor) right as I take it. At this larger size, you can really see what's going on in your photo (and how your lighting looks), and you can make adjustments based on a much larger-sized image, which makes it hard to look at that tiny 2½" or 3" LCD display anymore. Tethering itself is actually very simple, just two steps: (1) Connect a USB cable from your camera's mini-USB port to your computer's USB port. (2) Now, you just need some tethering software. Luckily, Adobe's Photoshop Lightroom and Apple's Aperture already have tethering built right in. If you don't have Lightroom or Aperture and you're a Canon shooter, you already have the software you'll need—it's that EOS Utility software you got when you bought your camera (if you can't find it, you can download it for free from Canon's website). If you're a Nikon shooter on a Mac, go to www.sofortbildapp.com and download their excellent free tethering software. If you're a Nikon shooter on Windows, go to ControlMyNikon.com. If you're a Sony Alpha-series DLSR Shooter, you can use Sony's free Sony Camera Remote Control software.

Getting Super-Saturated Background Color

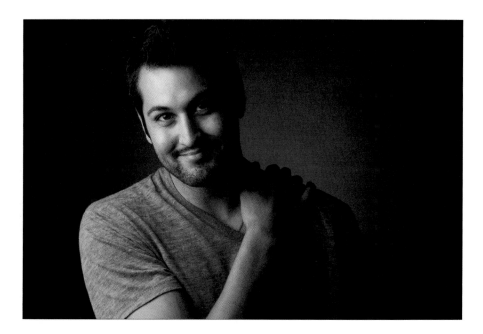

If you want some really vivid, punchy colors as your background, here's a recipe to get just that: Start on a background of black seamless paper (I know, it sounds weird that we start creating vivid colors with a black background, but believe it or not, this is the easiest way), and then position a light on the background. Now, for a background light you can use another one of the same strobes you already have (so, basically, you're going to need a second strobe if you want to light the background, or there's the trick you can pull to use your off-camera flash as a background light that we talked about a couple pages ago). Once you've got your black seamless paper in place and a second strobe (or off-camera flash) positioned behind your subject, aiming at the background, the trick is to put a vivid-colored gel (a translucent piece of plastic) over the front of your flash, and when your background flash fires, the color it produces is rich, vivid, and surprisingly colorful. You can get these gels (made by Lee or Rosco) from B&H Photo for around $6.50 for a 20x24" sheet (choose really vivid colors—reds, yellows, greens, etc.).

Lighting a White Background

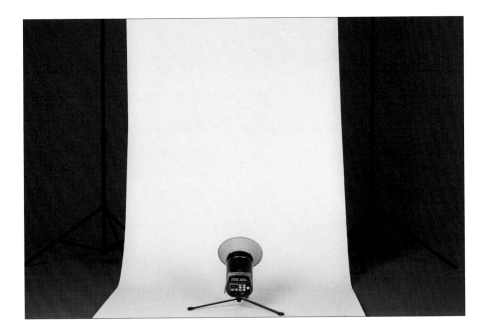

When you shoot on a white seamless-paper background, you'll probably be surprised to find out that most of the time it doesn't look white—it looks light gray. To get it to look solid white (that nice bright white you're used to seeing in portraits and product shots), you have to light the background. It doesn't take a bunch of lights—usually just one or two will do the trick, and they don't have to be very high-powered strobes either (see the off-camera trick a few pages back), so it's not a bad idea to buy a lower-powered, less expensive strobe just for lighting the background. But beyond just having a background light aimed at your white seamless background, there's a little trick you'll want to use to make sure that the light does make the background look that nice solid white, but without blowing out the background so much that the back light starts to wash out the edges of your subject (this happens more than you might think). The pros' trick to getting around this is (you guessed it) to use their light meter. They hold the meter up against the background, aim the white dome back toward the camera position, and check the reading. You want the background to be around one stop brighter than the light on your subject. So if your meter showed f/11 for your subject, you want the background to read one stop brighter (like f/16). You get that background brighter by increasing the power (brightness) of the strobe itself. Try increasing a bit, then recheck the background with your meter again, and keep adjusting the power of the background light until it reads that one stop (or slightly more) than your subject. That's the formula.

Which Color Reflector to Use

Outdoor Studio Both

Reflectors come in a variety of colors (white, black, silver, gold, etc.), and if you're wondering which color does what, well, here ya go:

- **Silver** reflects the most amount of light, and doesn't change the color of the studio light that hits it, so you see a lot of portrait pros using silver.

- **White** reflectors don't bounce nearly as much light, but they're still used in portraits because the reflected light is very soft and works both indoors and outdoors. White reflectors are also a good choice if you're doing product photography.

- **Gold** reflectors are for outdoor portraits to match the warm color of sunlight. They don't work well in a studio, because when the white light from your strobe hits the gold reflector, it becomes very yellow (so one side of your subject's face looks studio white, and the shadow side looks overly yellow).

- A **Black** reflector actually absorbs light, so it's used to cut reflections when you're shooting anything that's reflective, like glass, or jewelry, or tableware, or anything that's clear, etc.

For my studio portraits, I use a reflector that is silver on one side and white on the other, and I use the silver side around 80% of the time.

Where to Position a Reflector

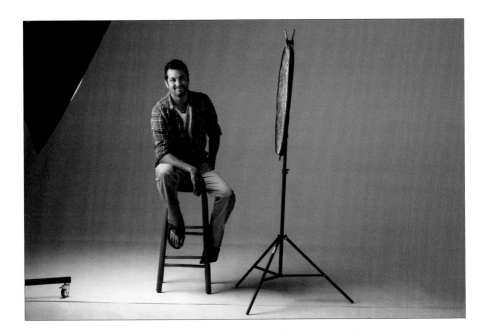

Reflectors are a key part of a studio setup, because they keep you from having to set up a second light. Luckily, they're pretty inexpensive (the Westcott 30" Silver/White square reflector I use costs only around $40), but once you've got one, where do you put it? A reflector's job is to bounce some of the light from your main light (your flash) back into the shadowy areas of your subject, so you'll need to position it where it can do its job, right? One popular method is to place the reflector directly beside your subject (on the opposite side from your studio flash), then move it a bit forward so it extends a little in front of the subject, so it catches the light and fills in the shadows. Make sure that: (1) it is indeed in front of them a bit, and not right beside them, and (2) it's not positioned up higher than they are—it should be at their height. Another popular place to position a reflector for head shots is directly in front of your subject, usually right below your subject's head and shoulders, so the light bounces back to lighten the shadows on their face—in particular, the areas under their eyes and neck. You can have your subject hold the reflector flat in front of them, or you can position it on a reflector stand, or even lay it on the floor in front of them. Another popular position is to place it out in front, where you'd place a second light (on the opposite side from your studio strobe), so it bounces light back toward your subject. The key thing to remember with reflectors is: if the light isn't hitting the reflector fairly directly, it has nothing to bounce, so make sure that wherever you position it, the light from your strobe is hitting it directly.

Reflectors Without an Assistant

If you don't have an assistant to hold your reflector in the studio, you just need an inexpensive light stand and a cheap clamp. The light stand I use for this is a 6' model made by Impact (I got mine at B&H Photo for around $20), and it's great for holding a pretty decent size reflector (like the Westcott 30" 5-in-1 Reflector I mentioned in the Flash chapter). Then just attach the reflector to the light stand using a cheap 2" Pony clamp, like the 2" Adjustable Clamp Company Pony Spring "A" Clamp with Plastic Tips for around $3. This is incredibly handy to have around (and much less expensive than hiring an assistant to hold your reflector).

VISIT B&H PHOTO'S NEW YORK SUPERSTORE

If you're ever in New York City, make it a point to drop by the B&H Photo store. It is absolutely amazing. It's like Disneyland for photographers. I could spend a day there (and I have). Anyway, they're good people and are pretty much beloved throughout the photography community (and that's saying something).

Seeing the Light from Your Reflector

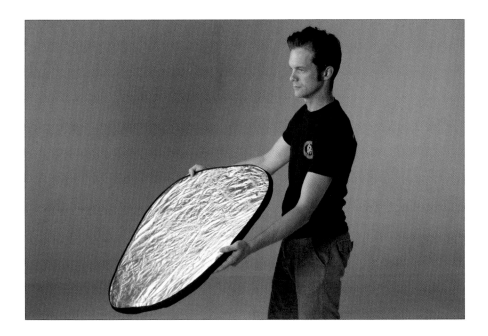

So, you're standing there holding a reflector. How do you know if it's really hitting your subject? Here's a quick trick for helping you position the angle of your reflector so you know the light is hitting where you want it to. Hold the reflector by its side and tilt it up and down a few times as you're facing your subject, and you'll see the reflected light move across their face. By tilting the reflector up and down a few times, you'll locate that "sweet spot"—where the light is hitting and fully bouncing from—and then you can tilt the reflector to right where you want it.

WHERE TO GO TO LEARN MORE ABOUT STUDIO LIGHTING

If this chapter gets you excited about what can be done with just one strobe (or one strobe and a hair light), and you want to learn more (and learn how and when to add more lights), then man did I write a book for you. It's called *Light It, Shoot It, Retouch It: Learn Step by Step How to Go from Empty Studio to Finished Image* and I go through a number of lighting setups from scratch, but without using diagrams. Instead, I use real photos, taken overhead, and from the front, the sides, and in back, so you can actually see exactly where everything goes. You'll totally dig it (but, of course, I would say that, right?). It's published by Peachpit Press.

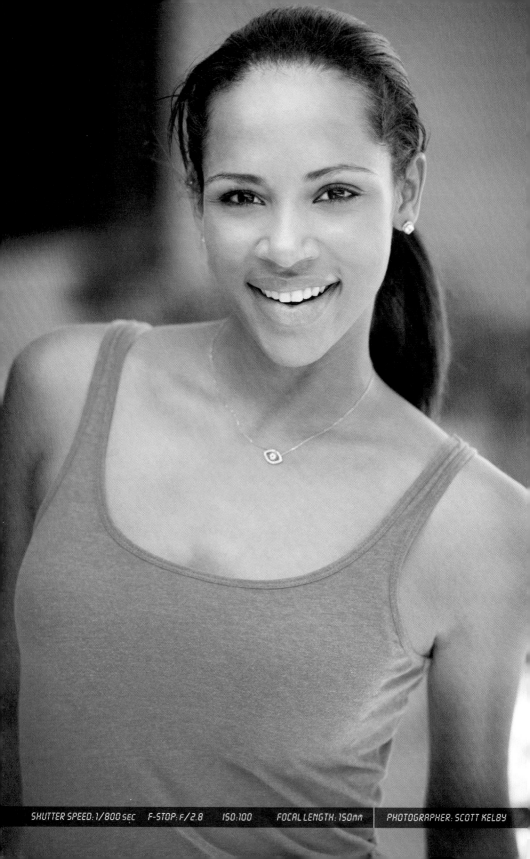

Chapter Three
Shooting Portraits Like a Pro
More Tips to Make People Look Their Very Best

Getting professional-looking shots of people is harder than you might think, for one simple reason: the pros hire really good-looking models, and as you know, models are models for one simple reason—they forget to eat. I'm joking, of course. They're models because they photograph really, really well. So, what makes our job so hard is that we're not surrounded by fabulous-looking models who just happen to be standing around not eating. Nope, we usually wind up shooting portraits of our friends, many of whom (on a looks scale) fall somewhere between Mr. Bean and Jabba the Hut. This is why our job, as portrait photographers, is actually substantially more challenging than that of a seasoned professional—we've got to make magic from some seriously un-model-like people. This is precisely why we're often so disappointed with our portraits (when it's really not our fault). So, in this chapter, we'll look at two proven strategies to get better, more professional-looking portraits every time, including: (1) how to make friends with better-looking people (it helps if you're rich), and (2) learning to control your light and pose your subjects so that no one gets a really good look at them. The key to this is to use dramatic light, and by "dramatic light" I mean—virtually none at all. The less you light these "un-model-like" subjects, the better your final images will be. In fact, think silhouette or long distance night photography, where your subjects are 100 to 200 yards away—anybody looks good from that distance (that's why long distance relationships work so well). Anyway, what this chapter will give you is a strategy for photographing people, and a list of places where good-looking people hang out and wear jeans that cost more than the gross national product of Luxembourg.

Don't Leave Too Much Headroom

When your average person takes a snapshot of someone, they almost always leave way too much space above their subject's head (as you see on the left here) because they almost always put their subject's eyes in the center of the frame. It's a classic mistake most amateurs make, but luckily it's one that's really easy to fix. Just don't do that—don't leave too much space. If you remember my portrait composition tip from part 1 of this book (position your subject's eyes at the top one-third of the frame), then you'll usually avoid this "too much headroom" problem altogether.

Great f-Stop for On-Location Portraits

In a photo studio, our goal is usually to make everything in focus, so we use high-numbered f-stops like f/11. However, if you're shooting on location or outdoors, now we have a new goal: make the background soft and out of focus, so our subject stands out from the background, creating some separation (this makes for a much more professional look on location). There are just two things you need to do to make this happen: (1) Shoot wide open (meaning, use the lowest number f-stop your lens will allow, so if your lowest number is f/4, use that. If it's f/2.8, even better—the lower the number, the more out of focus your background will be). And, (2) zoom in on your subject. Just changing the f-stop to a low number won't be enough by itself, the zooming-in part is really important (so you might have to stand back quite a ways from your subject). Try this and you'll see what I mean. Go ahead and set your f-stop to its lowest number (say, on your lens, it's f/3.5), then shoot a portrait without zooming in—shoot it with a wide angle, like a 24mm. Now, take a look at the photo. Everything's in focus, right? Even though the f-stop is low, a wide-angle shot will make everything sharp. That's why the "zooming-in" part of this two-step technique is so important. Do both and you'll have a wonderfully soft, out-of-focus background.

Shoot in Portrait Orientation

Most photos are taken in horizontal (landscape) orientation, and that makes perfect sense, since cameras are designed that way—to be held horizontally—and that's why the shutter button is on the top right, right where your finger would naturally be. However, professional portraits are generally taken using a vertical orientation (that's why it's referred to as "portrait orientation," but that term is most often seen when you go to print something on your computer—you'll see a button for Landscape [wide] or Portrait [tall]). So, if you want more professional-looking portraits, turn your camera vertically and shoot in portrait orientation (of course, like any rule, there are exceptions, some of which you'll learn later in this chapter).

Shooting Portraits? Get a Battery Grip!

If you shoot a lot of portraits, you're going to be spending a lot of time with your camera flipped vertically, and before long you'll get tired of reaching over the top of your camera to press the shutter button. When that happens, you'll want to get a vertical battery grip. Besides enabling you to use two batteries, so you can shoot longer without recharging your batteries, there's another huge advantage to battery grips, and that is that most include a vertical orientation shutter button and dials for setting your aperture and shutter speed, so you're as comfortable shooting vertically as when you're shooting horizontally. Besides those advantages, most of the photographers I know swear that it makes the whole camera feel better and more substantial in their hands, even when shooting horizontally (and how a camera feels in your hands is very important). The best news is these battery grips are available for most DSLRs, and for all the advantages they offer, they cost less than you'd think (starting at around $50). Just one thing to look for when ordering yours: not all battery grips have the vertical shutter button, so check to make sure the one you order does.

MOST HIGH-END CAMERAS ALREADY COME WITH A VERTICAL SHUTTER BUTTON

If you've got a high-end digital camera, like a Canon 1Dx or a Nikon D3s or D4, they already come with a vertical shutter button built right in. Hey, ya pay that type of money, they oughta come with one, right?

The "Sun Over Your Shoulder" Rule Is Bogus

You may have heard of the "Sun Over Your Shoulder" rule, which basically states that when you're shooting people outdoors, you put the sun behind you (over your shoulder), so your subjects' faces are lit. This is a perfectly fine rule for people taking snapshots, but it is the worst thing you can do for your group portrait (besides the "tall people in the back" thing). If you want more professional-looking shots of people outdoors, the last thing you want is the bright sun blasting them straight in their faces (although that's exactly what your average person does), so everyone is squinting, trying to shield their eyes, and turning away from the camera. Worse, it puts harsh, direct, unflattering light on them. Instead, position your subjects with the sun behind them (not behind you), so it puts a nice rim light effect around them (outlining their hair), and then use just a tiny bit of flash (keep the brightness of your flash low) to put just enough light into their faces to make them blend in with the natural light that surrounds them.

Shoot Wide and Push in Tight

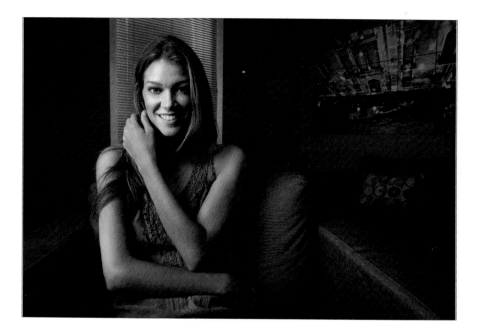

This is a concept—shooting on-location portraits with a wide-angle lens—that I hadn't considered for many years because of the time-honored rule that states: "Don't shoot people with a wide-angle lens because they look all distorted and weird." But it was one of the world's top shooters, the brilliant Joe McNally, who totally busted that myth and totally changed the way I shoot environmental portraits by turning me on to "shoot wide and push in tight." When you're shooting wide-angle and you get really close to your subjects (you're pushing in tight), they don't look distorted—only the stuff at the very edges of the frame looks a little "wide," but it's that stuff at the edge of the frame that shows the environment where the shot is taken. I was skeptical until Joe challenged me to pick up a *People* magazine and look at what most of the shots are—taken in tight with a wide-angle lens. I was shocked, but it's not just *People*, it's just about everywhere—from magazines to billboards to prints ads to the web. The pros are shooting wide and pushing in tight. You can, too!

NAME-DROPPING DISCLAIMER

Throughout this book, I wind up mentioning names of some famous photographers. The reason I do this isn't to drop names; instead, it's to give credit where credit is due. If I learned a tip or technique and I can remember who taught it to me, I think it's only right to give them the proper credit.

Shoot Profile Shots in Horizontal

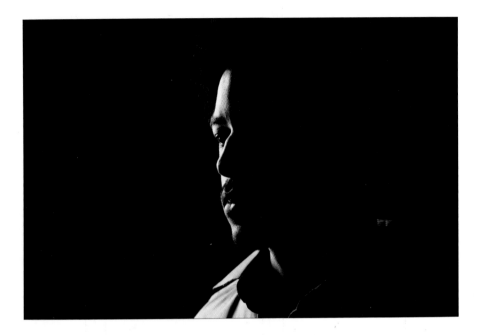

So, now that we've learned the Shoot Portraits Vertically rule, let's break it! (That's the great thing about the photographic rules—once you learn 'em, you can break 'em, then it's cool. It's only uncool when you break the rules by accident because you didn't know any better.) Anyway, one place where we intentionally break this rule is when we're shooting a profile view of our subject. The reason is this: because your subject is facing the edge of the frame, if you shoot your subject vertically, they look boxed-in, and that's uncomfortable for your viewer. So, by breaking the vertical rule and shooting profiles horizontally, it gives your subject some visual breathing room and makes your subject look more comfortable within the frame.

Shoot Long for More Flattering Portraits

Have you ever seen a high-end photo shoot on TV (maybe a fashion or celebrity shoot), and have you noticed how far back the photographer is from their subject? That's because they're taking advantage of "lens compression" offered by a longer zoom lens (which is very flattering to portraits). The shots above really tell the story—the one on the left was shot with a 50mm lens, and the one on the right with a 70–200mm lens zoomed out to 190mm. Even though all the camera settings and lighting are identical (they were taken just seconds apart), her features in the shot on the right look much more pleasing. That's why you'll see many pro photographers shooting portraits at the far range of their zoom. By that I mean they shoot with the lens extended out as far as it can go. So, if they're shooting a 28–135mm lens, they're shooting out in the 100mm to 135mm range to get the best, most flattering look for portraits.

Scott's Pro-Speak TRANSLATOR

The phrase we use for shooting all the way out at the longest end of a telephoto lens (for example, shooting at 200mm on a 70–200mm lens) is "racked out." So, you might hear a photographer say, "I shot racked out to 200," which means he shot with his lens extended out as far as it can go—to the far end of its range (in this case, 200mm).

Why Diffusers Rock for Outdoor Portraits

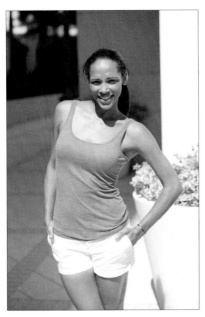 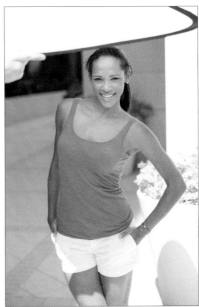

When it comes to really harsh, unflattering light for portraits, it's a toss-up between which is worse: your camera's built-in pop-up flash or direct sunlight. Luckily, as you learned in part 1 of this book, if you're shooting portraits outdoors and there's an area with some shade nearby, you can shoot there. But what if you're out at the beach, or in the desert, or one of a thousand other places that doesn't have a shady tree nearby? Then you'll want to own one of these—a 30" Lastolite TriGrip 1 Stop Diffuser (the same one I mentioned in the flash chapter for diffusing harsh light from an off-camera flash—so it does double-duty here). Just have a friend hold this diffuser between the sun and your subject (as shown above on the right), and instantly you have soft, beautiful, natural light on location. It sells for around $70 at B&H Photo, and you'll want this lightweight lifesaver with you every time you leave the studio.

Making a Better Background for Portraits

The key to great backgrounds for portraits is "less is more." If you're shooting an environ-mental portrait (a photo taken on location in someone's home, office, etc.), to get that pro look, it's not what you do to the background, it's what you take away from the background that makes it work. You want to have as few distracting elements in the background as you can, so either position your subject on a very simple, uncluttered background to begin with, or if that's not possible, remove as many distracting elements (or knicknacks) as your subject will let you get away with, as I did in the image on the right here. Don't take this lightly—to create a really great environmental portrait, it can't just be the foreground that works. The whole photo has to work together, and by choosing (or creating) a sparse, uncluttered background, your chances of having a winner go way up.

Cropping Off the Top of Their Head

This is the next step past "Don't leave too much room above your subject's head" in portraits. In this composition technique, you actually cut off the top of your subject's head, and while that probably sounds weird reading it here, it's a very popular pro technique that fills your frame with your subject's head. Getting in tight like this makes for a very compelling look, as you see above, and now that it has been brought to your attention, you'll see this composition technique is everywhere and has become the mainstay of many top fashion, beauty, and portrait shooters. (*Note:* Although it's perfectly fine to cut off the top of their head, or side of their arms, shoulders, hair, etc., you shouldn't cut off their chin. People are actually very used to seeing the top cut off and it looks natural, but seeing a shot where the chin is cropped off makes for a very uncomfortable composition.)

Trendy Composition Tip

Since most photos you see are either horizontal or vertical, doing something different looks…well…different! And right now, a very popular technique for portrait photography is to turn the camera at an angle, which puts your subject kind of up in the corner. The technique couldn't be simpler—just rotate your camera to the left or right a little bit and then take the shot. It may take you a couple of tries to get your subject positioned right where you want them in the frame, but this look (which has been around for years) is getting very popular once again.

Group Photos Are Easier Outdoors

Lighting a group shot, and getting a consistent amount of light on each person, can be pretty challenging, which is why, when it comes to group shots, you'll usually get better results by moving the group outside. It's easier to light the group using available outdoor light, especially if you can get them in the shade (not deep in the shade, just on the edge of the shade, but without letting any dapples of light appear on them through tree branches or gaps between windows or buildings). If you're lucky enough to wind up shooting a group portrait on an overcast day, then your job will be pretty easy—just get them outside and the overcast sky will take care of your lighting woes, so you can focus on getting them posed. (By the way, professional-looking group shots never start with the photographer saying, "Okay, all the tall people in the back row.")

Tip for Posing Group Portraits

The next time you're shooting a group portrait, rather than lining everybody up in rows (which you already know doesn't look good), instead try to get them to rally around something—some object—and they'll arrange themselves naturally around it. For example, try posing people in and around a couch, a column, a chair, a car, a desk, or any object that can pull them together into a group that isn't just a bunch of people standing in straight lines.

Great Tip for Casual Group Shots

Want to make a more compelling look for a casual group shot? Put your subjects in a very tight pyramid shape (a triangle), but by tight I mean so tight that they're all touching—arms around one another, their heads very close together, with one person at the top of your frame, and one on either side of the bottom of the pyramid shape (as shown above), with the others all scrunched in the middle. Also, you'll notice their bodies are not in a straight line—they're kind of staggered, but they're all leaning into the shot, which gives the shot more energy and a sense of fun. I wouldn't try this for an executive group portrait, but if you've got a fun-loving casual group, this is a great way to visually say that about them.

DON'T USE ROWS—USE CLUSTERS

If you're shooting a large group, instead of posing everyone in those tired rows, group people together in small clusters—like mini-triangles within the group, with three or four people in each triangle. These little mini-clusters add closeness and energy, and then when you've got two or three groups put together, slide them all a little closer together to visually make one big group. (These mini-clusters don't have to touch each other—small gaps between them are okay.)

Get Couples Really, Really Close

When you pose a couple and tell them to get in nice and close to each other (which you definitely should), they never get nearly close enough to look "close" in a photo. When you put your eye up to the viewfinder, you'll see the gap I'm talking about, so you tell them to "get even closer" and they move in all of about 2 inches, but I've got a trick that fixes this every time. Go ahead and take a quick shot—with the gap between them—then take it right over and show them the gap on your LCD monitor. Once they see it (and how big the gap that they thought wasn't there actually looks), they'll really get in close, and it literally makes the shot. I've done this again and again, and it always works like a charm.

Want Better Portraits? Don't Count Down!

If you want that really posed look, then count 1-2-3 right before you press the shutter button. It's almost a guarantee that you won't have any natural expressions in your portraits. It's your job as photographer to find that moment when your subject looks natural, and capture that moment in time. Anyone can stand there and say "1-2-3" and push the shutter button at "4," and if you do that, you'll wind up with images that anyone can take. If you want something special, something more natural—a genuine smile or expression—then ditch the 1-2-3 cliché and instead just talk to your subject. Engage them, get them talking, laughing, smiling naturally in the course of a conversation, or even goofing around, and then when the moment is right—capture that moment. Then you'll be giving them more than a well-lit, totally posed photo. You'll give them something special.

Shoot Before & Between Shoots
for More Natural-Looking Portraits

A number of pros swear by this technique for getting more natural shots: they tell the subject not to pose yet, because they're just taking "test shots" to check the lighting. Since you're not really shooting, they're not really posing, and you're just talking to them, firing away the whole time. Once you tell the subject, "Okay, here we go," they change their demeanor, and begin "posing," so make sure you get lots of these candid, non-posed shots before the official shoot and between shoots, because they will probably be the most natural, un-posed shots of the day.

Don't Light Your Entire Subject Evenly

When people look at a photo, their eye is first drawn to the brightest thing in the photo, so you only want the brightest light falling where you want them to look, right? Right. So, if you're shooting a portrait, do you want the person viewing the portrait to look at your subject's face or their folded arms? Right. But most people light the entire portrait with the same exact light throughout, where the subject's hands at their sides have the same approximate light as the subject's face. If you want to create portraits that really lead the viewer to where you want them to focus, light your subject so the light is brightest on their face, and it gradually falls off the lower down their body it goes. This adds interest, drama, and a visual focus that you'll find so often in high-end portraits. By the way, this is another case for feathering your light (see page 61), so that the edges of the light are what light your subject's face, and below that the light falls off pretty rapidly (but don't let it get too dark—it should still have light, and detail, just not as much as their face).

DON'T LET TOO MUCH LIGHT FALL ON THEIR EARS

If there's a part of your subject that doesn't need to be well-lit, it's their ears. Ears are often distracting because they're poking out of what is usually a darker area (a person's hair), so they catch enough light to draw your attention. Since a person's ears are rarely their best feature, you don't want your viewer's eyes stopping on them first, so just be careful to not have some really bright ears in your portraits.

Window Light: Where to Position the Subject

Window light, especially light from a north-facing window, is among the most beautiful light for portraits anywhere (in fact, some pros insist on only using natural window light for all their portraits—period!). The window diffuses the light streaming in, and the larger the window, the more soft and diffuse the light. So, if you've got some nice window light, where do you position your subject to make the most of this beautiful light? You want to position your subject with their shoulder facing the window (so the light comes across your subject, creating soft shadows on the far side of their face). Then, place them about 6 feet from the window, so the light is very soft and wraps around your subject (if you get them any closer, that soft light could turn very contrasty fast). Also, position your subject a little bit back behind the window, so they catch the edge of the window light and not the direct sunlight. This edge light is very soft and gives you that wonderful, almost magical light that so many pros swear by.

Window Light: Where You Should Shoot From

When shooting a window-light portrait, you want to set up your camera right near the window, with your shoulder facing the window. Then, you'll aim back a little toward your subject, who should be positioned just past the window, about 6 feet from it (so basically, you're up against the window, shooting at a slight angle back toward your subject).

Window Light: Where to Position the Reflector

Since we generally use a reflector to bounce light into the shadow side of our subject's face, you might think that with window light you'd put the reflector on the shadow side of your subject's face. It makes sense, right? Right. And you can do that, but with window-light portraits, try this technique I learned from legendary portrait and wedding photographer Monte Zucker: bounce the light from the camera position (near the window) above your head, bouncing the window light down onto the dark side of your subject's face to open up those shadow areas.

Six Quick Tips for Fixing Facial Challenges

You can hide or greatly reduce many typical facial problems (like a big nose, round face, wrinkles, big ears, etc.) by how you pose and light your subject. Here are six quick posing tips to help you make your subjects look their very best: (1) If your subject is balding, shoot from a lower angle, and don't use any hair light whatsoever. (2) If your subject has lots of wrinkles, try lighting them straight on, because side lighting tends to accentuate the shadows and make the wrinkles more prominent. (3) If your subject has large ears, pose them so they're only showing one ear, then light them so that ear appears on the shadow side of their face (so basically, only one ear is showing, and that one is kind of hidden in the shadow). (4) If they have a big honkin' nose (that's a technical term, by the way), then have them turn their head straight toward the camera, have them raise their chin a bit, and shoot from a little lower angle, which will take much of the emphasis off their schnozz. (5) If your subject has a double chin, have them look straight at the camera, and extend their head forward toward the camera a bit. This stretches and tightens the skin under their chin. Also, if you light them straight on (with the light positioned directly above where you're shooting from), this puts a shadow under their chin and helps to hide the double chin. (6) If your subject has a round or fat face, make fun of them, and tell them to lose a few pounds. Then, when they burst into tears, you'll have some of the most natural-looking expressions of the day. Or, you can have them turn their face to the left or right, giving a ¾-view of their face, which will make their face look less round, but really—it's your call.

Don't Shoot with Their Shoulders Straight On

Everybody—women, men, kids—generally looks better when posed with their shoulders angled toward the camera. If their shoulders are straight toward the camera, it makes your subjects look very wide and flat, and even somewhat confrontational. But by simply having them turn one shoulder away from the camera, it makes them look thinner and generally gives them a more pleasing look by lessening the width of their shoulders and focusing more attention on their head. Remember: Their head can still face the camera—you're just turning their shoulders. Two exceptions: (1) If you want somebody to look very wide and flat (like a football player), then the straight-on look can look fantastic. And, (2) if you work with professional models, they are usually experts at posing, so they can get away with posing shoulders straight toward the camera, and it still looks great. But, for the rest of us, we generally look better with our shoulders angled.

Making Your Subject Look Slimmer

If you want to make someone's body look slimmer, keep their arms from touching their body—leave a little gap between their arms and their body, so their arms don't add to their body mass and make their whole figure look larger. You'll see this trick used often in celebrity and fashion shots, and you'll be surprised what a difference this little gap between the arms and waist can make (as seen in the before/after above). Another trick is to have your subject face their body away from the camera at an angle, and then just twist the upper half of their body toward the camera (leaving their lower half still facing away). Again, this is one of those little tricks that makes a big difference.

Using a Posing Chair

One of the best reasons to pose your subject in a chair is that people often feel more comfortable in a chair, and if they're comfortable, your chances of getting a relaxed, natural portrait go way up. If you have your subject standing alone in the middle of a studio, with all sorts of lights aimed at them, you're giving your subject every opportunity to be uncomfortable, and that usually translates to less-than-natural, uncomfortable-looking portraits. By the way, if you do shoot your subject seated, here's a tip to help get better-looking poses: have them sit near the end of the chair (being that far from the back of the chair almost ensures that they won't slouch or lean back), and it helps the overall look to have them lean a little forward, into the camera. So, the next time your subject looks really uncomfortable, offer them a seat, and watch them instantly become more comfortable, which usually results in better, more natural-looking portraits.

Keeping Your Subject "In the Zone"

When you're shooting a person's portrait, it's a very vulnerable, and often uncomfortable, position to be in, and in most cases the person you're shooting wants you, the photographer, to be happy with what you see and what's going on with the shoot. If they feel things aren't going well, they start to think it's their fault. You want them feeling great—you want them confident and happy, enjoying their time in front of the lens as much as possible, because that translates into better portraits. One way to keep them "in the zone" and engaged is to keep talking to them. All the time. The entire time. Talk about what you're doing, why you're doing it, talk about the weather—anything to keep them engaged. Anytime there's a period of silence, they start to get worried something's wrong, and that it may be their fault. They have no idea what you're seeing through the viewfinder, and if things get quiet, they start to get concerned and they start to get edgy, and within a minute or two they're totally out of the zone. When I'm shooting a portrait, I'm talking to them the whole time. If I stop to move a light, I tell them why (I know they don't care, but I'm keeping them engaged in the shoot). I keep giving them constant verbal encouragement ("That looks great. Fantastic! Right on the money! What a great smile," etc.) the whole time, and it makes them more comfortable and confident.

Avoid Dappled Light

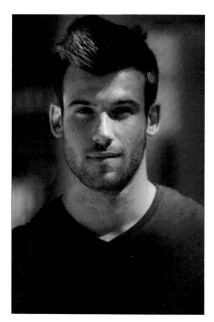 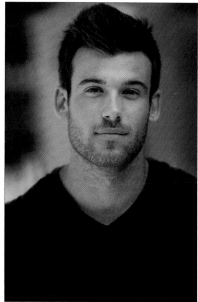

If you read part 1 of this book, then you already know about putting your subjects
in the shade to get better portraits outdoors (ideally, out near the edge of the shady
area for the best light), but when you do this, there's something to watch out for—the
dreaded "dappled light." That's those small areas of bright sunlight that break through
the trees, causing uneven hot spots of light on your subject, which pretty much ruin the
portrait (even if the dapples don't fall directly on their face). Luckily, the fix is amaz-
ingly easy—just reposition your subject in an area of the shade that doesn't have any of
this distracting dappled light shining through. You can see how much better this looks
in the image on the right here. Now, there are certain instances where dappled light
works when you're shooting landscape photography, but when it comes to shooting
people, dapples pretty much ruin any hope of a professional look, so be on the lookout
for them anytime you're shooting under trees, or in a barn (where sunbeams can come
through the cracks in the wood), or anyplace where small beams of sunlight can fall
directly on your subject.

Gold Reflectors Are for Outdoors

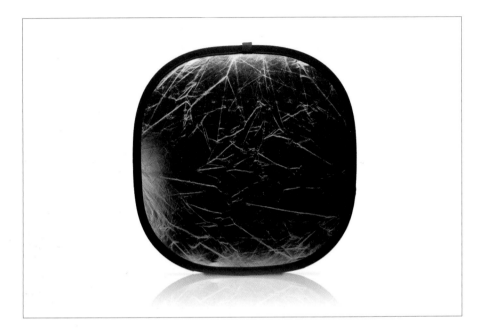

One of the most popular color combinations for reflectors is silver on one side and gold on the other. The silver side is usually used when shooting indoors or inside a studio. The gold side is usually used outdoors, and since it's gold (and light picks up the color of whatever it hits), the light it throws will be very warm—like sunlight. So why wouldn't you use this warm reflected light in the studio? Because the light in your studio is usually very white balanced, probably from a flash, and you don't generally want to have white-balanced light from a flash on one side of their face and warm, golden light on the other side.

Minimizing Shadows Under the Eyes

If your subject starts to get shadows under their eyes (from overhead lighting indoors or outdoors), one way to reduce those is to put a silver or white reflector directly in front of them at their chest (or as high up as right under their chin), aiming up at them and reflecting some of the light back up into their eyes.

Chapter Four
Shooting Landscapes Like a Pro
More Tips for Creating Stunning Scenic Images

In part 1 of this book, I had a chapter on shooting landscapes, and it turned out to be one of the most popular chapters in the book. So, when I started on part 2, I knew right then I would have to include another chapter with even more landscape techniques. And the only way to come up with new landscape techniques is to (you guessed it) shoot more landscapes, and what better place to shoot landscapes than at a landscape photography workshop? So, since I published the last edition of this book, I've taught at photography workshops in beautiful locations like Yosemite National Park, Cape Cod, Great Smoky Mountains National Park, and Glacier National Park, and then I just did some shooting in Maine this summer, and some other amazing places like Utah's Monument Valley, and the Grand Canyon, and a half-dozen other incredibly scenic spots. But when it's all said and done, do you know what all these places really meant to me? Tax deductions. That's right, because I went to these locations on business (the images will be used by me to teach photography), I get some really juicy write-offs for these trips. For example, you see that photo on the facing page? That's The Wave, which is just outside Page, Arizona, and not only is access to The Wave tightly restricted by the Bureau of Land Management, it was a grueling two-hour hike in scorching 112° desert heat over rocky mountains and hot desert sand, lugging all my camera gear, tripod (and bottles of water), and I have to be honest with you—there were times when I almost gave up, but you know what kept me going? It was the fact that if I didn't get there, and get a decent enough shot to make it into this book, I couldn't write my trip off as a tax deduction. See, I really do care.

The Secret to Shooting Sunsets

LOCATION: KAUAI, HAWAII

Because you're shooting into the sun, it can really throw your camera's built-in light meter way off, and what looked so beautiful when you were standing there comes out… well…pretty lame. Luckily, there's a simple trick to getting perfect sunset shots every time. The trick is to aim just above the setting sun itself (but make sure you can't see the sun itself through your viewfinder), then hold your shutter button halfway down, which tells the camera to set the exposure for just what it sees in the viewfinder right now. This gives you a perfect sunset exposure, but don't let go of that shutter button quite yet (keep it held down), then you can move your camera and recompose the shot as you'd like it to look. By keeping that button held down, you've locked in that perfect exposure, and once everything looks good to you, just press the shutter button down the rest of the way and take the shot. You will have nailed the exposure and captured the scene perfectly.

Cutting Reflections in Water

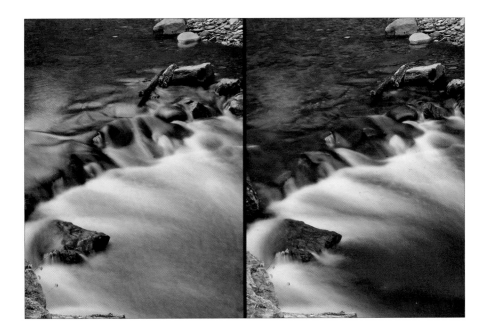

If you're shooting streams or lakes, or really anything with water, there's a filter you're going to want to use that does something very important—it removes the reflection of the sky from the water and lets you see through the water. That way, things like rocks below the shore or in a stream, fish in a koi pond, etc., all suddenly appear crystal clear, and that can make for some very compelling images. The thing that surprises most folks is that it's a filter that most photographers use to get bluer skies—a circular polarizer. As I mentioned in part 1 of this book, a polarizer is indispensable for getting those blue skies, but it's just as important for this overlooked double-duty of cutting reflections. Here's how it works: screw the filter onto your lens, aim at the water in front of you, and then rotate the circular ring at the end of the filter, and as you do, you'll almost magically cut through the reflections and see right through the water, as seen on the right here. It's one of those things you really just have to try to appreciate it, but believe me— you'll love it.

For Landscapes, You Need a Clear Subject

LOCATION: BIG SUR, CALIFORNIA

One of the things that kills a lot of landscape shots is that there's no clear subject, and for a landscape shot to really work, you have to be able to look at it and explain what you shot in one simple sentence. It's a lighthouse. It's that seagull on the rocks. It's that old barn. It's the palm trees on the beach. If you can't explain your landscape shot in a short sentence like that, you don't know what the subject is, and if you don't know, people viewing your image won't know either, and if that happens, the photo just isn't working. Keep this in mind when you're composing your landscape shots, and ask yourself the question, "What's my subject?" If you can't come up with a solid answer immediately, it's time to recompose your shot and find a clear subject. It makes all the difference in the world.

Using Your LCD Monitor Outdoors

If it's bright outside, you're going to quickly run into one of the biggest challenges of shooting outdoors, and that is you can't see anything on your LCD monitor—the sunlight washes everything out. In fact, it's often so hard to see anything that you might as well turn off your monitor and save your battery, but then your LCD monitor becomes about useless. That's why I've fallen in love with the Hoodman HoodLoupe Professional. You wear this around your neck (when you're shooting outdoors), then you simply hold it up over your LCD monitor and its soft rubber enclosure blocks out the sun and gives you a crystal clear view of your monitor. I carry this with me to all my outdoor shoots, and after you use it even once, you won't want to be without it. (*Note:* Even though it's called a "loupe," it doesn't really magnify your image like a traditional loupe—it just blocks the sun out, but really, that's all we need.) It sells for around $80 at B&H Photo.

A Trick for Shooting Great Rainbows

©ISTOCKPHOTO/PAUL GIAMOU

Want to really bring out the vibrance and color of your shots that have a rainbow in them? Then use a circular polarizer (now we've got three reasons to have a polarizer: [1] bluer skies, [2] cutting the reflections in water, and [3] making your rainbows "pop!"). Just turn the circular end of the filter while you're aimed at the rainbow and stop when the colors look their most vibrant. Easy enough to do, and the results are worth it. Now, beyond that, there's a wonderful tip I learned from my buddy, and renowned landscape photographer, Bill Fortney. Bill says, "If you see a rainbow, drive like the devil until you find something interesting for the rainbow to come down in." He doesn't mean drive until you come to the end of the rainbow, or all you'll get is a shot of that pot of gold. Just drive until you can find a gorge, or a water source, or something—anything interesting—for it to end with. Do those two things and you'll wind up with a remarkable shot.

A Timesaving Pano Trick

When you come back in from your shoot, if your shoot included some panos, you're going to quickly find out one of the hidden challenges of shooting panos: finding them. For example, when you open your images in Adobe Photoshop Lightroom, or Adobe Bridge, or in iPhoto, etc., you're looking at thumbnails of perhaps hundreds of images from your shoot, and it's a bit of a challenge to figure out where your panos start and end. In fact, numerous times I've been looking through thumbnails from a shoot, and I look at a shot and think, "What was I thinking when I took this one?" Only to find out later it was one frame from a 10-frame pano. Worse yet, if I'm shooting on vacation, it might be a week or more before I get home to look at the images, and I completely forget that there's even a pano included in a particular shoot, because they just don't jump out at you. Luckily, there's a simple trick that makes finding your panos a two-second job: Before you shoot the first frame of your pano, hold your finger up in front of your lens and take a shot (as you see in the first frame above). Now start shooting your pano. Once you finish shooting the last shot of your pano, hold two fingers in front of the camera and take another shot (as seen in the last frame). Now, when you're looking at your photos in a photo browser and you see one finger in your shot, you know there's a pano starting there. So, select all the photos that appear between your one-finger shot and your two-finger shot—that's your pano. Open those in Photoshop and let it stitch them together for you (we looked at this in Part 1 of this book series).

The Trick for Using a Fisheye Lens

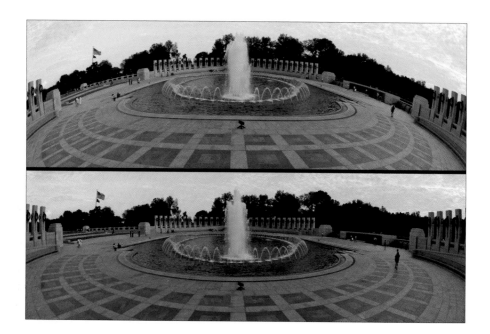

Fisheye lenses are making a big comeback, and they actually can be very cool for a variety of landscape shots—you just don't want your final image to look rounded and distorted, like many fisheye shots you see. You only want a very wide field of view. The trick to doing that is to simply keep the horizon line in the center of your image. This limits the amount of fisheye-like distortion and makes a huge difference in the final look. The best way to test this is to actually tip your camera downward, then back up toward the sky, all while looking through the viewfinder. You'll see the edges of your image distort as you move up and down (as seen in the top image), but you'll notice that as your horizon line gets centered in the image, the fisheye distortion is at its very minimum (like in the bottom image), and it just looks like a really, really wide-angle lens. Give it a try—you'll see what I mean (by the way, this is the only time you really want the horizon line in the center of your image, as you learned in part 1 of this book).

When to Shoot Streams

LOCATION: GLACIER NATIONAL PARK, MONTANA

If it's a gray, cloudy, rainy day (I don't mean pouring rain—a light drizzle or soft rain), then head to a local stream, because you're about to make some magic. The overcast, cloudy, rainy sky does two things that make it ideal for shooting streams: (1) it makes the rocks, leaves, and everything sticking out of the stream nice and wet, which looks great in stream photographs, and (2) it makes the scene much darker (and the darker it is while still daylight, the better), which lets you use long shutter speeds, and it's those longer shutter speeds that give the stream that wonderful silky-water effect. Try shooting in aperture priority mode, and set your aperture (f-stop) to f/22 (or a higher number if your lens has it). With this darker sky, f/22 will leave your shutter open long enough to give you that silky-water look. The shot above was taken on a drizzly afternoon where there was literally nothing else to shoot, and shooting at f/22 in the forest, under that dark, cloudy sky, left my shutter open for 13 seconds (in aperture priority mode, you pick the f-stop and then your camera will leave the shutter open for however long it takes to get the right exposure—in this case, I stood there in the gentle rain for 13 seconds. How do you like the way that phrase "gentle rain" made the experience sound? Actually, I was cold and wet, but cold, annoying rain just doesn't paint a pretty picture—but the camera sure captured one).

Don't Stop Shooting at Sunset

LOCATION: SAND HARBOR STATE PARK, LAKE TAHOE, NEVADA

More and more people have totally embraced the golden rule of landscape photography, which is to only shoot when that wonderful, magical light is available, and that only happens just before and during dawn, and just before and during sunset. However, a lot of folks pack up their gear just a few minutes after the sun has gone down, and the sad part is, they're about to miss what is often the most magical light of all. Around 20 to 30 minutes after sunset, sometimes the clouds turn bright orange, or deep red, or purple, or if you're lucky, a combination of all three, and some of my all-time best shots have been taken after everyone else has gone to dinner. Wait even longer (30 to 45 minutes or more after sunset), and the sky will often turn a vibrant, deep blue (not black, like the night—I'm talking blue—and it happens right before night). It only lasts for a few minutes (10 or 12 minutes usually), but what wonderful twilight photos you can get then. Try this blue twilight-hour shooting when you have a cityscape, or bridge, or other lit object in the background—it makes for a wonderful scene.

REMEMBER, YOUR CAMERA HAS SIMILAR SETTINGS

If I'm talking about white balance, and I'm showing the Canon white balance menu, but you're not shooting with a Canon, simply breathe deeply and say to yourself, "It's okay, my [insert your camera name here] also has a white balance setting and it works pretty much like this one." Remember, it's about choosing the right white balance, not exactly which buttons to push on your camera.

How to Shoot Fog

LOCATION: GREAT SMOKY MOUNTAINS NATIONAL PARK, TENNESSEE

I love the look of fog or mist in images. To me, it adds mystery and intrigue to the scene, but one unfortunate side effect is that it also is very hard for your camera's built-in light meter to read properly, so you get what you're seeing with your naked eye. Of course, like so many things, there's a trick of the trade that helps you get a good exposure that keeps that foggy look. Start by aiming at the fog itself, and then hold your shutter button halfway down (which tells your camera to take a reading of that area). Now, go to your camera's exposure compensation control and increase the amount of exposure by one stop (basically, what you're doing is disagreeing with what the camera read for the fog, and overriding it by increasing the exposure by one stop). On Nikon cameras, you do this by holding down the exposure compensation button on the top right of the camera (just behind the shutter button), and while you're holding that button down, turn the command dial on the top back of the camera to the right until you see +1 in your camera's viewfinder. On Canon cameras, you'll set the shooting mode to anything but manual, and then you'll spin the quick control dial (the big one on the back of the camera) to the right until you see +1 in the camera's viewfinder. Just one reminder: when you're done shooting your fog shots, set your exposure compensation back to zero, or you'll be shooting the rest of the day with every shot overexposed by one stop.

Getting Shots of Lightning (Manually)

©ISTOCKPHOTO/CLINT SPENCER

Shots of lightning can be very dramatic, because usually we only see lightning for a fraction of a second. If you can freeze that moment, it makes for a fascinating photo, but like many landscape shots, it requires a certain amount of timing (and luck). Now, before I share how to capture lightning with your camera, I want to make sure you don't capture lightning with your body. Don't stand in the rain, or under a tree, etc. Shoot from a very safe distance (because lightning will see you as a portable lightning rod) and exercise the same caution you would if you weren't a distracted photographer. Now, on to the technique. First, put your camera on a tripod (this is a must). Then, set your mode to bulb (the B setting on some cameras), which leaves the camera's shutter open for as long as you hold down the shutter button. Now, you can't actually press the button on your camera—for this to work properly you need to use either a shutter release cable (a cable that attaches to your camera with a shutter button you hold in your hand) or a wireless shutter release (you can find these for most camera makes and models at B&H Photo). The reason is: any minor vibration while your shutter is open, and the shot will be so blurry, it will be unusable. So, set up on a tripod, compose your shot (aim your camera in an area where you've been seeing lightning), use f/8 as a starting place, make sure your camera is set to bulb mode, then when you see a strike of lightning, press-and-hold the shutter release cable (or wireless) shutter button down and when you see a second strike, wait just a moment and then release the shutter button. It may take you a few tries at first, but you'll get it (hopefully the shot, not the lightning itself).

Getting Shots of Lightning (Automatically)

©ISTOCKPHOTO/CLINT SPENCER

If you try some lightning shots and fall in love with this type of photography, you might want to consider buying a Lightning Trigger (they're not cheap—so make sure you're truly "in love" first). This unit sits on your camera and it has a sensor that detects the bright flash of light from lightning, so it opens the shutter at exactly the right moment and gets the shot for you. In fact, you can pretty much set up your camera, set your camera to shutter priority mode (with your shutter speed anywhere from ⅛ to ¼ of a second), aim in the right direction, sit back with a cool drink, and wait for the magic to happen, knowing that your camera is doing all the hard work for you. Later, when you're showing off your amazing work, there is no obligation (from the manufacturer's point of view) for you to tell the people viewing your work that you used a Lightning Trigger. Hey, it's just another tool in your bag of tricks. Go to www.lightningtrigger.com for a model that works with most cameras (it runs around $329 direct from the manufacturer. Hey, I told you it wasn't cheap).

Where to Focus for Landscape Shots

LOCATION: LAKE LOUISE, BANFF NATIONAL PARK, ALBERTA, CANADA

When you're taking a landscape shot, where do you focus your camera's focal point (that red dot in the center of your viewfinder. Well, its default spot is in the center, but you can move that spot, so if you moved yours, get it back to the middle for this)? With landscape shots, the rule is: you want to focus about one-third of the way into the image. This gives you the widest possible range of focus throughout the image. Also, another trick you can use is to shoot big, sweeping landscape shots at f/22, which gives you the most focus from front to back in your shot.

GETTING THE CLEAREST LANDSCAPES POSSIBLE

Have you ever seen a landscape photo that just has incredible clarity throughout the image? I'm not talking about sharpness—I'm talking clarity (like a total lack of haze, or fog, or any other atmospheric effect). Well, there's a technique for getting that amazing clarity, and it's simple: shoot in winter. The air is the clearest during winter time, and it's the perfect time of year to get those amazingly clear shots that you just can't get any other time of year.

Find the Great Light First

LOCATION: SAND HARBOR STATE PARK, LAKE TAHOE, NEVADA

A few years ago, my friend, and landscape photography hero, Bill Fortney said something that really had an impact on my photography and I'm going to pass it on to you. Bill feels that the single most important thing in a shot of any kind is the quality of light, and that the quality of light is so important that he'll search for great light first, and then once he finds that great light, he'll find a subject—something or somebody to shoot in that wonderful light. Essentially, if the light is great, you'll find a subject, but if you've found a great subject, you have to be very, very lucky for great light to just magically appear. In short: "It's all about the light." Once you get that, everything else falls into place. It's deeper than it sounds.

How to Shoot on a Gray, Overcast Day

LOCATION: DINGLE PENINSULA, IRELAND

This one might sound kind of obvious when I say it, but I can't tell you how many times I've been out shooting with a group and one or more people in the group has come up and said, "Well, the sky is totally messing up our shoot today." While a gray sky definitely stinks, there is something you can employ for shooting on gray-sky days, and that is simply to compose so little (like the shot you see here) or literally none of that gray sky winds up in your shots. If you go into the shoot knowing that you're going to do your best to avoid seeing much of the sky in any of your shots, you can then get all of the benefits that a gray sky usually brings, which are colors that are actually fairly saturated and softer shadows throughout your images. You probably won't be able to fully eliminate the sky from your photos, so just compose your shots so the amount of sky you do see is kept to a minimum. This simple technique has saved many a landscape shoot.

A Trick for Great-Looking Flower Shots

Want a great quick trick for some interesting-looking flower shots? Get down low, and shoot the flowers so they're backlit, with the sun behind them. The sunlight shining through the translucent petals creates a beautiful effect, and this is a popular trick employed by serious flower shooters that works every time. Don't forget to get down low (so low that you're either shooting straight on or up at the flowers) to get the most from this effect.

The Full-Frame Camera Advantage

The vast majority of today's digital cameras have a built-in magnification factor because of the size of the sensors in the camera. For example, most Nikon cameras have a 1.4x magnification factor, and what that means is if you put a 100mm lens on a Nikon digital camera (like a D3200, D5200, or D7100), that 100mm lens becomes a 140mm lens because of the sensor's magnification factor. Most Canon cameras have a 1.6x magnification (like the Rebel T3i, Rebel T5i, 60D, 70D, and 7D), which makes a 200mm lens more like a 320mm lens. Many sports shooters, birders, and a host of other photographers who routinely use zoom and telephoto lenses love this added reach from digital sensors, but when it comes to the wide-angle lenses landscape photographers use, it can somewhat work against us. For example, a 12mm wide-angle Nikon lens becomes a less-wide 16mm lens. For Canon shooters, a 14mm wide-angle lens becomes a 22mm equivalent. That's why some land-scape photographers are drooling over the full-frame digital cameras, like Nikon's D4 or Canon's 6D (shown above), both of which are full-frame, and when you put a 12mm on the Nikon, it's that same, beautifully wide 12mm aspect ratio we used to enjoy back in the film days. When you put a 14mm on a Canon 6D, it's the same thing—a real 14mm with no extra magnification. I'm not saying you need to switch, or that you bought the wrong camera, I just want you to know what all the fuss is about for landscape photographers and other people who "go wide."

The Seven Deadly Sins of Landscape Photography

LOCATION: GLACIER NATIONAL PARK, MONTANA

Okay, in this chapter (and in part 1 of this book series), I've talked a lot about the things you need to do to make great landscape photos, but I haven't talked a whole lot about what to avoid when taking landscape shots. That's why in this new edition of the book I have included what I call "The Seven Deadly Sins of Landscape Photography," and one more I threw in just for good measure, but that last line isn't part of the official name because that would be really clunky. By the way, the shot you see above was taken in Glacier National Park in Montana (which is one of our largest national parks, spanning 1,013,322 acres) during a workshop I taught there with renowned landscape photographer Bill Fortney. Bill, who not coincidentally is one of but a handful of working photographers who happen to know the precise GPS location from which you can actually photograph this giant monolithic number seven (which soars more than 212 feet high at its peak), would be cringing right now if he read this because he would know that I obviously stuck that big seven there in Photoshop, after the fact (or he'd have a big seven in his shot, as well, which I'm pretty certain he does not). Nevertheless, this all makes a great (okay, decent) gateway to this new addition to the landscape chapter. If you can live your life avoiding these seven perilous pitfalls, your landscape shots will be blessed with the magical kiss of first morning light (not really, but they will certainly look a whole lot better).

Landscape Sin #1: Choppy Water

LOCATION: LAKE LOUISE, BANFF NATIONAL PARK, ALBERTA, CANADA

When we're shooting a lake or a cozy harbor, what we're looking for is that still, glassy water that creates a beautiful reflection. So, if you hike up to that beautiful lake with the snow-capped mountains off in the distance, but it's windy out that day and the lake looks more like the ocean…just keep walking. That's right, keep walking back to your car, drive back to your hotel, and try again the next morning at dawn. Dawn is your absolute best chance for having calm, still water (by mid-morning it's usually too late), and it's worth getting up early for (not to mention the quality of the light), because choppy water is instant death to lake and harbor shots. By the way, that telephone pole lookin' log there on the left isn't helping this photo much either.

Landscape Sin #2: Frozen Water in Waterfalls

LOCATION: NEAR HILO, ISLAND OF HAWAII, HAWAII

For a pro look to your stream and waterfall shots, you're looking for that smooth, silky water—the silkier, the better—and that means you have to keep your shutter open for a long time (the longer it's open, the smoother your water will be. See page 115). We're talking 30 seconds to 2 minutes here, and if you're snapping stream or waterfall photos in broad daylight, your shutter speed is going to be around $1/1000$ of a second at the minimum, but more likely $1/2000$ of a second or higher. This means two things: (1) frozen water, and (2) an amateurish looking shot. Don't let this happen to you.

Landscape Sin #3: Bald, Cloudless Skies

LOCATION: GREAT SMOKY MOUNTAINS NATIONAL PARK, TENNESSEE

Most people find clouds beautiful (I sure do), but when it comes to landscape photography, they're not just there to be pretty. They are there to hold the amazing colors of a sunrise or sunset, and without clouds, you get…well…pretty much what you see here—a whole lotta nuthin'. Now, picture this same shot with just an amazing sky of really interesting clouds that are red, pink, and purple. Then, look back at this one. See what I mean? So, even though you did the right thing by getting up early for the great light, and you got in place and were ready to shoot before dawn, and you were on a sturdy tripod, with a cable release, and you had a wide-angle lens on your camera, and you were at f/22, and you were at the top of a really cool ridge of mountains, if the clouds don't show, you won't look like a pro. Mother Nature is totally in charge of this one, and sometimes she delivers a spectacular cloud formation that makes you look like a star because all you have to do is literally press the shutter button, and sometimes she gives you squat! She's finicky that way.

Landscape Sin #4: Harsh, Midday Sun

LOCATION: DOUBLE ARCH, ARCHES NATIONAL PARK, UTAH

This shot really has it all. Sure, it has that trademark harsh, dried-out, awful, soul-sapping, direct midday sun look to it (even though it was actually shot around 10:20 a.m., so the light will actually get worse as the day goes on). But, it also has some bonus features, like an ugly dead tree, a bald, cloudless sky, and junk coming into the frame from the edges. (I ought to win some sort of bad light award for this one.) So, if you look around and the light on your landscape looks anything like this, you know one thing: you're in the wrong place at the wrong time. You should be at breakfast, back in your hotel taking a nap, feeding a gopher the contents of your purse, whittling a scale model of the U.S. Capitol building out of a dead tree branch, anything other than actually taking a photo. This light was designed to punish nature and the efforts of anyone who holds up a camera and aims it at any landscape.

Landscape Sin #5: A Crooked Horizon Line

LOCATION: CADILLAC MOUNTAIN, ACADIA NATIONAL PARK, MAINE

If there is one thing that drives people crazy when they look at a photo, it's a crooked horizon line. What's even worse, a lot of times people looking at an image with a crooked horizon line will tell you there's "just something about it that doesn't feel right," even if they don't realize the problem is the horizon line (it's easy to get distracted by beautiful colors and cool clouds, but the viewer will still perceive that something is wrong with the image, even if they can't articulate exactly what it is). Since just about every post-processing program out there has some sort of built-in straightening, there's no excuse for having a crooked horizon line. Hey, while we're here, although these clouds aren't spectacular or epic by any means, imagine this same shot without them, and instead you have a bald, empty sky. Really makes a difference, doesn't it?

Landscape Sin #6: Distracting Junk Near Edge

LOCATION: BIG SUR, CALIFORNIA

This one is particularly deadly because it's so easy to miss. When I teach landscape photo workshops, we do a class critique of shots from the participants in the workshop (the person who took the image always remains anonymous during the critique, unless we all really love the shot, then they usually stand up and shout, "Hey, I took that!"). Anyway, one thing that always stands out as a spoiler of some otherwise great images is that the image has a distracting element (also known as "distracting junk") in the photo. It can be a road sign, some seaweed on the beach, an empty beer can, some telephone wires, or quite often it's a tree branch extending into the photo. I've always felt that if it doesn't add to the photo, it takes away from it. There are three different ways you can deal with this "junk" that creeps into your photos: (1) Compose around it. When you're shooting, be very aware of what's in your shot, especially around the edges (we actually refer to this act of checking the outside edges of your frame as "border patrol"). Check all four sides of the frame (top, left side, right side, and bottom) for anything that you'll wish later wasn't there, and if you see something, change your composition to eliminate it. (2) Physically remove the distracting element (as long as you're not a photojournalist). If there's a beer can, a twig, some trash, etc., pick it up and move it out of the frame (be careful not to damage anything in nature—period!). Or, (3) remove it later in Photoshop or Lightroom, using the Healing Brush tool, the Patch tool, the Clone Stamp tool, or the Spot Removal tool. I've done a quick video clip for readers of this book to show you how to use these tools, and you can watch it at **http://kelbytraining.com/books/digphotogv2**.

Landscape Sin #7: No Foreground Object

LOCATION: LAKE LOUISE, BANFF NATIONAL PARK, ALBERTA, CANADA

If your shot doesn't have a strong foreground element, it's pretty much sunk. That's because one of the basics of landscape composition is that for a landscape shot to really work, it has to have three things: (1) something strong in the foreground, (2) an obvious middle ground, and (3) the background. This one has two out of three. It has a middle ground (the lake and the mountain). It has a background (the sky behind the mountains, although some might argue that the mountain and the sky are background elements, but it doesn't really matter because neither one of those is the problem here). What's missing is the strong foreground element, which is why this image looks so flat. If there were some large rocks at the bottom of the frame, or the tip of a canoe, or the shore, or a dock, or anything to show the depth of the image and lead the viewer into it, this shot would then have all three elements. It's kind of like a novel. If you skip the first few chapters and then jump in and start reading, you'll be missing key parts of the book, and you won't enjoy it nearly as much. You'll know you're missing something. Landscape photos are the same way—you shouldn't jump-in in the middle of the photo (or, in this case, the middle of the lake). You should start in the foreground and lead the viewer's eye throughout to the background. It's what gives landscape photos real depth and that big, epic feel. Don't start your photo in the middle of the lake, or the middle of the ocean, or in a flat, open desert. Find some object to include in the foreground and your composition will be much stronger.

And...Dead Trees and Tree Stumps...And...

LOCATION: MAUI, HAWAII

Okay, I said there were just seven, but since I had this extra page, I thought I'd add a couple more in. They're not nearly as deadly, but still worth avoiding like a festering boil. I'm just going to rapid-fire these off: Dead trees and tree stumps. I'm begging you, stop trying to make a good picture of these. And, no, converting your image to black and white won't help. There are beautiful living things found all over in nature. Stop shooting dead ones. Next, don't have out-of-focus things in your foreground. Not tree branches, or railroad crossing signs, or a big blurry rock. It's distracting to the viewer, who is programmed to try to focus on whatever is closest to them. Also, stop shooting really boring stuff just because you're standing in front of it. If you're looking at a scene and you realize that there's no chance anyone is going to look at the photo you're about to take and say, "Wow!" then here's what you do: move someplace else. It's like Joe McNally says, "If you want to take more interesting photos, stand in front of more interesting things." If you're standing in front of those ugly dead trees above, keep moving. Here's another: if you see a flat gray sky, avoid it like the plague. Another is if you're processing an HDR shot, or if you're adding tonal effects with a plug-in, keep this in mind: Clouds aren't black. They also don't have drop shadows or glows around them. Although you see incredibly vibrant colors in nature, don't make them all appear in your photo at once. Go easy on the saturation. Okay, now ya know, so there are no excuses for breaking the "Seven Deadly Sins."

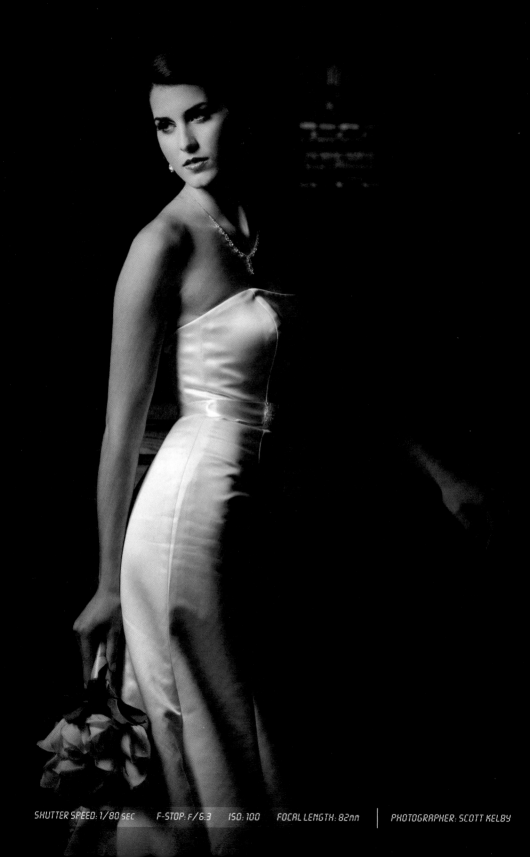

SHUTTER SPEED: 1/80 SEC F-STOP: F/6.3 ISO: 100 FOCAL LENGTH: 82mm PHOTOGRAPHER: SCOTT KELBY

Chapter Five
Shooting Weddings Like a Pro
How to Get Professional Results from Your Next Shoot

Shooting a wedding is tricky business, and if you have friends (and they know you have a nice camera), it's only a matter of time before you're standing in a church yelling things like, "Okay, next I need the groom's grandmother and grandfather." Once you've said that line aloud in a church, you are officially ordained as a temporary wedding photographer. Now, just because you took the gig for free, as a favor to that guy you know over in accounting, don't think for a minute that the bride is expecting anything less than absolute pro-quality images. Worse yet, the nicer gear you have, the better they expect those images to be, and if, up until this day, you've been a sports shooter or a landscape photographer, all that goes out the window, because today you are a wedding photographer, which is arguably the single hardest photography job in the known world. The reason is simple: there is no reshoot. This particular wedding, the one you are responsible for shooting, only happens once. There is no, "Oh, my camera broke" or "I didn't bring enough memory cards" or "I forgot my charger for my flash," because if the bride hears anything even approaching one of those excuses, she will take her bare hands and squeeze your neck until either your lifeless body falls to the floor like a wet bag of cement, or a pack of AAA alkaline batteries pops out of you like a Pez dispenser. That's because regardless of whether you're getting paid or not, she has waited, dreamed about, meticulously planned, agonized over, and micro-managed this special day to death, and if you miss any one of those critical moments (the ring, kissing the bride, walking down the aisle as man and wife for the first time, cutting the cake, the first dance, etc.), then it's time for you to die. That's why this chapter is all about one thing: increasing your life expectancy.

Create a Shot List

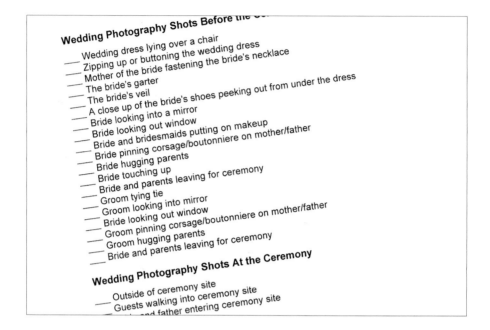

Before you even leave your office to head to the wedding, you should put together a shot list of photos you'll need to take for the wedding album, prints, etc. There are no redos at weddings, so you'd better be sure you leave with a list in hand of which shots you need, from bride and groom formals, to detail shots (the invitations, the rings, the bouquet, the bride's shoes, etc.), to reception shots like cutting the cake, receiving lines, place cards, and more. Without a written shot list, you're winging it, and it's almost an absolute lock that you'll miss one or more critical shots that your clients (the bride and groom) are going to expect to be in their album, so don't take a chance—this little bit of preparation can make a world of difference. Luckily, you can find wedding photography shot lists online for free at places like http://bit.ly/aboutshotlist or this article and shot list from Amazon.com at http://bit.ly/amazonshotlist (actually, there are literally hundreds of different shot lists available for downloading—just Google "wedding shot list" and you'll have a wide range of choices). Find a shot list that makes sense to you, and although you can get creative and do far beyond what it suggests, at least you'll have the most critical shots covered. Also, make sure you talk to the bride and groom before you finalize your shot list to ensure the specific shots they want are included (they may want shots with old friends from high school or college, or a special relative, and the only way to find out about these is to talk with the bride and groom in advance).

Have Backups for Everything!

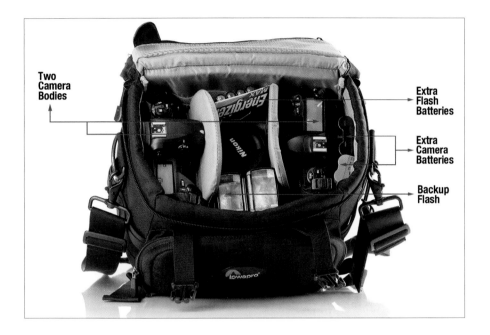

Two Camera Bodies

Extra Flash Batteries

Extra Camera Batteries

Backup Flash

If anything can go wrong at the wedding you're shooting, it will. That's why the pros always take backups for everything, because there are no retakes, no redos, no "do overs." Go through each piece of your gear and ask yourself what you would do if it wound up missing or broke. I can tell you this, at the very minimum you need to have two camera bodies—one main and one backup (a friend of mine was shooting a wedding, his camera slipped out of his hands, and the shoot was over. He was lucky enough to have a friend race him a replacement camera, but if his friend wasn't available, or was shooting a wedding himself that day, or was at the movies, etc., he probably would have ended up in court). You also need backup batteries for your flash, and even a backup flash unit. You need extra memory cards and a backup lens (I recently saw a photographer pick up his camera bag, which he thought was zipped, and we all cringed at the sound of breaking glass). Also, don't forget to bring backup batteries for both of your cameras. It comes down to this: you don't want to put yourself in a situation where one piece of equipment fails, one piece gets dropped, or your battery dies, and your job is in jeopardy (not to mention the loss of future wedding gigs from the fallout of having a large public event like a wedding day shoot go belly up).

Silencing Your Camera's Beep

The last thing the wedding couple (or the clergy, or the guests) wants to hear during the ceremony is the distracting sound of your camera beeping as it locks focus. Before the wedding begins, go to your camera's menu and disable the audible beep sound. From that point on, use the focus symbol that appears in your camera's viewfinder to let you know when the autofocus has locked on. Once the ceremony is over, you can always switch back.

Backlighting Your Bride

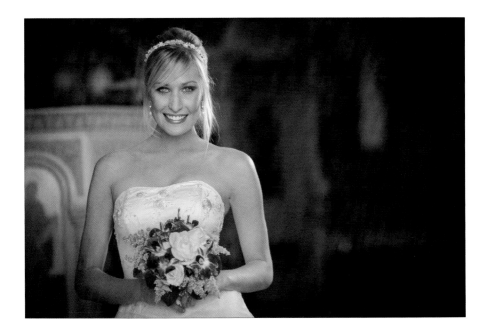

A popular effect with wedding photographers is to backlight the bride—where a bright light rims the outline of the bride—and then add in just a little bit of flash to light the front of the bride, so she's not a silhouette (as shown above). This takes two flash units: one in front of the bride (in this case, I used an off-camera flash on a light stand, positioned to the left of the camera at a 45° angle), and a second flash on a light stand behind the bride (here, it was behind and to the right, just out of the frame). The flash of light from the front flash triggers the second flash behind the bride. The key is to make sure the flash behind the bride is much brighter than the flash in front of the bride (in the shot above, I lowered the power of the front flash as low as I could, but kept it bright enough so it would still trigger the flash behind her. It took a couple of test flashes to find out just how low that front flash could go). Another nice look (which is very dramatic) is to go ahead and let her just be lit with a flash behind her, then turn the flash in front off, so she actually is mostly a silhouette. If you do this, you'll have to set your front flash so it doesn't fire the full flash, but only a very low light pulse—just enough to trigger the wireless flash behind her, but so it doesn't throw any measurable light on the bride (Nikon's DSLRs with pop-up flash have this feature built in).

Don't Changes Lenses, Change Cameras

Once a wedding starts, things happen very quickly and you're not going to have a lot of chances (read as: none) to change lenses. So, if you're shooting with your zoom lens, and you suddenly need to switch to a wide angle, take a tip from professional sports shooters and don't switch lenses—switch camera bodies instead. That's right—keep two camera bodies around your neck (or one around your neck, one in your hand), and put a wide-angle lens on one body, and a zoom lens on the other. That way, switching lenses takes two seconds, not two minutes, and because of that, now you "get the shot."

ANOTHER TWO-CAMERA STRATEGY

Besides the zoom and wide-angle double-camera technique above, here's another one to consider: have one camera with a flash mounted on your hot shoe for when you need flash, and have your second camera with a really fast lens, like a 50mm f/1.8 or f/1.4 (see page 145) for when you can't use flash (or don't want to use it), so you can capture those intimate moments without being obtrusive.

Bring a Stepladder for a Higher Vantage Point

At weddings, you're going to be posing and shooting large groups (for your formals), and one trick the pros use is to carry a small, lightweight, collapsible aluminum ladder, like the Conair Travel Smart LadderKart, which doubles as a hand truck to help you move your gear (when you're not standing on it). It holds up to 300 lbs., and sells for around $61, but I've found other similar ladders online, as well. Being able to shoot the formal group portraits from a higher angle is a big help, because it enables you to see more faces and arrange your groups more easily. Also, it's great for shots during the reception, where a higher angle gives you a better view of the bride and groom on the crowded dance floor. Actually, you can put it to use anytime you want a different perspective, plus you can even use it as a posing stool in a pinch. You'll find this to be an indispensable tool (even if you only wind up using it for lugging your gear).

Why You Want a Second Shooter

Many pro wedding photographers bring a second shooter to their jobs (sometimes even a third shooter) as an insurance policy to make sure they cover all the most important shots, and the bigger the wedding, the more you need a second shooter. After all, you can't be everywhere, and if any little thing goes wrong (equipmentwise or otherwise), there's someone else to either keep shooting, or to deal with the problem so you can keep shooting. This second shooter also usually acts as an assistant, and in the fast pace of a wedding, they can be an absolute lifesaver. But, beyond that, the second shooter may (will) have a different style than you and can bring a different dimension (they can shoot zoom while you're shooting wide), a different camera angle, they can shoot from a different location in the church and reception hall, plus there's a good chance that if you missed "the shot," your second shooter will have gotten it (or vice versa).

When to Shoot in RAW

Although many wedding photographers choose to shoot exclusively in JPEG mode, when you get in a tricky lighting situation, your Get Out of Jail Free card is to switch to RAW mode. Here's why: when you shoot in JPEG mode, the white balance you set in the camera is embedded into the file. If you set it wrong (which can happen in tricky lighting situations), you've got a color correction nightmare. However, when you shoot in RAW mode, you have the option of changing the white balance to any one of the same white balance settings you could have chosen in the camera itself. Best of all, once you've fixed the white balance for one photo, you can apply that change to all the other images at once. If you use Adobe Photoshop, here's how: (1) Select all the RAW photos you want to adjust and open them in Photoshop's Camera Raw (it will open all your selected photos at once). (2) Choose the White Balance setting from the pop-up menu. (3) Click the Select All button at the top left. (4) Click the Synchronize button, and when the dialog appears, choose White Balance from the pop-up menu at the top, then click OK. Now the white balance you chose for the current RAW photo will be applied to all your other open RAW photos. If you use Adobe Lightroom, select the photos you want to adjust, then go to the Develop module and choose your new white balance. Click the Copy button on the bottom left. When the dialog appears, click the Check None button, turn on just the checkbox for White Balance, then click Copy. Now click the Paste button to paste that white balance setting to all your other selected photos. Also, if you want the best of both worlds, set your camera to Raw + JPEG, which captures a RAW image and a JPEG version at the same time.

Where to Aim Your Flash

Another one of the tricks the pros use to get just that little extra bit of light into their wedding photos (even ones taken in daylight) is to aim their flash head straight upward (as shown here). This works best if you're not standing too far from your subjects, and even if there's no ceiling to bounce the light from the flash off of, it still sends that little bit of light forward to light the face. This helps in adding catch lights in the eyes, but it does it without creating that "too much flash" look. To help make sure those catch lights appear, pull up your flash's bounce card to help direct more of that straight-up light forward (you can see the white bounce card pulled up in the photo above). So, if you've got a nice white ceiling to let the light from your flash bounce off of—great (but keep that bounce card extended either way). If not, still keep that flash aimed straight up most of the time, especially if there's already some existing room light, as the light from your flash will be subtle enough to nicely blend in.

Shoot in Lower Light Without Raising Your ISO

Since you'll be shooting on a regular basis in the low lighting of a church, there's a tool many of the top pros use that lets them get away with shooting perfectly exposed, sharp, handheld shots without using flash, or without pumping their ISO up to 1200. They buy an inexpensive 50mm f/1.8 lens (right around $100), or better yet, a 50mm f/1.4 lens (like the one shown above, which goes for around $469). These super-fast lenses let you shoot handheld in really low light, and you won't find a wedding pro that has one who doesn't swear by it. They're lightweight, surprisingly crisp (considering their low cost), and another tool in your bag of tricks to make sure you get the most important shots.

CHARGE EVERYTHING THE DAY BEFORE THE WEDDING

The day before the wedding, make sure you charge everything—including your cameras (both bodies). Make sure you have fresh batteries in all your flash units. If you're taking your laptop, make sure its batteries are charged. And just make certain that if a piece of your equipment has a battery, it's a fresh battery, or a freshly charged battery. Also, it's not a bad idea to fill your car up with gas now, too.

A Recipe for Balanced Flash in Church

When you're shooting the formals in the church (before or after the ceremony), here is a recipe you can use to get a natural-looking light balance between your flash and the available light in the church: set your ISO to 800, set your shutter speed to $\frac{1}{60}$ of a second, and set your f-stop to f/5.6, or a lower number if possible (like f/4, f/3.5, or even f/2.8). By using a relatively low shutter speed like $\frac{1}{60}$ of a second, it's a slow enough speed that your camera can properly expose the background (you see it lit with the available light in the room), and then your flash comes in to freeze the action. Once you've got those two settings in place, now all you have to do is take a test shot with your flash, and if it over-powers the room light (the background looks black), then lower the brightness (power) of your flash unit, so although your subject will be mostly lit with flash, you'll still see some of the natural light in the church. This gives a nice balance between the natural light (which should be around 30% to 35% of the light in the photo) and your flash (which should be 65% to 70% of the light).

Compose to Include the Church

This is one of many tricks I learned from my friend, and wedding photography guru, David Ziser (a master wedding photographer and brilliant teacher): compose a decent number of the formal bride and groom portraits to include a lot of the interior of the church (as shown above). It's important to brides to see the church where the ceremony took place, and by composing it into the formals, it really gives the shots a sense of place (after all, if you compose them so tight that you don't see the church, you might as well have taken them the day before in the studio).

DON'T FORGET YOUR BUSINESS CARDS

There is no better place to book new business than at the wedding you're shooting, and if you seem calm, in control, and confident, you may get inquiries right there on the spot (before your prospective client has even seen a single image). They assume if you got this gig, you must be good, so make sure you have some extra business cards on you. Writing your number on a napkin doesn't instill confidence.

Tip for Posing the Bride

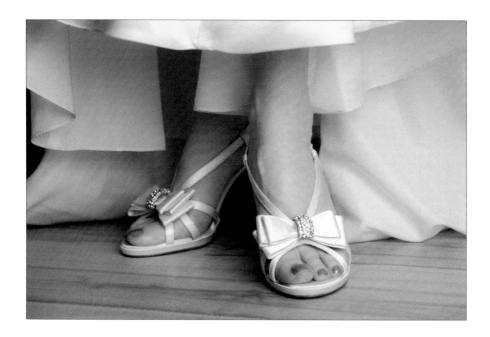

Another tip I picked up from David Ziser is a posing tip for formal shots of the bride that lowers the shoulder that's farthest from your light source, which creates a flattering diagonal line between her shoulders. To do this, have the bride stand with her feet in a staggered V-shape (as shown above), and then have her shift her weight to her back foot, which creates a much more dynamic look for your pose.

Keeping Detail in the Bridal Gown

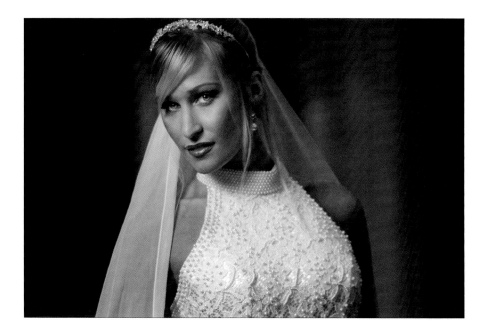

Since most bridal gowns are white, we have to be careful how we position the bride when shooting the formal bridal portraits, so we don't blow out the highlights on the gown and lose all the important detail of the dress (and that detail is very important to the bride). David Ziser taught me a great trick that works every time for keeping this critical detail, and it has to do with how you position the bride. You want the light from your flash (or from a window, if you're using window light) to cross the dress (so it accentuates the shadows and brings out detail), not hit it straight on and blow everything out. The easiest way to do this is simply to position your bride so her shoulder that is closest to the light source is angled toward the light source. That's it. This is important because if the shoulder closest to the light isn't in front, the flash hits the gown straight on and you lose the shadows and the detail. So, just make sure to angle the bride so her shoulder that's closest to the light is angled toward the light (as shown here, where you can see by looking at the bride, the flash is to the left of my camera, because she's much brighter on that side. The shoulder closest to the camera is aiming toward the light). Easy enough.

Getting More Flashes Per Wedding

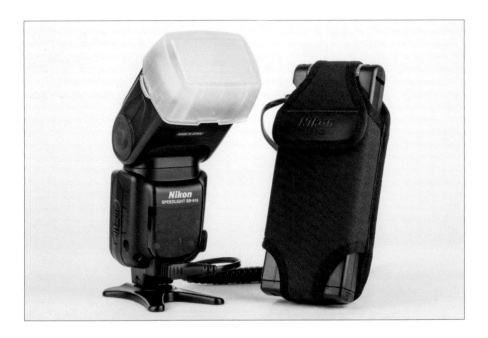

Your flash is going to get a workout at a wedding, and you're going to be stopping to pop in fresh batteries on a pretty regular basis. Batteries must sense fear, because they always seem to die during absolutely critical moments in the wedding, so you want to be changing batteries as little as possible. (Plus, as your batteries start to wear down, it starts to take longer and longer for your flash to recycle so it's ready to fire again.) That's why many pros use a small external battery pack to double how long they can shoot with flash before having to change batteries. Better yet, it greatly cuts the recycle time between flashes. These packs are a little larger than a deck of cards, and run on six or eight AA batteries (depending on the model). You just connect the pack's cable to your flash, pop the pack into your shirt or suit pocket, and fire away. If you don't have a battery pack and your battery's getting low, try shooting at a higher ISO—it cuts the flash output and extends your battery life considerably.

Scott's Gear Finder

Canon Compact Battery Pack CP-E4 (around $150)

Nikon SD-9 High Performance Battery Pack (around $200)

Quantum Slim & Compact Turbo Battery Packs (around $350 and up)

How to Lessen Noise in Your Photos

When you raise the ISO on your camera (so you can shoot in lower light), there is a trade-off, and that is you increase the amount of noise (grain) in your shots. Depending on the make and model of your camera, this noise might be acceptable or it might be so visible that it kind of ruins the shot. If you have Photoshop CS5 or later or Lightroom 3 or later, they all have excellent built-in noise reduction (I used to have to use a plug-in for reducing noise, but not anymore). Here's what you do: Just open your noisy image in Camera Raw (or Lightroom's Develop module) and zoom in really tight, so you can see the noise (usually lurking in the shadows). Click on the Detail icon (panel) to get to the Noise Reduction controls, and then just use the Color slider to remove the color noise (those red, green, and blue color spots) and the Luminance slider to remove the luminance noise (those grainy-looking gray spots).

A TIP FOR OUTDOOR WEDDINGS

If you go a day early to scope out the location where you'll be shooting an outdoor wedding, make sure you're there at the exact same time of day that you'll be actually shooting the wedding. That way, you can see what the real lighting conditions will be when you're shooting the "real thing."

Tips for Shooting the Bride's Profile

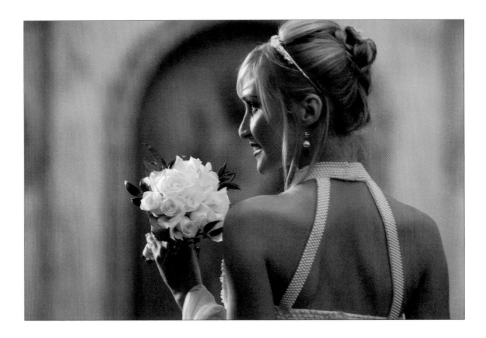

Here are a few more tips I picked up from David Ziser for making perfect profile portraits of your bride: (1) Shoot horizontal. As I mentioned in the portrait chapter, this puts some breathing room in front of your subject, so they don't look squeezed into the frame. (2) Position the bride so it's a full profile shot, where you don't see any of the eye on the other side of her head, or any of the other side of her face at all. (3) Don't position your flash (or softbox) directly in front of her face—position it slightly behind her so the light wraps around her face. (4) Don't have her look straight ahead, or you'll see too much of the whites of her eyes. Instead, have her look just a tiny bit back toward the camera (don't let her move her head—just her eyes). That way, you see more iris and less whites. (5) If the shadow side of her face (the side facing the camera) gets too dark, use a silver reflector to bounce some of that light into that dark side of her face.

GET TO THE CHURCH EARLY AND SCOPE EVERYTHING OUT

The last thing you want during the wedding shoot is to frantically search for good light, good backgrounds to shoot in front of, or a power outlet to plug in your charger. Get there crazy early (or go a day before the wedding, if possible) and scope everything out in advance. That way, you're calm, prepared, and you have some great spots already picked out so the couple looks their best.

Wedding Zoom Effect Made Easy

Here's a popular effect for adding a sense of motion and energy to your reception shots (perfect for dance floor shots). It's a zoom effect that you create using your flash and zoom lens, and it's easier to get than it looks. First, set your camera to manual mode, and lower your shutter speed to around ⅛ of a second (or slower). Then, zoom in tight on the couple dancing, press the shutter button with your right hand, and then immediately zoom the lens out all the way to wide angle with your other hand. Because the shutter is open while you're moving the zoom lens, it creates that motion effect, and then your flash fires to freeze the motion. The key is to zoom out to wide just as soon as you press that shutter button. Try this just a few times and you'll "get it." (That's another benefit of digital photography—you can try the trick and look at the LCD on the back of your camera to see if you got the zoom effect or not. If you didn't, you can just try again.)

THROW SOME SNACKS IN YOUR CAMERA BAG

While everybody else is eating, you're expected to be shooting, so make sure you throw a few small snacks (energy bars are ideal) and some bottled water in with your gear. Even if the bride and groom have offered to feed you while you're there, you probably won't get a chance (once a reception starts, there's no break—too much is happening), so keep some snacks and water handy.

Add B&W to the Album

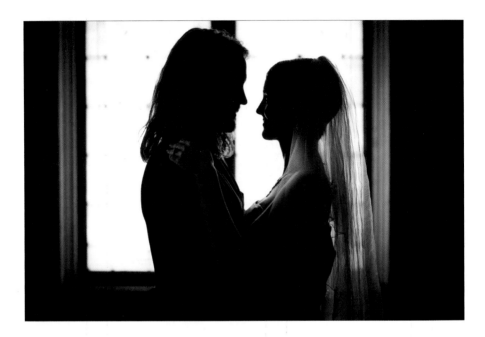

Another popular element in today's wedding albums is to include a number of black-and-white images. You'll still shoot these in color, and then you'll use Adobe Photoshop to convert some of your images into black and white. This enhances the "photojournalistic" look of the wedding album, it adds contrast to the album, and many wedding photos look just wonderful in black and white. If you have Photoshop or Lightroom, there is a black-and-white conversion tool that you can use to convert your color image into black and white (and it comes with some built-in presets—you just have to choose one you like). If you have Photoshop Elements, it can do the job, as well. While I do use Photoshop for converting images into black and white from time to time, most of the time I use Nik Software's Silver Efex Pro 2 black-and-white plug-in. Almost all the pros I know use it as well, and it's absolutely brilliant (and super-easy to use. You can download a free 15-day trial copy from www.niksoftware.com and see for yourself). I've created a short video clip to show you how to convert from color to black and white—you can find it on this book's download site at **http://kelbytraining.com/books/digphotogv2**.

Read David Ziser's *Digital ProTalk* Blog Daily

If you're serious about this stuff, do what I do: read David Ziser's *Digital ProTalk* blog every day. He is an absolute fountain of information for professional wedding photographers, and on his blog, he not only shares his tricks of the trade and hard-earned techniques, he also shares some of his amazing photography (including some wonderful non-wedding imagery). Plus, David does a lot of live speaking gigs, and if you ever get to see him in person, he will just blow you away. David speaks for me each year at the Photoshop World Conference & Expo, and the first time I sat in on his class (which was an on-location wedding shoot at a local church, complete with professional bride and groom models), I was amazed. When I came back to the conference hall, one of my buddies asked me how his workshop was, and I described it this way: "He was teaching more than just lighting and posing. He was teaching them the business of today's wedding photography, in such a meaningful and straight-to-the-point way that it was like he was running around stuffing money in their pockets. It was that good!" I find his blog as inspirational as it is informative. Check it out at www.digitalprotalk.com. Also, David wrote what many consider to be the Bible on wedding photography—it's called *Captured by the Light* (shown above). I worked with David on this book and I think he did just a wonderful job sharing his techniques and photography.

SHUTTER SPEED: 5 SEC F-STOP: F/4.8 ISO: 200 FOCAL LENGTH: 68mm PHOTOGRAPHER: SCOTT KELBY

Chapter Six

Shooting Travel Like a Pro

How to Bring Back Photos That Really Make Them Wish They Were There

 When you come home from a really amazing trip, it's not enough to chronicle your trip through photos and show factual images that detail where you were. You want to move people. You want to create images that are so powerful that they make the person viewing them want to go there so badly that they're willing to risk a series of white collar crimes (mostly embezzling) to pay for their trip to that very same place. Now, if you took good enough shots, it won't be long before your friends are overcome with emotion (jealousy) and will have to go to the exact same location to experience that same amazing feeling once again. Now, if either of your two friends have DSLR cameras, it's helpful to understand right up front that they're not going to that spot because they trust your judgment on travel. They're going there because they think they can get better photos from that spot than you did. Then, once they come back and show off their images, all your mutual friends will say something like, "Did you see Rick's photos from Machu Picchu? Wow, his were much better than Sandy's" and at that moment—you've been blinged. Actually, this is what is known as an IB, or an "Intentional Bling," and it gives you some insight into just how shallow your friends really are. But as shallow as they are, you can drain a little more water out of the pond by pulling this quick and easy stunt: when they see a really cool travel shot of yours, and they ask you where you took it (which means they don't already recognize the landmark)—lie. They'll never know. For example, if you shot the Portland Head lighthouse in Cape Elizabeth, Maine, tell 'em it's the Nauset lighthouse in North Eastham, Massachusetts. By the time they catch on, they'll already be back home, and you can feign a mysterious illness.

In This Case, Less Gear Is More

I'm a total gear freak, but the one time I definitely don't want to lug around a lot of gear is when I'm doing travel photography. You're going to be lugging your gear all day long, hopping on and off of all sorts of transportation, and as the day goes on, your gear seems to get heavier and bulkier, and by the end of the day, you've all but stopped digging around in your camera bag. To get around that, take as little with you as possible—one or two lenses, tops. For example, for crop sensor cameras, Nikon and Canon make reasonably priced 18–200mm lenses, and Sony makes an 18–250mm lens, that let you leave your camera bag back in the hotel because you've got everything covered from wide angle to long telephoto in just one lens. For full-frame cameras, if you want the same type of range, Nikon, Canon, and Tamron make 28–300mm lenses that don't go quite as wide as the 18–200mm, but are amazingly small and lightweight. Also, there are some incredibly lightweight travel tripods available today, ranging from the Slik Sprint Pro II for around $90, to the Oben CT-3500 for around $350, to what is probably the best travel tripod on the planet, the Gitzo GT1542T Traveler carbon-fiber tripod (for around $680). When it comes to lugging around lots of gear in an unfamiliar city, travel photography is definitely a case of "less is more." Do yourself a favor and travel light—you'll find yourself taking more shots, because you're changing lenses and messing with your equipment less.

Working People into Your Travel Shots

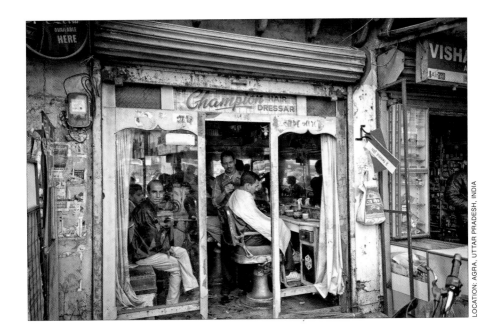

LOCATION: AGRA, UTTAR PRADESH, INDIA

If you want to improve your travel photos, here's a simple trick: add more people to your shots. When you really want to capture the flavor of an area, don't just shoot buildings, cathedrals, and monuments—show the people of that area. Nothing conveys the character and soul of a city more than its people, and that's why so many of the top travel photo pros work people into the majority of their shots. The next time you're feeling disappointed with your travel shots, it's probably because you're looking at cold buildings and empty streets. Add people and everything changes (for the better).

Getting People to Pose

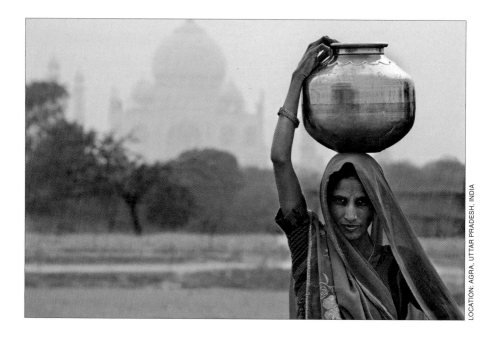

LOCATION: AGRA, UTTAR PRADESH, INDIA

Candid shots of some of the locals make a nice addition to your travel shots, but if you have too many of them, they start to look less like travel photos and more like surveillance photos. To get those close-up, fascinating personal shots, you'll need to get some of the locals to pose for you. One of the best tricks for getting people to stop what they're doing and pose for you is to get them to let you take the first shot. When they see that I have a camera, I smile at them, hold up the camera with my finger on the shutter, and nod my head as if to say, "Is it okay if I take your picture?" Most of the time, they smile and nod back, and pause just long enough to let me snap one photo. Then I immediately turn the camera around and show them the photo on the camera's LCD monitor. Once they see that photo on your LCD, it kind of breaks down a barrier, because everybody loves a photo (especially if they're the subject), and they're usually more than happy to pose for a few more.

A SUREFIRE WAY TO GET THEM TO POSE (BUY STUFF)

If you're uncomfortable with the "lift-and-nod" technique I outlined above, here's one that can't miss—find somebody selling something and buy one. If you're in a market, and you buy something from a vendor, you can bet that they'll pose for a quick picture or two, because now you're not just some tourist with a camera, you're one of their customers. This one works like a charm.

What to Shoot on Overcast Days

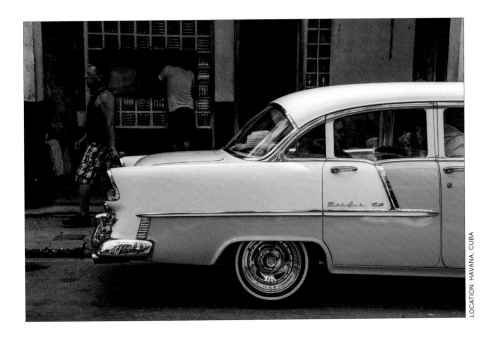

LOCATION: HAVANA, CUBA

When the weather gets cloudy and overcast, don't pack up your gear—this is the time to shoot people on the street, open-air markets, stained glass windows (which look great under cloudy skies), and close-ups of architecture (as long as you do your best to avoid including any of that gray, cloudy sky). Cobblestone streets are great to shoot right after it has rained, and flowers photograph great under the shade that comes from a cloudy sky. Plus, if the sky gets really nasty, it may be a great time to shoot the sky itself. If it's just a flat gray, it's boring. But if a storm is on the way, the dark clouds can make an interesting subject, or add to a boring subject just with the shadows and mystery they bring.

WHAT TO DO IF YOUR ROOM DOESN'T HAVE A VIEW

If you can't get a room with a view (see next page), try these: (1) See if there's a restaurant or lounge at the top of the hotel—you can bet it has plenty of great views, and they may let you shoot there at dusk, before they start serving dinner. (2) See if you can take a few shots from the rooftop. Strike up a rapport with the concierge (give him a big tip) and you'll be amazed at the doors that will open.

Shooting from Your Hotel Room

Everybody wants to have a "room with a view," and now you have even more motivation to ask for just that, because your hotel room can be a wonderful platform to shoot the city from. When you check in, ask for a room on the highest available floor and be prepared for some amazing opportunities to unfold right outside your window. If you don't have a balcony, or a window you can open, you can shoot right through the window if you follow these three rules: (1) Turn off any lights in your hotel room—they'll cause reflections in the glass that can show up in your photos—and (2) put your lens as close to the glass as possible (I keep a lens hood on my lenses, so I put the lens hood right on the glass itself. If you think you'll be doing this a lot, you can buy a rubber lens hood, which runs from around $5 on up). And, (3) you can often use a polarizing filter to cut the reflections in the glass, but since you lose some light, you might need to shoot on a tripod, which makes getting right against the glass that much trickier. (I'm not even going to count this last one as a rule, because I hope it goes without saying, but…don't use your flash.)

The Magic Time for Cityscapes

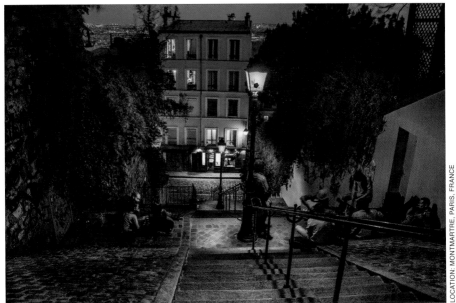

LOCATION: MONTMARTRE, PARIS, FRANCE

Great shots of cityscapes don't happen at 2:00 in the afternoon. If you want that killer shot of the city skyline, wait until about 30 minutes after sunset and shoot at twilight. The sky will usually be a rich, dark blue and the lights of the city will all be on, creating that magical photographic combination that creates the type of cityscapes you've always dreamed of taking. Now that you know what time to shoot, there's one more key to making this type of shot work, and that is you absolutely, positively must take this type of low-light shot with a tripod. Your shutter is going to have to stay open for a full second or more, and if you're not on a tripod, you're going to wind up with a blurry mess.

TAKING THE CITYSCAPE LIGHTS SHOT UP A NOTCH

If the city you're shooting is near water, try to position yourself so that water comes between you and the city (for example, try shooting from a bridge). That way, you see reflections of the city lights in the water, which can add a tremendous amount of visual interest. This is another one of those "can't miss" travel shots, and what an impact it makes when friends, family, and even other photographers see your city-at-twilight-reflected-in-the-water shot.

Get These Shots Out of the Way First

LOCATION: PIAZZA DEI MIRACOLI, PISA, ITALY

If you travel to a famous city, your friends and family back home will be expecting shots of that city's most famous landmarks. For example, if you go to Italy, you'd better come back with a photo of the Leaning Tower of Pisa or the Colosseum in Rome. If you go to Paris, you'd better come back with some Eiffel Tower shots (cliché as they may seem), because people expect it. If you don't come back with some Colosseum or Eiffel Tower shots, they'll be so distracted by what you didn't shoot that they won't pay attention to what you did shoot. So, get those out of the way first—shoot those for the folks back home now and get them "in the bag." That way, you can spend the rest of your time showing the city your way—shooting the people, the local flavor, the customs, and taking shots that speak to the photographer in you. One more thing: When you get back home, and friends and relatives tell you some of your shots look like postcards (and they will), just smile and thank them. Although photographers sometimes tend to look down on travel postcards, your average person doesn't, so if they tell you your shots "look like postcards," they're actually paying you a huge compliment.

One Landscape Rule Kinda Applies to Travel

LOCATION: ROSS CASTLE, KILLARNEY NATIONAL PARK, COUNTY KERRY, IRELAND

In Chapter 4 (the landscapes chapter), I talked about how important it is that you only shoot landscape photos twice a day—around dawn and around dusk—but landscape photos are all about having great light. Luckily for travel photography, we can pretty much shoot all day and night (look for tips about what to shoot during different times of the day here in this chapter). However, if we apply part of that landscapes rule to our travel photography, we'll have the opportunity to make travel photos that are truly spectacular, because just like landscapes look best in soft, beautiful dawn or dusk light, so do famous landscapes, monuments, cityscapes, castles, and charming old buildings. That doesn't mean we can only shoot travel at dawn or dusk (far from it), but if you really want to create some magical images, get up way before the tour bus arrives at your hotel and get some shots of the city in beautiful first-morning light. Or, plan your day so you'll have time after the bus tour to get in position in front of a beautiful landscape, or church, or monument (etc.), so you're in place at sunset to capture a shot that will make your photography friends back home totally jealous when they see it. Remember, beautiful light pretty much makes everything beautiful, so if you thought that fountain or majestic tower looked fascinating in the dry, harsh light of midday, imagine it wrapped in beautiful morning or evening light. Try it once—it'll make a believer out of you.

Air Travel with Camera Gear

Earlier, I mentioned that you want to travel with as little gear as possible, and here's another reason—you absolutely, positively want to bring your gear on the plane as a carry-on. If your camera bag is too big and bulky, there's a good chance it won't fit in the overhead bin, especially if at some point in your trip you wind up in a smaller regional jet or turboprop with little, if any, overhead space. If you're thinking of buying a hard case and checking your gear, I'd reconsider. A photographer I know once got *all* his checked gear stolen—lenses, camera bodies, flashes, the works! When he arrived at his destination and opened his case, it was completely empty. Keep your gear down to a minimum, take a small camera bag, and take it with you on the plane as a carry-on, and you'll avoid a lot of stress and complications, and possibly having to replace all of your gear. The camera bag shown above is the Airport International from Think Tank Photo. It's the best camera bag I've ever used.

BRING EXTRA BATTERIES

When you're in an unfamiliar city, the last thing you want to waste your time doing is searching for batteries (believe me, I learned this one the hard way), so make sure one thing you do bring with you is plenty of extra batteries for your flash unit and your camera (at the very least, recharge your camera battery every single night, because if your battery runs out, that's the end of the shoot).

Shoot the Food

Take a look at any great travel magazine and in every feature about a charming city, you'll always find a photo of its food. Trying new dishes is one of the most fun things about traveling to a new destination, so why wouldn't you include it in your photographs? Watch the expressions of people who look at your album when they come across a photo of a great-looking dish—do that once, and you'll always "shoot the food." Your best opportunities will be during the day, especially if you ask to sit near a window (to catch some of that gorgeous natural window light) or outside (preferably under an umbrella or awning, so you can shoot in shade). If you've got a white tablecloth (which is likely), you've got a great background to shoot on—just remove distracting items from around the dish as much as possible. Also, the classic food shots you see in these magazines generally have two things in common: (1) They generally use a very shallow depth of field (where the front of the plate is in focus and the back is somewhat out of focus). To get this effect, use the lowest f-stop possible (f/4, f/2.8, or even lower if you can). And, (2) shoot plates that have great presentation (in other words, shoot food that's beautifully arranged on the plate, which usually comes from higher-end restaurants). Desserts often are presented nicely, as are appetizers and sushi, and keep an eye out for anything served in a unique-looking dish.

Get a GPS for Your Digital Camera

Today, you can buy small, incredibly lightweight GPS units that sit in your camera's hot shoe or attach directly to your camera's 10-pin terminal, and each time you take a photo, they embed the exact location (longitude and latitude) of where the shot was taken directly into the digital photo itself. Then, applications like Lightroom can display that information (it appears in Lightroom's Metadata panel), and you're then one click away from seeing that location plotted on a Google map, and better yet, you can even see a satellite photo of that exact location while you're there. I use Dawn Technology's tiny GPS unit called the di-GPS that works with most digital cameras. They start around $150.

HAVE SOMEONE ELSE SHOOT YOU

If you're the one behind the camera, nobody's getting any shots of you in these fascinating, exotic, wonderful places. That's why you need to make it a point to get a friend or acquaintance you meet in your travels (even if it winds up being the waiter who serves you at a restaurant) to get at least a few shots of you. Although it might not mean much to you that you're not in any of your photos, it does mean something to your family and friends that you are in the shots.

Shooting Where They Don't Allow Flash

If you plan on shooting in museums, cathedrals, and other places that generally don't allow you to set up a tripod or use your flash, then I recommend buying an inexpensive 50mm f/1.8 lens. This is an old trick pro wedding photographers use (see the wedding photography chapter), and these super-fast lenses let in so much light that you can handhold shots where others dare not tread. Both the Nikon and Canon 50mm f/1.8 lenses sell for around $110–125 each, they take up little room in your camera bag, and they add very little weight to your bag, as well. If you can spring for an even faster lens (like an f/1.4, shown above, or an f/1.2), they let in an amazing amount of light, so you can fire away in incredibly low light (like candlelight situations) without having to raise your camera's ISO to 800 or more (which can greatly increase the amount of noise in your images).

WHEN THEY WON'T LET YOU SET UP YOUR TRIPOD

If you're in a place where they just won't let you set up your tripod, but the light is so low that your camera is going to leave the shutter open for a few seconds, try using your camera bag as a tripod. Turn your camera bag on its side, position it on a ledge, a counter, or any tall surface, then rest your camera on top. Put some spare batteries under the lens to support it and use the self-timer to take the shot.

Look for High Vantage Points

LOCATION: VENICE, ITALY

Your average person's view of a city is going to be from the city streets (or from a tour bus on those streets), so if you want a more compelling place to shoot from, look for a different vantage point—one above the city. Look for towers, observation decks, tall hotels, church towers, cable cars, a bridge, an office building, or mountains overlooking the city, where you can show the city from a completely different view that your average photographer wouldn't get. It's just another thing that keeps your travel photos from looking average.

THE PERFECT BACKGROUND MUSIC FOR TRAVEL SLIDE SHOWS

Want to find the perfect background music to put behind slides from your trip? Try this: buy the movie soundtrack from a movie that was filmed where you took your shots. For example, if your shots are from your trip to Italy, you can be sure you'll find instrumental background music that sounds very Italian in the movie *Under the Tuscan Sun*. If you shot in Paris, try the soundtrack from Disney's *Ratatouille*. If you shot in Russia, you can get some very dramatic Russian-sounding background music from the movie *The Sum of All Fears*. These all work so well because most movie scores are instrumental, which is ideal for your travel slide shows.

Give Yourself a Theme

THE DOORWAYS OF KENNEBUNKPORT

Once you've shot the classic local landmark photos, here is a great way to spark your creativity and show the city in a different light for a day: give yourself a mini-assignment. Pick a topic, spend part of the day focusing on that subject, and you'll be amazed at what you can come up with. For example, some of the mini–travel assignments I have given myself are: (1) shoot charming street numbers on the outsides of buildings, homes, and apartments; (2) shoot interesting doors and/or doorways; (3) shoot just things that are one vivid color; (4) shoot weather vanes; (5) shoot nothing but flowers; (6) shoot charming local barns; and (7) shoot close-ups of local architecture. Other ideas might be: shooting coffee cups; shooting those little food signs in local markets; shooting interesting columns, traffic signs or street signs, mailboxes, or things that are a particular shape (like only things that are round), or things of a particular color (only things that are red). You don't have to make one of these the only thing you do all day, just keep an eye out for it during your travels, and each time you see one of your assignment objects, make sure you get it. Then, you can present these all together in one print (an example is shown above).

Chapter Seven
Shooting Macro Like a Pro
How to Take Really Captivating Close-Up Photos

If you're one of those people who believes life is all about the little details, then have I got a style of shooting for you. It's called macro photography (macro is actually an acronym that stands for Man, Are Cows Really Obnoxious), and it's based on a special type of lens called a macro or close-up lens, which lets you focus on objects much closer than you'd normally be able to, and because of this close-up capability, you can often get close enough so that your subject completely fills your frame. Some of the most popular subjects for macro-loving photographers to shoot are flowers, leaves, ladybugs on leaves, bees on flowers, and other everyday things in nature that we're not used to seeing close up. That's one of the things that makes macro photography so captivating: you're often seeing images at a view or magnification we rarely, if ever, see with the naked eye. Now, because I was just able to work the word "naked" into the book, it's almost guaranteed that the book will be a bestseller. That's because, from now on, anytime someone goes to the web and searches for the word "naked" (so basically, most of my friends), one of the results they get back will be this book. Now, thinking that my book will have lots of nudie nakedness, these people will often buy it sight unseen, because apparently people who search for the word "naked" are also very loose with money—they'll buy any product that they feel will get them closer to actually seeing nudie nakedness. However, once they receive the book, they will soon realize, as you have (with great disappointment), that there is no nudie nakedness in the book, but if it makes you feel any better, I'm totally naked under my underwear (see that? I got the word "underwear" in now, too). Cha-ching!

Maximize Your Depth of Field

Macro lenses have a "sweet spot" where you get absolutely the most sharp results, and in macro photography, having tack-sharp images is critical. One trick to get the most sharpness out of your macro lens is to shoot with your lens aiming perfectly straight at the subject (in other words, don't angle your lens upward or downward toward your subject—try to shoot straight on for the best sharpness and clarity). So, for example, if you're shooting a bee on a flower, you'll need to lower your tripod to the point where you are aiming directly at the flower without having to tilt the lens, even a little bit (as shown above).

THIS IS TRIPOD TERRITORY

Although there are now macro lenses that have built-in image stabilization (IS) or vibration reduction (VR), if you're serious about macro, you're going to be serious about how sharp your images are, which means you seriously need a tripod. This is absolutely tripod-land for sure, and a tripod may well be the single most important piece of your "making great macro shots" puzzle, so although you can cut a lot of corners in other areas, shooting on a tripod is one thing you absolutely, positively should do. They haven't yet come up with a built-in stabilization device that holds a camera as steady as even the cheapest tripod.

Why You Should Turn Autofocus Off

By now, you've learned that one of the big challenges of macro photography is getting things sharp and in focus. You're about to come to one of the things that can be the most frustrating, and this is using autofocus when you're as close in on your subject as you are with macro shooting. If I can give you one tip that will lower your frustration level by a hundred, it's to turn off the autofocus on your camera's lens and manually focus instead. I know, you hate to give up the autofocus feature because, honestly, on today's cameras it's really amazingly accurate. That is, until you shoot macro. What will happen is your camera will try to find a focus point, and you'll hear the whirring of the lens as it tries to snap onto something, anything to focus on, and while it's getting frustrated—so are you. Just switch over to manual focus, and you'll both be better off.

Don't Touch That Shutter Button!

If you're going through the trouble of putting your camera on a tripod (and you absolutely should), you can still get a "less-than-tack-sharp" photo from the vibration that happens when you push the shutter button. That's why, when shooting macro, you should either use a shutter release cable (a cord that attaches to your camera that lets you take a shot without touching the shutter button on the camera itself) or use your camera's self-timer, which takes the shot for you about 10 seconds after you press the shutter button, so any vibration caused by your pressing the shutter button will be long gone.

FOCUS ON THE EYES

In portrait photography, we always focus on the eyes to get the sharpest image. Same thing in wildlife photos. Same thing in macro shots of insects or butterflies, or any little critters that wind up in your viewfinder.

Which f-Stop Works Best

Is there an f-stop that works best for macro shots? Well, yeah. It's f/22. Because the depth of field of macro lenses is so shallow (meaning, the front of that flower you're shooting can be perfectly in focus and the petal just one inch behind it can be totally out of focus), you need to get as broad a depth as possible, and that comes when your aperture setting is at something like f/22. You could get away with f/16, or maybe even f/11, but to get the maximum amount of your subject in focus, try f/22 (or higher if your lens will allow). The higher the number, the more of your photo will be in focus.

Point-and-Shoot Macro Photography

Most compact point-and-shoot cameras these days actually have a macro lens built right into them—you just have to know how to engage it (so to speak). You do that by switching your mode to macro (its icon is usually a little flower). This sets up your camera so you can get very close to your subject (like a flower, an insect, etc.) and still focus the camera (you can't get as close as you would with a dedicated macro lens on a DSLR, but you still can get surprisingly close for a compact digital camera). Once you've got this mode turned on, you can shoot using all the rest of the rules in this chapter, like shooting on a tripod, not shooting in even light wind, etc.

A Trick for Visualizing Macro

©ISTOCKPHOTO/NAIVE

When you're out shooting and you're looking at something and thinking, "I wonder if that would make a good macro shot?" you don't have to pull out all your gear and test it (especially because you probably won't). Instead, just carry a small magnifying glass (you can get thin plastic ones that fit in right in your wallet), then pull it out, go up to the object you're thinking about shooting, and you'll see right then and there whether it makes a good macro subject. Also, you can use this magnifier to try out different angles (think shooting flowers from way down low) before you go crawling around on your stomach with all your gear.

SIMPLE BACKGROUNDS ARE BEST

The same background rule we follow in portrait photography is also true in macro photography, and that is: keep the background simple. It may even be more important with macro than with portraits, because you're in so close your background will play a bigger role, so make sure your background is as simple as possible.

Why You Might Want to Shoot Indoors

A lot of nature macro photography is actually done indoors, rather than outside (in most cases, you're going to be so close in, you don't have to worry much about anyone realizing that you're in a studio). One of the main advantages of shooting macro indoors is that there's no wind. This might not seem like a big deal at first, but when you set up your camera with a macro lens outdoors and look through the lens, you'll see firsthand that the tiniest bit of wind—wind that you don't really even notice is there—is moving your flower (leaf, twig, etc.) all over your frame, which means your photos are going to be soft and out of focus. It'll really throw you, because you'll back away from the lens, and you'll swear there's no wind, but then you'll look through the viewfinder and know right away—you're hosed. Another advantage of shooting indoors is that you can control the light (especially if you're shooting under studio strobes), and the key to lighting macro shots is to have nice even lighting across the entire image. You don't want drama and shadows—you want nice even light, and getting that in the studio is easier than it is outdoors by a long shot.

Buying a Macro Lens

If this macro thing sounds really interesting, there are three ways you can dip your toe into the close-up shooting world: (1) Check to see if you already have a telephoto or zoom lens that has macro capability built right in. (2) Buy a macro lens—both Canon and Nikon make great macro lenses (that's a Nikon lens above), and you can get a Sigma 105mm macro lens for around $769. Or, (3) add a close-up lens attachment to one of your existing lenses. These screw on the end of your lens and turn any zoom lens into a macro lens (I have one of these, and it's small enough and lightweight enough that it goes with me everywhere I go). When it comes to macro lenses, the higher number the lens, the closer your subject will be in the frame (so a 65mm macro lens might get you the entire bee, but a 105mm will get so close you can get just the bee's head).

CREATE YOUR OWN WATER DROPS

Use a tip from part 1 of this book, and that is: don't wait for rain—bring a water bottle on your shoot and spray water on your flower petals (or leaves) to create the look of fresh raindrops, which look great in macro photography. Plus, if you get close enough, you'll be able to see reflections in the water drops themselves. Cool stuff.

Perfect, Even Light for Macro Shots

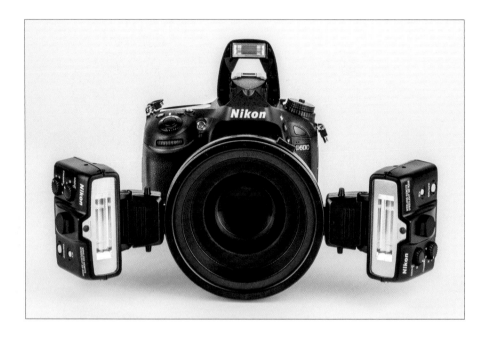

When it comes to lighting close-up shots, your goal is to get as even lighting as possible, and there's actually a special flash, called a ring flash, that's designed to do exactly that. It's actually not one flash, it's a series of flashes attached to a ring that slides over your lens, and because these flashes light your subject from all sides, it creates that very even light you're looking for.

Scott's Gear Finder

Sigma EM-140 DG Macro Flash (around $379)

Canon MR-14EX Macro Ring Lite (around $549)

Nikon R1C1 Wireless Close-Up Speedlight Flash w/SU-800 (around $719)

Making Your Lens into a Macro Lens

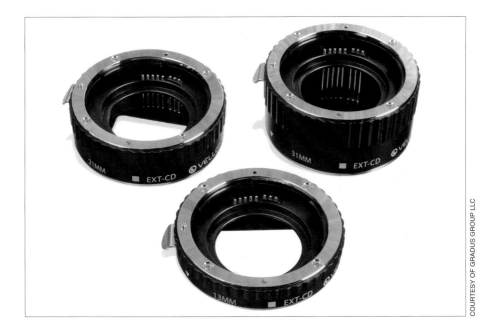

COURTESY OF GRADUS GROUP LLC

The more space you put between your camera's sensor and your lens, the closer you'll be able to focus, and because of that, companies make extension tubes. These extension tubes attach between your lens and your camera (they look like a thin extra lens) to move the lens farther away from your camera's sensor, which cuts your minimum focus distance big time, so you can get in there and shoot nice and close (like you had a true macro lens). The advantage of these extension tubes is: they're much less expensive than a dedicated macro lens, starting around $83. (By the way, if you have a macro lens already, an extension tube can make your macro focus even closer. Sweet!)

SHUTTER SPEED: 1/4000 SEC F-STOP: F/2.8 ISO: 200 FOCAL LENGTH: 300mm PHOTOGRAPHER: SCOTT KELBY

Chapter Eight
Pro Tips for Getting Better Photos
Tricks of the Trade for Making All Your Shots Look Better

 There are some tricks of the trade that just don't fit under any of the existing chapters, because they're not really just about getting better-looking portraits or more luscious-looking landscapes—they're about being a better photographer and getting better shots. And getting better shots is what it's all about, right? This is something we're all very passionate about, and if we get to the point where we're actually starting to sell our work (maybe as fine art prints, or through assignment work with a magazine), and are turning our passion into profits, then we're really living the dream—doing something we truly love for a living. Speaking of dreams, I haven't made a big deal about this on my daily blog (http://scottkelby.com) or in any of my live classes yet, because I don't want it to come off like bragging, but I recently signed a year-long contract with *National Geographic* that I'm pretty psyched about. In the terms of this agreement, I get 12 monthly issues for only $15, which is 74% off the newsstand price, so as you might imagine, I'm very excited. Anyway, in this chapter, we're going to focus on lots of those little tricks of the trade that you can apply to a wide range of photography to make everything you shoot look that much better. Now, one last thing: You might have heard I run with a dangerous crowd. We ain't too pretty, we ain't too proud. We might be laughing a bit too loud, but that never hurt no one. (I just wanted to see if you're still reading this after that whole *National Geographic* scam I pulled on you above. Come on, you have to admit, I had you going there for just a second or two, didn't I?)

Which Mode to Shoot In

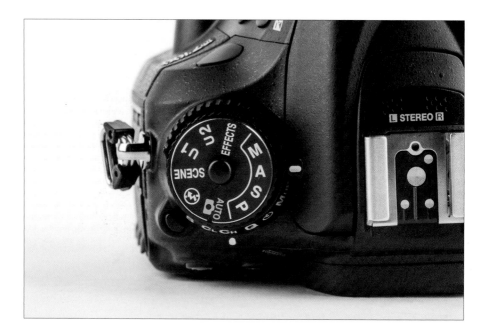

Not sure which mode you should be shooting in? Here are some tips:

Aperture Priority (A or Av): I recommend this mode for both portrait photographers and landscape photographers, because it gives you control over your background. You get to choose whether you want your background out of focus (by choosing lower numbered f-stops, like f/4 or f/2.8) or totally in focus (by choosing higher f-stop numbers, like f/11, f/16, and higher), and no matter your choice, your camera will automatically choose the right shutter speed to give you a good exposure.

Shutter Priority (S or Tv): I recommend this mode if you're shooting sports, where you generally need to freeze the action. This lets you choose to shoot with very high shutter speeds (provided you're shooting in bright enough light—like daylight), and then your camera will automatically choose the right f-stop for you to give you a good exposure.

Manual (M): If you're shooting with studio strobes, you need to shoot in manual mode, because in aperture priority or shutter priority, you won't get a proper exposure, as they won't take into account the fact that you're using strobes.

Program (P): Shoot in this mode when you want to be in point-and-shoot mode, but don't want the flash popping up. Perfect for when you need to quickly capture a moment and don't want to mess with any settings.

Choosing the Right ISO

Our goal is to shoot with our digital cameras set to the lowest possible ISO (ideally 100 ISO) for one simple reason—it offers the lowest amount of noise (grain) and gives us the sharpest, cleanest images possible. The only reason to raise your ISO is to be able to handhold your camera in low-light situations. So, for regular daylight or brightly lit situations, we shoot at 100 ISO. If you raise your camera's ISO setting to 200, it lets you handhold your camera in a little lower light and still get a sharp photo, but the trade-off is a tiny increase in visible noise. At 400 ISO, you can handhold in even lower light, but with more visible noise. At 800 ISO, you can handhold in the low light of a church, but with even more noise, and so on. It comes down to this: the higher the ISO, the lower light you can handhold your camera in, but the higher the ISO, the more noise you get, too. That's why we try to use tripods as much as possible. When our camera is on a tripod, it's perfectly still, so we can shoot at 100 ISO the whole time without worrying about getting blurry photos in low light.

Which Format to Shoot In (RAW, JPEG, or TIFF)

Most digital cameras these days (and all DSLRs) offer at least these three main file formats: RAW, JPEG, and TIFF. Here's when to use each:

JPEG: Shoot in JPEG if you're really good at nailing your exposure every time. If you're dead on (or really close) on your exposure and white balance, and don't think you'll need to tweak it much later (or at all) in Photoshop, then JPEG is for you. The file sizes are dramatically smaller, so you'll fit more on your memory card, and they'll take up less space on your computer.

RAW: Shoot in RAW mode if you don't nail the exposure and white balance most of the time, and think you might need to tweak your images later in Photoshop or Photoshop Lightroom. In RAW mode, you can control every aspect of the processing of your images, so if the image is underexposed, overexposed, or has a color problem—you can fix it easily. RAW offers the highest-quality original image, too, and offers maximum flexibility.

TIFF: Shoot in TIFF if you're loose with money. This is a great format for people who have money to burn, people who shoot to huge 32-GB memory cards and have plenty of 'em handy. TIFFs are also perfect for anyone who has lots of spare hard drive space and lots of spare time, because TIFF files are huge to deal with. Outside of that, I can't think of any really compelling (or remotely reasonable) reason to shoot in TIFF format.

Which JPEG Size to Shoot In

I recommend shooting at the largest size and highest quality setting that your camera will allow, so if you're shooting in JPEG format, make sure you choose JPEG Fine and a size of Large, so you get the best-quality JPEG image possible. If you choose a lower size, or JPEG Norm (normal), you're literally throwing away quality. The only trade-off is that JPEG Fine photos are a little larger in file size. Not staggeringly larger (those are TIFFs or RAW files)—they're a little larger—but the increase in quality is worth it. If you're serious about getting better-looking photos (and if you bought this book, you are), then set your image size to Large and your JPEG quality to Fine, and you'll be shooting the exact same format many of today's top pros swear by.

WHIMS Will Keep You Out of Trouble

Let's say you're going out shooting landscapes one morning. Do you know what your camera's settings are? They're whatever they were the last time you went shooting. So, if your last shoot was at night, chances are your ISO is set very high, and your white balance is set to whatever you used last. I've gotten burned by this so many times that I had to come up with an acronym to help me remember to check the critical settings on my camera, so I don't mess up an entire shoot (I spent a whole morning in Monument Valley, Utah, shooting at 1600 ISO because I had been shooting a local band the night before). The acronym is WHIMS, which stands for:

W: White balance check

H: Highlight warning turned on

I: ISO check (make sure you're using the right ISO for your surroundings)

M: Mode check (make sure you're in aperture priority, program, or manual mode)

S: Size (check to make sure your image size and quality are set correctly)

Before you take your first shot that day, take 30 seconds and check your WHIMS, and you won't wind up shooting important shots with your camera set to JPEG small (like I did when shooting one day in Taos, New Mexico).

How to Lock Focus

This is another one of those things that has snuck by a lot of people, and that is how to lock your focus. For example, let's say you're lying down, shooting a landscape through some tall grass, and you want the blades of grass in front of you to remain in focus, but when you lift the camera up to get the rest of the scene, the camera refocuses on the background. You can force the camera to keep its focus locked onto those blades of grass by simply holding the shutter button down halfway. While that shutter button is held down, your focus is locked, so now you can recompose the image without your camera trying to refocus on something else. I use this a lot on photos of people who may not be in the center of the frame (it keeps me from having to move the autofocus dot— I just point at the person, hold the shutter button halfway down to lock the focus, then recompose the shot the way I want it. When it looks good, I just press the shutter button down the rest of the way to take the shot).

Moving Your Point of Focus

You know how you look through your viewfinder and, in the center of your viewfinder, there's a red circle or a red rectangle? That's your camera's autofocus (AF) point, and what that point hits winds up being what's in focus. Well, something a lot of people don't realize is that most cameras let you move that focus point up or down, left or right. That way, if you've composed a shot where your subject is standing over to the left side of your frame, you can move the AF point over, right on them, so they wind up being perfectly in focus. On Canon cameras, you move your AF point by using the tiny multi-controller joystick or the dial on the back of the camera. On Nikon cameras, you move the AF point by using the multi-selector on the back of the camera.

Zooming in Close? Fast Shutter Speeds Help

If you're using a long zoom lens, like a 200mm lens, there's something you should know to help you make sure you get sharp photos, and that is: the closer in you zoom, the more any tiny little movement of your lens is exaggerated. So, if you're handholding your camera, and you're shooting zoomed in to 200mm, any little movement on your part and you're going to have some blurry photos. Now, if it's a bright sunny day, you'll probably be shooting at some very fast shutter speeds, which will pretty much neutralize your movement, so you can sidestep that problem. However, if you're shooting in the shade, or really in anything where your shutter speed falls below 1/250 of a second, the best remedy is to put your camera on a tripod (even though it's during the day) or raise your camera's ISO enough to raise your shutter speed to at least 1/250 of a second. That way, you can shoot out at 200mm all day long and not worry about some tiny movement on your part causing a serious loss of sharpness in your shots.

When It's Okay to Erase Your Memory Card

If you only have one memory card, it won't be long before you have to erase that memory card so you can get back to shooting. I have a pretty simple rule I use to know when it's actually okay to erase a memory card, and that is I erase it when I know I have two backup copies of the images that are on it. In other words, I have one set that I copied onto my computer, and then I copied that folder of images over to an external hard drive, so I have two copies. Then, and only then, I feel comfortable erasing that card and shooting again. Remember, when you have just one copy, you're working on the negatives. If your computer's hard drive crashes, those images are gone. Forever. That's why you gotta make a second backup copy, because I've seen people lose their work again and again, year after year, because they didn't make that second backup copy, but don't let that happen to you—back up twice, then erase that card!

DON'T JUST DELETE YOUR PHOTOS, REFORMAT THE CARD

You've probably heard horror stories of people who have done an entire shoot, only to have the memory card go bad and they lose all their shots (if you haven't heard this story, I've got dozens). Anyway, one thing you can do to avoid problems is to not just delete the images on the card (once you've backed up twice), but to format the card in the camera, which erases all the files in the process. Yes, it's that important.

Why You Need to Get in Really Close

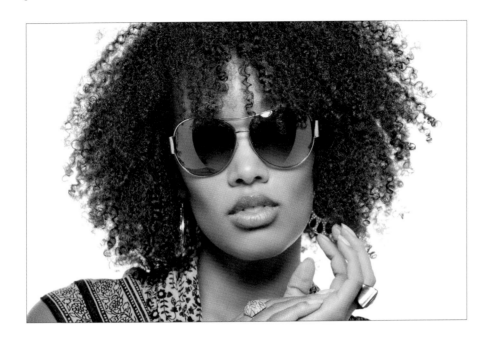

This is probably the single simplest tip in the whole book, and the one that has the potential to make your photography the best, but it's also the one people will resist the most. The tip is: move in close to your subject. Really close. Way closer than you'd think. If you search the Internet, you'll find dozens of references and quotes about how much you can improve your photography by simply getting in closer to your subject. You'll find the famous quote (I'm not sure who it's attributed to) that says (I'm paraphrasing here), "Get your shot set up to where you think you're close enough—then take two steps closer." Or my favorite quote, which I think really sums it up nicely, from famous photographer Robert Capa, who once said, "If your pictures aren't good enough, you're not close enough." The pros know this, practice this, have embraced it, and have passed it on to their students for who knows how long, and yet your average photographer still tries to get "the big picture." Don't be an average photographer, who gets average shots. Take two steps closer, and you'll be two steps closer to better-looking photos.

What to Use Your Histogram For

Today's DSLRs can display a histogram (which is a graphical reading of the tonal range of your photo) right there on the camera's LCD monitor, but if you don't know how to read one (or didn't know it's there), it doesn't do you much good. I only use my camera's histogram for one thing, and that's to make sure I haven't clipped off any important detail in my highlights. So, what am I looking for when I look at my histogram? Two things: (1) I don't want to see the histogram's graph touch the far right wall. If any of that graph hits the far right wall, I'm losing detail. So, what I'm really hoping to see is (2) a small gap between the end of the histogram and that far right wall (as shown above). If I see that gap, I know I'm okay, and that I'm not clipping any highlights. I can look at my histogram and immediately see if this has happened, and if I have clipped off important highlight information, I will generally use the exposure compensation control on my camera to override what my camera read, and lower the exposure by ⅓ of a stop, then I take the shot again and check my histogram. If I'm still clipping, I lower the exposure compensation to –0.7 and then shoot again, and check again. I keep doing that until my clipping problem goes away. Now, the histogram can only help so much, because what if there's a direct shot of the sun in my photo? That sun will clip big time, and there will be no gap, but that's okay, because the surface of the sun doesn't have any important detail (well, at least as far as I know). So the histogram can help, but it's not the bottom line—you still have to make the call if the area that's clipping is (here's the key phrase) important detail, so don't get hung up on histograms—at the end of the day, you have to make the call, and the histogram is just a helper, not your master.

Leave Your Lens Cap Off

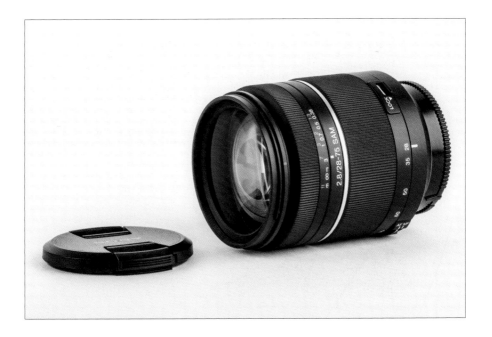

My buddy Vinny calls your lens cap "The Never Ready Cap," because whenever that magical once-in-a-lifetime moment happens while you're out shooting, don't worry—it will be long gone by the time you stop and take your lens cap off. I definitely recommend putting your lens cap on when you're storing your gear back in your camera bag, but if your camera is out of that bag, your lens cap needs to be off your camera. If you're worried about scratching your lens, then buy a lens hood (or use the lens hood that came with your lens), but keep that cap off once that camera comes out of your bag.

Removing Spots and Specks After the Fact

If you have a dust spot, smudge, or speck on either your lens or your camera's sensor, you're going to see that spot (or smudge or speck) again and again once you open your photos in Photoshop (or Lightroom, or Elements, etc.). If you want a quick way to get rid of that junk, try Photoshop's (or Elements') Spot Healing Brush tool. All you do is choose it from the Toolbox, then click it once over any spot or speck, and it's gone. That's all there is to it. Now, if you have Photoshop, you can fix a bunch of spots all at once (because, after all, if you have a spot on your lens, every shot from your shoot will have that same spot in that exact same location, right?). So, here's what you do: STEP ONE: Select all the photos that are in the same orientation (for example, select all your horizontal shots) and open them in Adobe Camera Raw. STEP TWO: Get Camera Raw's Spot Removal tool (from the toolbar up top) and click it once right over the spot. This removes that spot from your current photo. STEP THREE: Press the Select All button (on the top left) to select all your other photos, then click the Synchronize button. STEP FOUR: When the dialog appears, from the Synchronize pop-up menu up top, choose Spot Removal, and then click OK. This removes that spot from all your other selected photos automatically. Click Done to save your retouch. STEP FIVE: Open all the photos you took with a tall orientation and do the same thing. Now, all your spots are gone from all your photos in less than two minutes. If you shot 300 or 400 photos—that's sayin' something!

What Looks Good in Black & White

Some subjects just look great when you convert them from color to black and white, so when you're out shooting, keep an eye out for anything with lots of texture, like the peeling paint on the side of an old building, rusty old machinery, anything with an interesting shape or lots of contrast (because you don't have the crutch of color, you have to look for other things to lead the eye), objects with a lot of metal, old barns, old cars, old abandoned factories, and also consider cloudy days with dark menacing skies a perfect subject for black and white. In fact, any gray nasty day can wind up being a field day for black and white because you don't have to worry about avoiding the sky since it's not a nice, blue, sunny day. In black and white—it's all gray.

Recompose, Don't "Fix It" in Photoshop

I love Photoshop. I think it totally rocks, and I've written around 35 books on Photoshop. That being said, it's much faster and easier to get it right in the camera than it is to fix it later in Photoshop. If you see something distracting in your viewfinder, like a telephone line or a road sign, that's ruining your shot, you certainly could remove either one later in Photoshop. It probably wouldn't take you more than 10 minutes or so to remove that telephone line or road sign in Photoshop. But it probably wouldn't take you more than 10 seconds to move one foot in either direction to recompose your shot so you don't see the telephone wires (or the road sign) at all. Getting it right in the camera is just so much faster, and besides—you want to save your time in Photoshop for finishing your photos, not fixing them. Do yourself a favor, and compose so those distracting elements aren't in your frame, and you'll spend a lot more time shooting and having fun, and a lot less time on tedious cloning and repairing in Photoshop.

Want to Be Taken Seriously? Start Editing

If you want to be taken seriously as a photographer and you want people to start to view you as a pro-quality photographer, then take a tip from the working pros, which is: only show your very best work. Period. One thing that makes a pro a pro is they're really good photo editors—they're really good at picking, and only showing, their very best stuff. You don't see their so-so shots or the shots that would have been great, if only…. You also don't see them showing seven or eight similar shots of the same subject. Only show your best of the best. That means if you went on a trip and you took 970 shots, you don't come home and show a slide show of 226 images. If you want people to think you're good, show your best 30. If you want people to think you're great, show just your best 10. Think about it: If you took 970 shots, maybe 400 are decent. Out of those decent shots, maybe 80 are pretty good. Out of those 80, maybe 30 are really good. Out of those 30, maybe 10 are outstanding. Now, just show those 10—and blow people away. (Just ask yourself what you would rather see—80 pretty good shots, or 10 outstanding shots.)

Label Your Memory Cards

This is another tip I picked up from Derrick Story, and he tells the true story of how he left a memory card in a taxi cab, but because he always puts a sticker on his cards with his name and address, he was able to get that card returned to him with all the photos still intact. That's right, he lost his memory card in a taxi and got it back. This obviously didn't happen in New York. (I'm totally kidding. You knew that—right?)

Go Square

Today's digital cameras all produce an image that is rectangular, so no matter whose photo you see, it's either a tall rectangle or a wide rectangle. Want to make your photo stand out from the pack and have more of a "fine art" look when you print it? Then "Go square!" That's right—just crop your photo to a perfect square (as seen above), and then position that perfect square with plenty of nice white space around it, for a nice fine art, gallery look, like the layout you see here. It's a simple little thing, but they're all little things, right?

Tip for Shooting at Night (Long Exposure Noise)

If you're shooting at night, your shutter is going to wind up staying open long enough for you to make a good exposure, and depending on how dark it is where you're shooting, it could open for ¼ of a second, 4 seconds, or 40 seconds. If you start to have long exposures, like 40 seconds, chances are you're going to start to get some serious noise in your photo (even if you were shooting at 100 ISO). One thing you can do to help is to turn on your camera's Long Exposure Noise Reduction feature (Nikon, Canon, and Sony DSLRs all have this feature). This kicks in your camera's built-in noise reduction to combat the kind of noise that shows up in long exposures like these, and they actually do a surprisingly decent job, so they're worth turning on (just in these long exposure instances—this is *not* for everyday use).

The Very Next Book You Should Get

You've heard me mention legendary assignment photographer Joe McNally here in the book, and Joe has a book that I truly believe is the most important photography book in many years. It's called *The Moment It Clicks: Photography Secrets from One of the World's Top Shooters* (from New Riders), and what makes the book so unique is Joe's three-pronged "triangle of learning" where (1) Joe distills the concept down to one brief sentence (it usually starts with something along the lines of, "An editor at *National Geographic* once told me…" and then he shares one of those hard-earned tricks of the trade that you only get from spending a lifetime behind the lens). Then, (2) on the facing page is one of Joe's brilliant images that perfectly illustrates the technique (you'll recognize many of his photos from the covers of your favorite magazines), and (3) you get the inside story of how that shot was taken, including which equipment he used (lens, f-stop, lighting and accessories, etc.) and how to set up a shot like that of your own. There's just never been a book like it. The photography is so captivating, you could buy it just for the amazing images (think, coffee-table book), but his insights on equipment, technique, and the fascinating backstory behind the shot let the book totally stand on its own as a photographic education tool. This book combines those elements as it inspires, challenges, and informs, but perhaps most importantly, it will help you understand photography and the art of making great photos at a level you never thought possible. I worked as an editor on the book, and I have to tell you—it blew me away. It will blow you away, too!

Chapter Nine

Photo Recipes to Help You Get "The Shot"

The Simple Ingredients That Make It All Come Together

The chapter from part 1 of this book that I probably got the most emails on was this last chapter—the photo recipe chapter. In this chapter, I show some of my shots, and then give the details for how to get a similar shot, including what kind of equipment you'd need, what time to shoot (if it's relevant), where to shoot it, where to set up your lights, tripod, etc., so it's kind of a photo recipe cookbook. Although there are a lot of shooters that do anything to get "the shot," you'll be happy to know—I'm not one of them. In fact, I've often toyed with the idea of starting a trade association for people like me and calling it "The International Society of Convenient Photographers" (or the ISCP, for short). Our credo would be, "Any shot worth getting, is worth driving to." Our ideal situation would be we drive up to a location, roll down the window, take the shot, and drive off. It doesn't get much more convenient than that. There would be special recognition for members who abide by our 50-ft. Cone of Convenience rule, which states: "If a once-in-a-lifetime photographic opportunity presents itself, the member may venture as far as 50 ft. from the member's vehicle, in any one direction, as long as they leave the car's engine running and the air conditioner turned on." But then I realized this was very limiting, because it would exclude most studio photographers. So, we added a special dispensation for them, in rule 153.45, Section B, which states: "A studio photographer should avoid changing their subject's pose, as doing such could force an inconvenient repositioning of the light, which breaks with the sacred tenets of our group." Sure, it's a small group, but we really get around.

The Recipe for Getting This Type of Shot

LOCATION: YOSEMITE FALLS, YOSEMITE NATIONAL PARK, CALIFORNIA

Characteristics of this type of shot: A sweeping shot with a silky waterfall effect, with lots of detail front-to-back and a real sense of depth.

(1) To get this type of sweeping look, you need to use a very-wide-angle lens. This was shot with a 12mm wide-angle (it's not a fisheye lens—just a super-wide-angle).

(2) To get the detail from front to back, shoot in aperture priority (Av) mode and choose the highest number f-stop you can (this was shot at f/22, which keeps everything in focus from front to back).

(3) You absolutely need to shoot on a tripod for a shot like this because you're shooting at f/22, which means your shutter will be open long enough that even a tiny bit of movement will make the photo blurry.

(4) Another benefit of shooting at f/22 is that since your shutter stays open longer, the water in the waterfall looks silky (you might remember this trick from part 1 of this book—how to get that smooth, silky water effect). You'll also want to use a cable release (or your camera's self-timer function), so you don't add any blur when pressing the shutter button (yes, it makes a difference).

(5) The final key to this shot is shooting it right around dawn. This does two things, the first being that since it's darker outside, your shutter will stay open longer and your water will look silkier. You couldn't get that silky water look at 1:00 in the afternoon. The second thing is even more important: the quality of the light and the nice soft shadows only happen like this around dawn (and around sunset), so get up early and get the shot!

The Recipe for Getting This Type of Shot

Characteristics of this type of shot: Very shallow depth of field (the front of the plate is out of focus, so is the back). The subject looks very sharp and the lighting is just great.

(1) The biggest challenge in getting a shot like this in a restaurant is having enough light to make the shot look great. The secret is, of course, to ask to sit outside (dining alfresco) or near a window, so you can use natural light to light your food (this shot was taken at a table outside, so there was plenty of light, but the umbrella over the table kept the light from being too harsh). Next, position the food so the light is coming from either behind it, so it's backlit (my first choice), or from the side.

(2) The second technique for capturing a shot like this is to use a long lens, so you can zoom in really tight on one part of the plate (for this shot, I used an 18–200mm f/3.5–5.6 lens zoomed in all the way to 200mm). By zooming in tight and locking focus (in this case, on the appetizer right in the center), it puts the rest of the food out of focus at the top and bottom of the image, which is what you want.

(3) The last part is the compositional part, and it's perhaps the most important one (well, besides the light, anyway). Don't try to capture the entire plate of food. Pick one part of it and zoom in tight on that. It's okay to include the curve of the plate, but if you do, just show that one side.

(4) If you're shooting indoors, even near a window, you might need a very small table-top tripod (I use a Manfrotto tabletop tripod, barely big enough to hold my camera). To minimize any blur, use your camera's self-timer feature to take the shot.

The Recipe for Getting This Type of Shot

LOCATION: ST. NICHOLAS GREEK ORTHODOX CATHEDRAL, TARPON SPRINGS, FLORIDA

Characteristics of this type of shot: A large, wide, sweeping shot of a cathedral with lots of detail in all the ornate objects in the scene.

(1) In many ways, this shot was taken like it was a landscape shot—it was designed from the outset to have that big, sweeping look. Shoot a church like this with a wide-angle lens (this was shot with a full-frame camera, which means it was extra-wide compared to a cropped sensor camera, and it was shot with a 14mm lens).

(2) Churches generally have low light, and even though the ceiling of this church was white and there was natural light coming in through the windows, it was still dark enough that, at f/4, my camera needed to keep the shutter open $1/13$ of a second, which is way too slow to handhold. So, you'll absolutely have to be on a tripod.

(3) This is the beautiful St. Nicholas Greek Orthodox Cathedral in Tarpon Springs, Florida. I'm positioned in the center aisle between the pews, right at the first pew, so there are no obstructions (pews) between the camera and altar.

(4) Compositionally, I used a trick that helps make it look like a big, sweeping shot: I collapsed the tripod legs, so the tripod was only about 18" tall (if that). That way, you see a lot of the marble floor leading up to the altar, which creates its "bigness."

(5) To bring out the detail, you finish off this shot in Photoshop (or Elements or Lightroom) using a plug-in filter that creates a tonal contrast effect, like Nik Software's Color Efex Pro, onOne's Perfect Effects, or Topaz Labs' Topaz Adjust—all offer one-click presets for that effect (you can download fully-functional, free trial versions of all three from their websites).

The Recipe for Getting This Type of Shot

Characteristics of this type of shot: A soft, dramatic, backlit silhouette of a bride taken with just one small light.

(1) This was shot using only one light with a small (24x24" square) softbox attached. Start by making the room she's standing in so dark that the only thing lighting her is the light from the softbox. Set your camera to manual mode, so you can control the shutter speed and aperture separately. Set your shutter speed to the highest number that will still sync your camera/flash (for most studio strobes, that's 1/200 of a second. For most hot shoe flashes, it's 1/250 of a second). By using a high shutter speed number like this, it lets in less existing room light.

(2) Keep your flash turned off, set your f-stop to f/8, take a test shot, and then look at the image on the back of your camera. If you can clearly see the bride, raise the f-stop to f/11, and take another shot. Keep doing this until you're pretty much getting a solid black image (no bride, no detail, no nuthin'). Now, turn on your flash.

(3) You're going to position the flash with the small softbox behind her, but not directly behind her. You want to position it off to one side behind her, so it is coming from behind but aiming back at her at an angle. Next, position her so her head is turned a little toward that light, so some of that angled back light reflects back onto her face (here, you can see some of the light reflecting off the flowers back into her face). Now, your job is to keep the power of the flash low (like 1/4 power or less) to keep it looking dramatic.

(4) When you're done, convert the photo to black and white and add a brown tint in Photoshop or Elements (use a Photo Filter adjustment layer), or Lightroom (use a Develop preset).

The Recipe for Getting This Type of Shot

Characteristics of this type of shot: Dramatic portrait, nicely suited for male subjects, with lots of drama to the lighting.

(1) This was taken with an inexpensive hot shoe flash on an inexpensive 6' light stand.

(2) I used a roll of black seamless paper for the background (around $25 for a 53" roll).

(3) To get directional light like this, you have to get the flash off the camera, and to get it off the camera this far, you have to use either a wireless flash or a really long sync cable (but, try not to use a long sync cable—at some point you'll trip over it).

(4) To get the softness and wrapping quality of the light from the flash, you'll need to either fire the flash through a diffuser or use a small softbox made for hot shoe flash (that's what I used for this shot. It was a 27x27" hot shoe softbox from Impact. Lastolite makes a softbox like this, too, and there's even a Joe McNally signature version of this handy hot shoe softbox that folds up flat like a reflector).

(5) Position the flash to the right of the camera, up about one foot higher than your subject, at about a 45° angle aiming down toward them. Put it about six feet back from your subject. If you're using a small softbox, you're all set. If you're using a diffusion panel, position it as close as you can get it to your subject without actually seeing it in the photo. Put your flash about one foot behind that panel.

(6) No reflector is necessary (you want the dark shadows on the far side of his face) and no tripod is necessary because the flash will freeze your subject and stop any movement.

The Recipe for Getting This Type of Shot

LOCATION: SAND HARBOR STATE PARK, LAKE TAHOE, NEVADA

Characteristics of this type of shot: Glassy, still water; a beautiful gradient of colors in the sky; and a wide, interesting vista.

(1) The key to this shot is when you shoot it. This type of shot needs to be taken before sunrise, not just for quality of light, but perhaps more importantly, to get the glassy, still water. The best time for this is at dawn. About an hour later and, in most cases, that water won't be still and glassy any more.

(2) While the sky does have a nice color gradient, it has something really important missing—clouds. Clouds are what make the sky interesting, so when you have a bald, cloudless sky like this, compose the shot so the horizon line is up in the top third of the frame. That way, you don't show much of the sky at all.

(3) In low dawn light like this, you need to, of course, shoot on a tripod and use a cable release or your camera's self-timer to minimize any camera shake. Because you're on a tripod, you can shoot at your lowest ISO (here, that was 100 ISO) to minimize any noise.

(4) You'll need to use a wide-angle lens to capture this wide a view (this was taken with a 14–24mm f/2.8 lens set at 14mm).

(5) This is another one of those occasions where you want to use a high f-stop number to keep as much in focus, front to back, as possible. I used f/22 (my go-to f-stop for landscapes).

(6) For a landscape shot to be successful, you need a strong foreground element (like these rocks, and to accentuate them, I put my tripod way down low).

The Recipe for Getting This Type of Shot

Characteristics of this type of shot: A simple sunset portrait using hot shoe flash.

(1) Start by positioning your subject with their back to the setting sun.

(2) Make sure your flash is turned off, because you first want to meter as if you're taking a regular ol' natural-light photo with no flash. Switch your camera to manual mode, set your shutter speed to ¹/₁₂₅ of a second (that's important), then aim at your subject, and hold the shutter button down halfway so your camera takes a meter reading of the scene. Look inside your camera's viewfinder, and you'll see a meter graph (on a Nikon, it's on the right; on a Canon or Sony, it's on the bottom). You're going to adjust *only* your f-stop until the meter reading reads 0 (zero; the proper exposure). So, move the dial to adjust your f-stop and, as you move it, you'll see that meter move, as well (keep it aimed at your subject while you're doing this). Once you've got the meter set to 0, look at your f-stop (let's say it's f/5.6, for example). Your job is to underexpose (make darker) the scene you're about to shoot by about 2 full stops (or more). So, if you were at f/5.6, you'll go two stops higher to f/11. Now, take a test shot. Does your subject look like a silhouette against the sky? If not, darken the scene more—try f/13 and take another test shot. When your subject looks like a silhouette, your settings are good to go.

(3) Turn on your flash with a *very* low flash power setting, like ¼ or ⅛ power, and put an orange gel over your flash so the light isn't white (see page 26). Use a diffuser or softbox to soften the light and take a test shot. If the flash is too bright, lower the power. If it 's not bright enough, raise the power, but keep it natural looking—don't "over-light" your subject.

The Recipe for Getting This Type of Shot

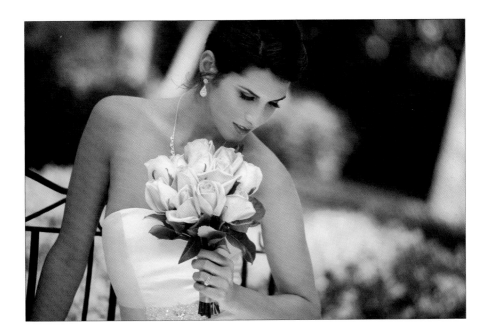

Characteristics of this type of shot: A natural-light shot taken in direct sunlight, with a soft, out-of-focus background and a shallow depth of field.

(1) This shot, taken in the garden area between the church and the church office, was in direct sunlight. To get soft, beautiful light in a situation like this, we have to diffuse the light (use something to make the harsh, direct sunlight soft and beautiful), so standing just to her left (from the camera position) is a friend holding up a diffuser right over her head (see page 84 for more on diffusers). You basically put the diffuser between the sun and your subject and it spreads and softens the light in a big way (as you can see above).

(2) To make the diffused light even softer, have your friend hold the diffuser as close to the top of your subject's head as possible without actually being visible in the frame itself. The closer you get the diffuser to your subject, the softer the light (in fact, you can almost see a glow as the diffuser gets really close).

(3) By looking at the photo, you can probably figure out the f-stop I used, because the background is way out of focus, and you've learned that f-stops that do that are "wide open" f-stops with low numbers, like f/1.8, f/2.8, f/4, and f/5.6 (in this case, it was f/2.8).

(4) If you remember back to page 77, then you also know that f-stop alone won't give you that out-of-focus background look like this—you have to use a longer lens and zoom in (in this case, it was a 70–200mm zoomed in to 200mm).

The Recipe for Getting This Type of Shot

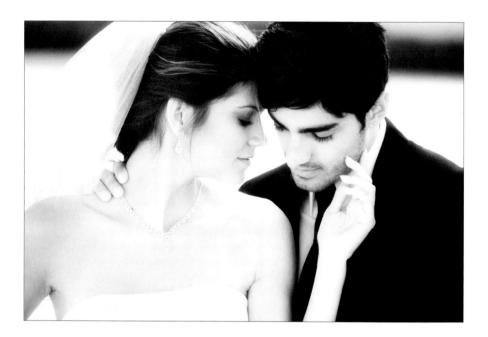

Characteristics of this type of shot: A bright, clean, dreamy look using softened natural light.

(1) This shot was taken in the worst light possible, at "high noon" (well, at 12:07 p.m. to be exact), in an empty lot near downtown, but still the light is just gorgeous. The trick is simply to make the sunlight soft (you learned that trick back on page 84), which is to put a diffuser between the sun and your subjects. We used an inexpensive Westcott diffuser (part of their 5-in-1 reflector/diffuser kit for around $40) and I had a friend hold up the diffuser over their heads to block the harshness of the light, making the light source larger by spreading and diffusing it.

(2) At high noon like this, the sun is usually straight overhead, but if it's not (you're shooting earlier or later in the day), just remember to position the sun behind your subjects (so their backs are facing the sun). That way, any sunlight from behind them just creates a nice rim light around them and doesn't spill onto their faces.

(3) To create a soft glow with your diffused light, have your friend (or assistant) hold the diffuser right over their heads, as close to your subjects as possible without actually seeing the diffuser itself in your frame.

(4) Now, give the entire image a soft glow effect in Photoshop (or Elements). Just duplicate the Background layer and apply a 50-pixel Gaussian Blur filter to this layer. Lower the Opacity of this layer to 30%, and then, at the top of the Layers panel, change the layer's blend mode from Normal to Soft Light. Lastly, convert the photo to black and white.

The Recipe for Getting This Type of Shot

Characteristics of this type of shot: A bright, backlit, blown-out look shot with visible motion to give the sense of speed.

(1) In sports photography, you normally try to freeze the action, which means getting a shutter speed of $^1/_{1000}$ of a second or faster. However, there are times (and certain sports, like cycling and motorsports) where you want to create a sense of motion and speed, so the athletes (cars) appear to be moving (and not parked in position, ready for the race to start). To do this, shoot at a slow shutter speed and pan with your subject (in this case, the cyclist), which keeps most of the bike in focus, but makes the wheels and background show motion.

(2) To do this, shoot in shutter priority mode (S) and set your shutter speed to $^1/_{60}$ of a second (far below the $^1/_{1000}$ you'd use to freeze motion), and then turn on Continuous High-Speed mode (on a Nikon) or Continuous Shooting (on a Canon or Sony), so it takes multiple photos when you press-and-hold the shutter button.

(3) When the athlete is nearly to you, lock your focus on them (I usually aim my center focus point at their helmet), and then track along with them, firing in continuous mode, taking a series of photos as they go by. Hold that shutter button down until they are well past you.

(4) Many of the shots will be terribly out of focus and that's normal, but in that burst of shots, you'll usually find one that looks just right (and that's the only one you need).

(5) Lastly, to get the popular blown-out look, take your lens hood off your camera, position the athlete between you and the sun, and fire away. Lens flare will come.

The Recipe for Getting This Type of Shot

Characteristics of this type of shot: A tight, close-up shot of the wedding rings with a glassy reflection.

(1) Getting something as small as two wedding rings to fill the frame, like these do, and still look really sharp means using a lens that was made for this type of shot: a macro lens. If you have a macro lens, you're all set. If not, there are three alternatives that can help: (a) Use a Canon Close-Up lens, which screws onto the front of your regular size lens like a filter, turning it into a macro lens. It's cheaper and smaller and does the trick. (b) Many zoom lenses have a Macro mode, in which case you're already set. Or, (c) you can use an extension tube (see page 183).

(2) The reflection comes from just placing the rings on a shiny surface (in this case, ivory piano keys. You can also place the rings on a black area of the piano for a more mirror-like reflection). On the off chance that neither the church nor the reception hall has a piano, then head out to the parking lot to see who has a shiny white or black car (maybe the bride and groom hired a limo, or someone in the wedding party has one). Just put the rings on the hood and—voilà—instant reflection (of course, ask permission before you put things on someone's hood or a reflection may become the least of your worries).

(3) If you have a tripod, this is the time to pull it out, because you'll be shooting at an f-stop that will help keep as much in focus as possible, like f/22. You'll need this because the depth of field for macro lenses, even at f/22, is so small that the front of the rings will be in focus, and the back will be a little out of focus.

The Recipe for Getting This Type of Shot

LOCATION: PARIS, FRANCE

Characteristics of this type of shot: A sweeping view of a city skyline at sunset.

(1) The first key to this shot is the high vantage point. To get a rooftop skyline shot like this, you have to be up at least as high as the average building height. This shot was taken from the roof of the ultra modern L'Institut du Monde Arabe in Paris, along the Seine River, just behind Notre Dame. It has an open rooftop where you can even set up a tripod for a beautiful view of Notre Dame at night. However, this shot was taken on the opposite side of the building where there is no open rooftop and no clear view of the Eiffel Tower, which is what made getting this shot a bit of a challenge. But, I used the technique from page 162 on shooting through the glass window in your hotel. By the way, I used this same technique for the opening shot for this chapter, except it was pressed against the glass window of a moving tour bus.

(2) Near the elevators on the opposite side of the building is a patterned facade facing the building's courtyard. It covers the entire side of the building, but the pattern had a circular hole in the center of each square—just big enough for me to press my lens up firmly against the glass to minimize glare. That was total luck, but there's more to it than this. The way it's constructed, I couldn't use my tripod to hold the camera, but of course, it's sunset and low lighting (not to mention the fact that I'm now shooting through what I imagine is tinted glass). So, I had to raise the ISO on my camera to 800 ISO. This raised my shutter speed above $1/60$ of a second, which is a fast enough shutter speed where I could handhold the shot and not get a blurry photo.

The Recipe for Getting This Type of Shot

LOCATION: PARIS OPERA HOUSE, PARIS, FRANCE

Characteristics of this type of shot: An empty hallway with a wide, long look, lit with natural light, with lots of detail visible throughout.

(1) There were two keys to this photo: The first was patience. There is nothing that kills a shot faster than one filled with tourists, and this is a hallway in the Paris Opera House, which is open to the public all day for self-guided tours. Loads of tourists were walking right in front of me from this vantage point, going to the balcony outside to the left that overlooks the street below, and even more people were walking down the hall-way itself straight toward me. The only way to get a shot where it was not packed with people was to stand there, camera in hand, and literally just wait. I stood there for nearly 25 minutes to get this shot (you can still see a few tourists way off at the other end, but for the most part, they blend into the background).

(2) The other key was kindness and a smile. As soon as I started to set up a tripod (it doesn't look like it, but the light was pretty low), a security guard immediately came up to me and told me it was "not allowed." I smiled and said "just one quick shot." He shook his head, "No." But, I was really nice about it, and then said, "I'll just take one quick shot—this hall is so beautiful, and I'd love a quick shot." He paused and then said, "Well…I'm just going to walk into this next room and if you take a quick shot with the tripod, just don't let me see you do it." He smiled. I smiled. And, I didn't abuse it—when the time was right, I unfolded the legs, took the shot, and then packed it up. I smiled, winked, and gave a thumbs up as I left. He smiled back. Kindness and a smile go a long way.

The Recipe for Getting This Type of Shot

Characteristics of this type of shot: A simple two-light food shot using a couple of little tricks that make the food look more appetizing and the shot look better.

(1) This was actually shot in the restaurant (I was hired by the restaurant to shoot different dishes for their menu), but they set us up in a dark back corner in a part of the restaurant that wasn't being used. We used a dining table as our shooting platform.

(2) I used two continuous, always-on lights from Westcott (see page 46), which are perfect for food and product shots like this. I placed one light behind the food, at an angle off to the right, with a small softbox, and another in front of the food, off to my left, with a small softbox.

(3) This is taken with a macro lens (to get that super-shallow depth of field, where only part of the food is in focus). This means shooting on a tripod with a shutter release, and keeping the barrel of the macro lens pretty straight (not tipping it down too much—see page 174).

(4) To keep the food looking moist and fresh, we kept a small bowl nearby with vegetable oil and we brushed it liberally on the food to give it that shine.

(5) To make the highlights really pop, we used four very small, inexpensive (we bought them at the local pharmacy) tabletop swivel vanity mirrors, and we bounced light from the back light into areas where we wanted an extra kick of light in front (that swivel comes in really handy for this—with continuous lights like we're using, you can literally see the beams of light from these mirrors as you swivel them up/down).

The Recipe for Getting This Type of Shot

LOCATION: MAUI, HAWAII

Characteristics of this type of shot: A misty, almost cloudy sea with beautiful clouds above to make a classic sunset scene.

(1) A key part of this is simply luck. The next day I could have come to this same location, at the same time, with the same equipment, and been faced with a bald, cloudless sky. But this particular night, I got lucky with a beautiful, cloud-filled sky, which is exactly what you need to create a beautiful sunset image.

(2) For a sweeping landscape like this, you need to use a wide-angle lens (this was taken with a 28–300mm zoom lens, set at 28mm—its widest angle). To keep a decent amount of focus throughout the shot, you should choose a higher number for your f-stop (f/14, f/16, f/22, etc.).

(3) Since you're shooting around dusk, the light will be low, so you absolutely need to shoot this type of shot on a tripod or your shot will be blurry. Also, use a cable release or your camera's self-timer to minimize any camera shake. Since you're on a tripod, you can shoot at 100 ISO for the cleanest image.

(4) But just shooting a f/22 alone won't get you that misty, cloudy water you see here— you're going to need a filter to darken the scene even more, so your shutter can stay open for 30 or 40 seconds or longer (longer is better). It's called a Neutral Density (or just ND, for short) filter. It screws onto your lens and darkens the scene by 2 stops, 4 stops, or even 10 stops (the more stops, the longer your shutter stays open). Here's a link to a video tutorial I did on using ND filters: **http://bit.ly/173IgGL**.

The Recipe for Getting This Type of Shot

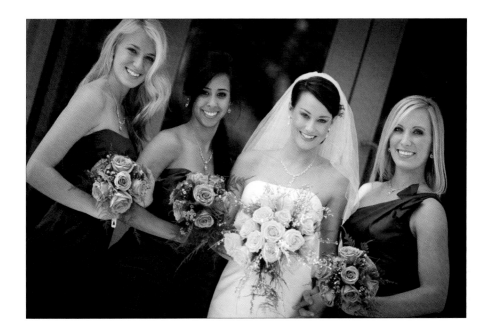

Characteristics of this type of shot: Nice, soft, beautiful light on the bride and brides-maids, even though it's taken outside at "high noon."

(1) Have you noticed a theme in this chapter? It's all about getting soft, beautiful light, and once you have that, the rest all falls into place. Here, we have a shot of the bride and bridesmaids, taken outside when the sun is its harshest, and all it took to get this shot was to make sure all of them were fully under an awning in front of the reception hall. By simply having them under an awning, so they're in the shade, the light is soft and beautiful. For softer, more beautiful light, move them toward the edge of the shade (I had them move a few steps forward, toward the camera, until they were almost in the sun without any of it actually hitting them directly).

(2) To have the background behind them a little bit out of focus, you want to use an f-stop that makes the background soft and out of focus, like f/2.8 or f/4. It's not super-out-of-focus because I wasn't able to zoom in tight enough (I would have had to use a really long lens and stand across the street to zoom in tight and fit four people in the frame).

(3) To add a little more energy to the shot, I tilted the camera to its side a bit (you might hear some photographers say, "Oh, not that cliché tilty trick," but clients still love it, and that's who you want to make happy)..

Index

A

about this book, 2–4
action photography, 217
air travel, 166
AlienBees studio strobe, 39
angled camera technique, 87, 223
aperture priority mode, 186
Aperture program, 67
aperture settings. *See* f-stops
autofocus feature
 moving the AF point, 192
 turning off for macro shots, 175

B

B&H Photo store, 72
backgrounds
 black, 68
 collapsible, 63
 color saturated, 68
 flash, 16, 24
 lighting, 65, 66, 69
 macro photography, 179
 out-of-focus, 77, 215
 portrait, 77, 85
 stands for, 38, 63
 studio, 38, 63, 65, 68–69
 white, 65, 69
backlight
 bridal portraits and, 139, 211
 flower photos and, 123
 outdoor portraits and, 80
backup gear, 137
battery grips, 79
battery packs, 150
Black, Dave, 27
black backgrounds, 68
black flags, 64
black reflectors, 64, 70

black-and-white images
 shots conducive to, 199
 wedding photos converted to, 154
bounce card, 19
bouncing light, 18, 51, 97
Bowens Jet Stream Wind Machine, 60
bridal portraits
 backlighting, 139, 211
 bridal gown in, 149
 photo recipes for, 211, 215
 posing the bride, 148, 149
 profile shots, 152
 See also wedding photos
budget categories for gear, 3
Buffalo Tools Industrial Fan, 60
bulb mode, 118
business cards, 147

C

Cactus wireless flash system, 11, 45
Camera Raw, 143, 198
cameras
 histogram display in, 196
 magnification factor of, 124
 moving the AF point on, 192
 orientating for portraits, 78, 82, 152
 silencing beep on, 138
 two-camera strategy, 140
 WHIMS acronym for checking, 190
 See also Canon cameras; Nikon
 cameras
candid portraits, 92, 93
Canon cameras, 3
 battery pack, 150
 dedicated flash units, 6
 EOS Utility software, 67
 exposure compensation controls, 117
 full-frame versions of, 124
 macro lenses, 181
 moving AF point on, 192
 ring flash, 182

The Shoot
Like a Pro
Tour

WITH SCOTT KELBY

See the concepts, images, & ideas from Scott Kelby's Digital Photography book series come to life—LIVE!

a full day of LIVE training for only $99

NAPP members pay $79

PRESENTED BY:

Kelbytraining

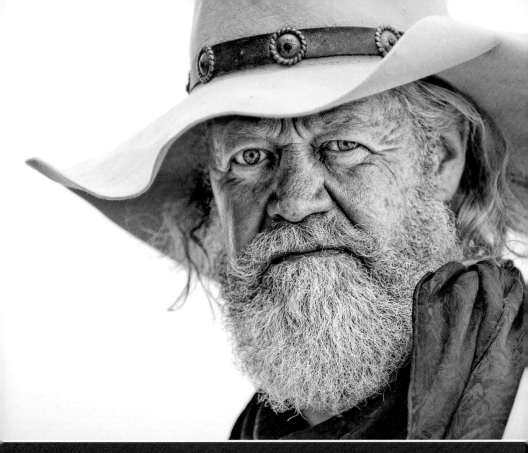

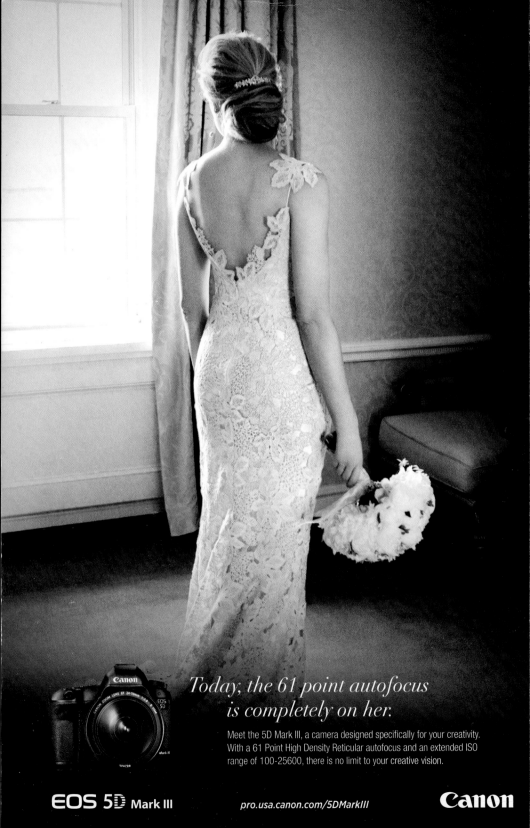

Today, the 61 point autofocus is completely on her.

Meet the 5D Mark III, a camera designed specifically for your creativity. With a 61 Point High Density Reticular autofocus and an extended ISO range of 100-25600, there is no limit to your creative vision.

EOS 5D Mark III

pro.usa.canon.com/5DMarkIII

Canon